ART IN THE AGE OF MASS MEDIA

ART IN THE AGE OF MASS MEDIA

Revised edition

JOHN A. WALKER

 Pluto Press LONDON

First edition published 1983 by
Pluto Press
345 Archway Road, London N6 5AA

Revised edition published 1994 by Pluto Press

British Library Cataloguing in Publication Data
A catalogue record for this book is available from the British Library

ISBN 0 7453 0832 5 hbk

Designed, typeset and produced for Pluto Press by
Chase Production Services, Chipping Norton, OX7 5QR

Printed in the EC by The Cromwell Press, Broughton Gifford, SN12 8PH

CONTENTS

ACKNOWLEDGEMENTS

Thanks are due to all the artists, galleries and organizations who kindly supplied photographs for illustrations. Sources and credits are given in the captions. While every effort has been made to trace copyright holders, the publisher would be glad to hear of any omissions.

' ... élites and ruling groups have always sought to distinguish themselves from others by the possession of objects which symbolise their superior status.'

Keith Thomas, *Observer* 7 March 1993, p. 58.

'Both avant garde art and mass culture bear the stigmata of capitalism, both contain elements of change ... Both are torn halves of an integral freedom, to which, however, they do not add up.'

Theodor Adorno, letter to Walter Benjamin, 18 March 1936. *Aesthetics and Politics* (London: NLB, 1977), p. 123.

'If the artist is not to lose much of his ancient purpose he may have to plunder the popular arts to recover the imagery which is his rightful inheritance.'

Richard Hamilton, *Collected Words 1953–82* (London: Thames & Hudson, 1982), p. 42.

'I'm for the artist to regain the responsibility for manipulation and seduction: for art to have as much political impact as the entertainment industry, the film, the pop music and advertising industries.'

J. Koons, *The Jeff Koons Handbook* (London: Thames & Hudson/Anthony d'Offay Gallery, 1992), p. 33.

INTRODUCTION

For many centuries, up until the mid nineteenth century, architecture, painting and sculpture were the three principal visual arts of Europe. These arts flourished because they received substantial patronage from the most powerful and wealthy individuals, groups and institutions within European society, that is, kings, princes, aristocrats, the Church, merchants, national governments, city councils and guilds. Today the situation is very different: our culture is not dominated by the fine arts but by the mass media. Changes brought about by the industrial revolution, by the development of a capitalist economic system, and by the emergence of an urban, consumer society, have irrevocably altered the social context in which fine arts operate. Architecture, it should be acknowledged, has been far less affected by these changes than painting and sculpture.[1]

Machines of various kinds have played a crucial role in this social and technological transformation. Until the advent of colour photography and printing, for example, painters enjoyed a virtual monopoly over the production of coloured images. Now millions of high-quality colour images, and millions of copies of those images, can be simply and rapidly generated by the use of the camera and the printing machine. The art of painting has not died out as a result but, arguably, there has been a decline in its status and power; its social functions have also altered.

This book examines certain aspects of the condition of the fine arts in the age of the mass media; it identifies the differences between these two relatively autonomous realms, but it also discusses the ways in which they interact. (The fact that a line can be drawn between two realms does not prevent two-way traffic across the line from taking place: frontiers exist between countries, but people, goods and information cross them every day.)

Key questions to be considered are: what has been the response of fine artists to the existence of the mass media? How have the mass media made use of the visual arts? Is there any vital social role left for fine art? If so, what is it?

Just because the fate of the visual arts in the age of mass media is the primary concern of this book, readers should not assume that it takes the view that all virtue is on the side of the former and all vice on the side of the latter. In both realms one can find new and creative ideas, old and reactionary ideas, well and badly made artefacts, the aesthetically good and bad.

During the 1970s and 1980s art historians employed in British colleges of art and design were asked to broaden their expertise. Lectures and courses on the history of industrial design, advertising, photography, film, television, video, computer graphics, fashion and youth sub-cultures were required in addition to those already given on painting, sculpture and architecture. This was because they were teaching trainee designers

and craftspersons, photographers, film- and video-makers in addition to fine art students. Indeed, art students were a minority. Some of the pressure for the expansion of the art historian's object of study was due to the cultural dominance of the mass media. Also significant was the fact that many modern artists had adopted new media technologies – photography, film, video, computers – in order to make art. As the art historian's object of study expanded, seemingly without limit, one question in particular became ever more pressing: what was the relationship between the traditional fine arts and the new mass media? It was not only artists, therefore, who were confronted by the problem of coming to terms with the mass media.

In the event, the task faced by scholars was not simply one of taking on board new subjects such as advertising, but of encompassing the mass mediation of art itself. That is to say, analysts of contemporary art in particular found that they could not limit themselves to the interpretation and evaluation of works of art because they had also to absorb and consider press releases and other publicity material, colour reproductions, catalogue essays, newspaper and magazine reviews, photographs and films of artists, interviews with them, radio and TV arts programmes about them. (What some theorists call 'the metatextual narrative or discourse'.) Some readers may be thinking 'Surely, compared to the art, such material is secondary, unimportant.' Yet, increasingly, this is not the case. As more and more artists realize the crucial importance of the media to a successful career, more and more of them seek to control and manipulate their image and the dissemination of their work through the various channels of communication. As we shall see later, in reference to the American artist Jeff Koons, there is a symbiotic relationship – indeed an interplay – between his art and his media presence. Salvador Dali and Andy Warhol were two precursors of Koons in this respect. In their application of creativity to self-presentation and self-promotion, fine artists increasingly imitate the behaviour of such mass culture stars as Madonna and Michael Jackson.

The first edition of this book was intended as a student textbook for a course on Art and Mass Media taught at Middlesex Polytechnic (now Middlesex University). Naturally I hoped it would be of interest and value to a wider readership, but its educational purpose should perhaps explain the somewhat schematic manner in which it is organized.

Although there are two chapters which discuss the art of the 1970s and the 1980s, on the whole an analytical rather than a strictly chronological approach has been adopted. No attempt has been made to provide a comprehensive history or survey of the subject. Many theoretical texts about culture are short on illustration and concrete examples. In contrast, this book reproduces and analyses a series of examples taken from different periods in order to explain abstract concepts. I am aware that the kinds of analysis of images contained in this book are not the end of the story: viewers 'read', interpret, appropriate and use works of art and mass culture products in a variety of ways, some of which are oppositional. It must be obvious, however, that a book of this size and

introductory character cannot provide analyses of images and accounts of the responses of millions of people to those images.

A text which relates art to the class structure of society and discusses issues of concern to socialist and feminist artists and art historians will not be welcomed in certain quarters. There are many who still regard art as a realm of value which transcends ideology, politics and class struggle altogether, even though it is impossible to understand art as a *social* phenomenon without reference to the structure of the society within which it is produced, and understanding that social context inevitably involves consideration of such issues as class, ideology, economics, politics, power, gender and race.

It is often maintained that analysis of art destroys its mystery. In my view, knowledge deepens understanding and appreciation. However, it is true that a socialist critique of art has a demystifying impact upon the bourgeois concept of art. Another commonly held belief is that images which are politically partisan are propaganda, not art. The Catholic Church's use of art as a means of persuasion during the Counter Reformation is just one example of the fact that art and propaganda are not necessarily mutually exclusive. Today, few are aware that the very word 'propaganda' – meaning 'propagating the faith' – was invented by the Catholic Church in 1622.

When this book first appeared the cataloguers of the British Library categorized it as 'communism and art'. However, the word 'communism' has become so debased by its association with repressive regimes such as those of Stalin, East Germany, China and Pol Pot, that it has become unusable except as a term of abuse. Readers should not assume that just because a writer or an artist finds fault with present western society, what they have in mind to replace it is a totalitarian dictatorship, a secret police state. I should also like to point out to future cataloguers that this text is as much about *capitalism* and art as it is about 'communism' and art.

Existing Literature

The published literature on the relationship between 'high' and 'low' culture, art and mass media, is extensive (see Bibliography). Much comment has emanated from cultural historians, art and literary critics. Many visual artists have also made illuminating statements via interviews or essays. During the 1930s and 1940s art's relationship to mass culture was discussed by the German philosophers Walter Benjamin and Max Horkheimer, both associated with the Frankfurt School of Social Research. Clement Greenberg, the American art critic, published an essay in 1939 on the differences between avant-garde art and kitsch that was subsequently to become famous. In London during the late 1950s the topics fine art, popular culture and mass media preoccupied the British pop artist Richard Hamilton and the theorists Lawrence Alloway and John McHale.[2]

For many artists and art historians, myself included, the appearance of John Berger's *Ways of Seeing* (TV series and paperback book) in 1972 was

a crucial intellectual stimulus. In some respects this text is a continuation of the train of thought Berger set in motion. *Ways of Seeing* provided an overview of the development of western art in terms of four themes: mechanical reproduction, representations of women, oil painting and private property, publicity and politics. Modern publicity, Berger argued, inherited its system of pictorial rhetoric from the European oil painting tradition. This is why *Ways of Seeing* concluded with a discussion of advertising. What *Ways of Seeing* omitted was any consideration of modern art and the problems of practice faced by living artists. It is this weakness which this text seeks to remedy.

During the period 1980–92 critical and curatorial interest in the theme of art and mass media was intense – exhibitions devoted to different aspects of the subject were held in both private and public galleries.[3] Retrospective exhibitions were also devoted to the work of individual artists cited in this book, namely Laurie Anderson, Richard Hamilton, John Heart-field and the late Andy Warhol. The fact that the above mentioned shows took place in Europe, Australia and the United States indicates that the issues discussed in this book were international in character.

Some of the exhibitions were accompanied by lavishly illustrated book-length catalogues. The volume for *High and Low: Modern Art and Popular Culture* (New York: Museum of Modern Art, 1990), written by Kirk Varnedoe and Adam Gopnik, was particularly substantial. (It in-cluded a lengthy bibliography which nevertheless managed to ignore the first edition of this book.) The *High and Low* project – a piling up of example after example in order to prove that an extraordinary variety of interactions have taken place between fine art and popular culture – appeared designed to refute the idea that any systematic account of the phenomenon could be provided.

Aside from periodical articles, other literature on the subject of art and mass culture published after 1983 included: R. Pelfrey and M. Hall-Pelfrey's textbook *Art and Mass Media* (1985); my own books *Cross-overs: Art into Pop, Pop into Art* (1987) (a study of the interactions between fine art and rock/pop music), *Art and Artists on Screen* (1993) (a study of the ways art and artists have been represented in the cinema); *Synthesis: Visual Arts in the Electronic Culture* (1989); M. Lovejoy, *Post-modern Currents: Art and Artists in the Age of Electronic Media* (1989).

Craig Yoe and Janet Morra-Yoe edited *The Art of Mickey Mouse* (1992), a book devoted to the use of images of the famous Disney character by an international galaxy of artists. (Later several works of art employing the image of Mickey Mouse in a critical rather than a celebratory way will be described.) This book – together with the exhibition catalogues *The Comic Art Show* (New York: Whitney Museum of American Art, 1983) and *Comic Iconoclasm* (London: ICA, 1987) – testified to a widespread fascination with the appearance of comic strip images in fine art. And, as we shall discover, some fine artists have adopted the comic book as their prime medium of expression.

A new British magazine dedicated to serious (but non-academic) discus-sion of popular culture – *The Modern Review* – was founded in 1991. It

promoted itself as 'low culture for highbrows'. On the cover of issue one was an updated version of Richard Hamilton's famous 1956 collage: 'Just what is it that makes today's home so different, so appealing?'. The magazine was the brainchild of the abrasive journalist Julie Burchill, and its editor was Toby Young. Burchill believed it was possible to enjoy the best of avant-garde art and the best of mass culture – what she despised, however, was what lies between the two extremes, that is the middlebrow. The latter is a vast continent somewhat neglected by critics and historians (see, however, Joan Rubin's book *The Making of Middlebrow Culture*, 1992).

A relevant British television series transmitted in 1991 was BBC 2's *Relative Values*. (There was also a tie-in paperback written by Louisa Buck and Philip Dodd.) Especially useful was the final programme entitled 'The Agony and the Ecstasy'. It examined the myths and legends historically associated with artists and the way the mass media of books (that is, novelized biographies such as Irving Stone's *Lust for Life*) and movies relayed them to the general public.

Although arts programmes on British television have always featured both popular and highbrow forms of culture, in recent years there has been an increasing tendency to treat mass culture stars as seriously as major fine artists. In 1990 some commentators criticized this non-hierarchical approach to culture on the grounds that distinctions of quality – between good and bad art, between 'serious' art and 'mere' entertainment – were being blurred. A heated debate followed on television and in the press about the respective merits of great artists and entertainers (it was usually posed in terms of a stark, either/or choice between Mozart and Madonna, John Keats and Bob Dylan, rather than a both/and). The debate – a recurring phenomenon – revealed that, despite the supposed triumph of post-modern pluralism and relativism, hierarchical notions of culture persist and are still a source of anxiety and disagreement. The division which Theodor Adorno identified between high art and mass culture remains, despite many recent examples of convergence and overlap. Consequently it continues to be a site of cultural struggle and artistic opportunity.

Finally, Professor John Carey's 1992 volume *The Intellectuals and the Masses: Pride and Prejudice Among the Literary Intelligentsia 1880–1939* is worth citing even though it is concerned with literature rather than the visual arts, because it so comprehensively exposes the cultural élitism manifested by so many leading modern writers. In the case of some of these writers, contempt for people they considered socially inferior resulted in a flirtation with fascist ideas of mass extermination. In contrast, most of the visual artists whose work is examined in this book wish to overcome the élitism of contemporary art and to contribute to the building of a better, more socially just world.

1. CORE TERMS/CONCEPTS

Traditionally, culture has been categorized in a variety of ways. For instance, it has been divided into three ranks: high, middle and low. Cultural production has also been discussed in terms of particular media or artforms – painting, photography, graphic design, etc. – and in terms of broader groupings such as the fine arts, the crafts, industrial design, the mass or electronic media. Such categories influence the way we think about, interpret and value visual artefacts, but they also have consequences in the world outside the mind. They have material consequences in terms of the policies and practices of educational and arts institutions, galleries and museums. To cite just one example: in 1979 an application to the British Arts Council for a grant to repair trade union banners was rejected on the grounds that the banners were craft not art, even though many such banners feature painted images. In Britain trade union banners are collected and preserved by the Museum of Labour History in Manchester, not by the Tate Gallery, the Victoria and Albert Museum or the National Gallery in London.

All visual artefacts, no matter what their medium, can be ranked according to a good-to-bad scale of aesthetic value, but in terms of the hierarchical schema high/middle/low it has been customary to assign the fine arts to the top and the mass media to the bottom. It is surely no coincidence that this hierarchical schema echoes the division of European society into three classes: the aristocracy, the bourgeoisie or middle class, and the proletariat or working class. (A more complex model introduces the petty bourgeoisie and the lumpen proletariat or underclass.) Appreciation of the fine arts is primarily associated with the upper classes and appreciation of the mass media with the lower classes. Of course, a person's opportunity to enjoy a variety of types and levels of culture increases dramatically with the possession of wealth and leisure; consequently some rich people appreciate both high and low culture. The intelligentsia – a social group privileged in terms of cultural capital if not monetary capital – also has the opportunity to enjoy a broad spectrum of culture.

The Fine Arts

In the ancient world and in the Middle Ages, what we call 'the visual arts' were regarded as useful crafts on a par with shoemaking and cooking. The situation began to change from the Renaissance onwards as artists succeeded in raising the low social status of the visual arts by emphasizing their intellectual, theoretical and learned character, and by playing down their manual aspects. By the eighteenth century, according to cultural historians, the modern system of the arts (a grouping of five arts: painting, sculpture, architecture, poetry and music) had become established. The use of the term 'fine' implied beauty, skill, superiority, elegance, perfection and an absence of practical or utilitarian purpose.

The fine arts gained their specific character by contrast with mechanical, applied or useful arts and crafts. In some instances qualitative distinctions are made even within a single type of activity; for instance the distinction that has been drawn between architecture and mere building (a Gothic cathedral counts as architecture, whereas a bicycle shed counts as building).

Although historically the concept of fine art became associated with particular artforms – namely painting, sculpture and architecture – there is nothing intrinsic to the practices, materials and media of these arts which makes them 'fine'. This point is confirmed by the fact that many contemporary fine artists employ the new technologies of lithography, photography, film, video, holography, photocopying and computers. It is not the materials and technologies themselves which produce the distinctions between fine art, craft and mass culture, but rather the way in which those materials and technologies are habitually used – the different formal conventions employed – and the social institutions within which artefacts are produced, distributed and consumed. Even the concept of art itself (the concept which enables us to distinguish works of art from non-art objects) can be regarded as a social institution. A satisfactory history of European art, therefore, ought to include a history of the concept 'art' as well as a history of artists, works and patrons.

As already indicated, the distinction between the fine and the applied arts is based partly on the contrast between useless and useful. However, the idea that the fine arts are useless, that is exclusively concerned with the provision of aesthetic pleasure, is a dubious one. Architecture clearly serves practical as well as aesthetic functions. In fact, this is also true of the other arts: painting, for instance, serves ideological-symbolic ends and decorative functions. Our contemporary conception of works of art as purely aesthetic owes much to the existence of public museums and art galleries. (Many major museums date from the nineteenth century.) Isolated on the walls of these institutions, works of art derived from churches, country houses and public buildings are detached from their original physical settings and from the religious/secular contexts which helped to determine their meaning.

Curators usually arrange their collections in chronological sequences and in national schools. This kind of arrangement pleases art historians but, unfortunately, it fosters the impression that art's evolution is autonomous, growing primarily out of previous art rather than out of any external social demand. Once the museum existed, artists began to make works of art with that display context in mind. The result was that the size of works of art increased and many of them began to be about art or formal issues rather than about the world outside.

For centuries the visual arts were funded by, and served the interests of, the ruling classes of Europe and North America. When, in the eighteenth and nineteenth centuries, the upper middle class (that is, industrialists, businessmen, merchants, financial speculators) replaced royalty and the aristocracy as the dominant force in society, it inherited the culture promoted by the aristocracy. Even now, the fine arts are

appreciated, supported and collected by a mainly middle-class public. Today, however, the fine arts exist in a culture dominated by the mass media. The fine arts continue, but in a sense they are a *residue* of a pre-industrial social formation. To some they appear marginal and anachronistic. Arguably, their fate resembles that of the horse in the age of motor cars, trains and aircraft.

Pre-industrial values are evident in an art such as painting where skilled handwork results in a small output of unique products which are, as a result, expensive. Paintings and sculptures are usually luxury goods which only the wealthiest individuals or companies can afford to buy or commission. If, as some argue, all distinctions between art and mass culture have been dismantled, how do we explain the fact that a reproduction of one of Van Gogh's 'Sunflowers' can be purchased for a few pounds while the original painting costs tens of millions?

A specific set of practices, training schemes, organizations and institutions – what is commonly referred to as 'the artworld' – ensures the particular identity and continuity of the fine arts. The part played by academies and art colleges in supplying the artworld with fresh talent is clearly crucial. A few artists succeed without any art education but the vast majority of contemporary artists have benefited from a period at artschool. In these schools, individual production is the norm and it is highly valued. (This contrasts with the mass media where people tend to work in teams.) Modern artschools have fostered personal expression and experimentalism. The emphasis on creativity and self-fulfilment means that most art students are not encouraged to please patrons or to communicate with the public. Work is generated out of inner necessity – viewers and buyers come later. Only a small proportion of artschool graduates are taken up by dealers and are then able to make a full-time living as professional artists.

Many fine artists struggle to exist on various small sources of income. They therefore occupy a socially marginal position. This position does have a positive aspect: the artist has a greater degree of independence and intellectual freedom than, say, the graphic designer working in an advertising agency who has to serve the needs of clients. (Again the situation is somewhat different for architects.) This means that the more politically aware artists are free to make works of art that are critical of the society around them. Of course, this advantage is counterbalanced by a chronic lack of the resources which would enable artists to disseminate their critical images widely. But, as we shall see later, some artists have succeeded in forming links with existing organizations and community groups in order to disseminate their ideas.

A few professional artists manage to become very famous, successful and rich. The names Picasso, Dali, Warhol and Hockney immediately spring to mind. Once they have reached a position of eminence, such artists can wield a considerable degree of power and influence. They can make statements either through their work or via the media, or by contributing money and their names to particular campaigns and causes.

The Mass Media and Mass Culture

The expression 'mass media' denotes certain modern systems of communication and distribution which 'mediate' between relatively small, specialized groups of cultural producers and very large numbers of cultural consumers. A list of the mass media generally includes photography, the cinema, radio, television, video, advertising, newspapers, magazines, comics, paperbacks and recorded music in the form of discs and tapes. (It is obvious that some of these categories are not exact equivalents and also that some of them overlap – films are shown on TV and released on videotape; adverts make use of photography and appear in a variety of media.) Some historians regard the invention of printing as the beginning of the age of mass media, but a situation in which billions of individuals are exposed daily to a spectrum of powerful mass media is surely a uniquely twentieth-century experience.

A characteristic common to the mass media is the use of machines such as cameras, projectors, printing presses, computers and satellites to record, edit, replicate and disseminate images and information. What the mass media make possible are cultural products which are cheap, plentiful, widely available and capable of rapid distribution. Machines and their outputs *enable* communication to take place, but they also *stand between* the audience and the artists or performers; thus direct contact typical of much folk and popular culture is absent from mass culture. (Direct contact persists in the live arts such as theatre, ballet, rock and pop music performances.) On the positive side, technology and mechanical reproduction have brought about a tremendous democratization of culture. On the negative side, billions of people have become consumers of culture – much of it trivial and sadistic – produced by others.

Another characteristic common to several of the mass media is that they use more than one medium, that is, they are mixed- or multi-media. Feature films, for example, employ moving coloured pictures, natural noises and the sounds of human language and music; they also combine the skills of storytellers with those of costume and set designers, and with the skills of actors who may well have trained in the theatre. The combination of media appealing to different senses makes for a rich, perceptual experience. It also facilitates communication and understanding because the meaning of an image can be repeated or reinforced by the words or music that accompany it. There is thus a sharp contrast between the mixed-media aesthetic of the mass media and the media-purity aesthetic typical of modernist painting and sculpture.

Since the mass media are vehicles or channels capable of transmitting pre-existing information, they can transmit examples of culture from any level – high, medium or low, via television, a Beethoven symphony, a documentary film or a game show. However, the mass media are designed to reach the largest possible audiences – 'success' is often measured in quantitative rather than qualitative terms. Consequently their cultural content is predominantly low-to-medium in character. The idea 'mass audience' often has negative associations because it is assumed that

an item which appeals to millions must represent the lowest common denominator of taste. However, reality is more complex: in 1991 a taste for opera singing was extended to millions who had never been to an opera house when an operatic aria was used by television as the theme music for the World Cup soccer games held in Italy.

No one should underestimate the power of the mass media to *relay* art images. For instance, in 1988, a rock concert was held in London to honour the seventieth birthday of Nelson Mandela; works of art by the side of the stage created by African, American and British artists were seen by an estimated audience of 500 million in 63 countries. Film and video pieces by artists produced for the same event ran into censorship problems because of their radical content. This illustrates another negative characteristic of the mass media: a tendency towards blandness and conformity.

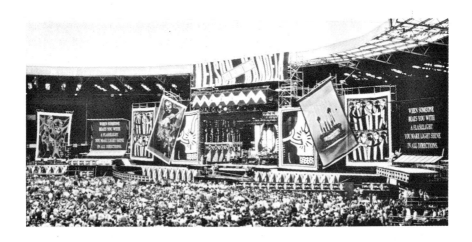

Rock concert and benefit to celebrate Nelson Mandela's 70th birthday, Wembley Stadium, London, 11 June 1988. Photo Chris Rodley, courtesy of the ICA and Fisher Park Ltd.

At the time of the concert the black ANC leader was still a political prisoner of the South African regime. In the stadium were 72,000 people. The show included 300 performers and lasted ten hours. The show's design was by Fisher Park (a rock set company established by the engineer Jonathan Park and the architect Mark Fisher in 1976).[1] The works of art flanking the stage were: Malangatana Ngwenya: 'The Eyes of the World'; Jenny Holzer: 'When Someone Beats you with a Flashlight you Make Light Shine in All Directions'; John Muafangejo: 'Hope and Optimism'; Sue Coe: 'A Clean Sweep'; Keith Haring: 'Untitled'; and Ralph Steadman: 'The Struggle is my Life'.

A curious feature of the mass media is that the large audiences reached are not gathered together in one place in a single crowd but dispersed in many locations. A TV programme is watched by millions of families and individuals but their experience is not a *collective* one. In other words, the mass media atomize and demobilize their audiences. In spite of letter columns in newspapers, phone-in programmes on radio, studio audiences, market research and rating charts, feedback is very difficult for mass audiences. Their ability to influence or to have a democratic say in the form and content of the mass media is extremely limited. (Purchasing power is probably their greatest weapon.) The mass media function *vertically*, that is to say messages tend to be transmitted in one direction only, from top to bottom (and from urban centres to rural peripheries, from the developed countries to the developing ones). Power in the mass media is concentrated and centralized; the aim of the community arts and media movements of the 1970s was precisely to demystify and decentralize the means by which visual culture is produced.

Marshall McLuhan, the mass media pundit of the 1960s, once argued that the consequence of the invention of a new medium is to displace older ones in the direction of art. A new medium often causes older ones to decline or to change their character. Furthermore, the older media usually become the content of the newest. Television, for instance, contributed to a decline in cinema attendances, caused film companies to make different types of films, and fed off the past of the cinema by showing hundreds of old movies.

High culture (including the fine arts) is normally thought of as the antithesis of mass culture, as a form of culture appealing to an educated, privileged élite or minority, hence the alternative term 'minority culture'. But, in fact, minority cultures – in the sense of small or specialist audiences – are catered for by the mass media: radio channels are differentiated according to levels of culture; so-called 'quality' newspapers reach much smaller audiences than tabloid newspapers; magazines about specialist subjects are designed to appeal to particular interest groups within society. In other words, niche marketing does take place within the mass media. (As media and channels proliferate, the mass audiences of the past are fragmenting.) However, even a 'small' mass media audience is normally many times larger than the total number of people who will visit an exhibition of contemporary art in a private gallery.

Since the advent of industrialization, social scientists have increasingly preferred the concept of 'the masses' to 'the people', hence 'mass culture/ media/society'. Some left-wing theorists have argued that mass culture is a myth, a mystification devised by bourgeois sociologists.[2] In their view it is misleading for two reasons: first, it implies the masses themselves are the source of the culture (this was one reason why the Frankfurt School philosophers devised the term 'culture industry'); and second, the mass media audience is never a monolithic, homogeneous mass – it is always stratified and variegated. Even marketing and advertising agencies recognize that the public can be sub-divided according to such factors as income, employment, psychology, tastes and lifestyle. In spite of these qualifications,

the term 'mass' cannot be abandoned altogether because of the sheer size of the audiences the cultural industries continue to reach.

In most countries of the world, but especially in those which are advanced, industrial, consumer societies, the mass media dominate human consciousness. Only the most isolated or reclusive individuals can escape their influence. They are major forces in the development and reproduction of culture. Many intellectuals, especially those employed in education, are critical of the mass media for several reasons: the media, it is argued, reproduce dominant ideologies and are thus a conservative or counter-revolutionary force; they encourage passivity, apathy and a sense of power-lessness; power is concentrated in the hands of a few people who are motivated by self-interest, private profit and/or social control; the culture associated with the mass media tends to be of low quality, bland, escapist, stereotyped, standardized, conformist and trivial. In short, mass culture is seen as an 'opium of the people', a means by which the labouring classes are manipulated and diverted during their leisure hours in preparation for their daily toil in offices and factories, or as a compensation for the misery of unemployment. The education system is viewed as one of the principal sites of defence against the blandishments of the mass media because it is one of the few places where the media are critically examined.

These charges will not be considered at length here. There is much truth in them but at the same time they are too sweeping and simplistic. For example, not all mass media products are of low artistic quality; to some degree the injustices, problems and contradictions of the world are discussed by the media; some TV documentaries are even sharply critical of the present organization of society. Furthermore, whatever promises, lies and fantasies the mass media transmit, there is always the lived experience of reality to act as a corrective. This is especially true in poor countries which receive, via the media, images of affluence emanating from Europe and North America. In the view of the Chilean sociologist Armand Mattelart, the belief that the bourgeois media are omnipotent is a serious error:

> The messages of mass culture can be neutralized by the dominated classes who can produce their own antidotes by creating the sometimes contradictory seeds of a new culture.[3]

As already noted, mass media products are the work of groups of specialists operating in teams in response to briefs, commissions or specifications laid down by employers or clients. Scope for individual creativity and imagination certainly exists within the mass media – indeed originality, fresh ideas, artistic skill and aesthetic pleasure are essential to their functioning – but the specialists' freedom and independence is generally more limited than that enjoyed by fine artists.

The collective or collaborative method of production typical of the mass media means it is difficult to credit works to an individual. In the mass media realm, names are deceptive: the name of a superstar fashion designer may in fact be the name of a label or brand – which is itself the work of many hands – rather than the work of the person who originally created the brand. Of course, the public knows the names of film stars

and top directors but it is not generally familiar with the names of the vast majority of mass media professionals. However, the latter cannot really be described as anonymous artisans, because their names are known within their various professions. For these and other reasons mass media specialists do not count as artists as far as the artworld is concerned. While a public gallery devoted to fine art, such as the Tate in London, will display the illustrated cover of a popular magazine when it is part of a collage made by a leading pop artist, it will not display that cover in its own right or recognize its maker as a fine artist. In short, despite the fact that artistic skill and aesthetic qualities are to be found in both realms, a conceptual and qualitative distinction between them is still maintained.

Some signs of cultural change have been evident in recent years. One that occurred in Britain during the 1980s was the increased visibility of, and praise lavished upon, design and designers, particularly graphic designers. (Some journalists called the period 'the design decade'.) This tendency culminated, in 1989, with the opening of the Design Museum, London (funded by the Conran Foundation). As a result, consumer products and the work of named designers were exhibited in a manner characteristic of fine art shows. Even so, the Design Museum's main focus was 'high' rather than 'low' design. As far as this text is concerned, a more significant cultural indicator was the exhibition 'Keith Haring, Andy Warhol and Walt Disney' organized by Bruce D. Kurtz at the Phoenix Art Museum, Arizona in 1991. Without any reservations Kurtz treated Disney, the mass entertainer, as an artist comparable and equal to Warhol and Haring, even though the exhibition made it clear that Disney was the leader of a team of skilled animators rather than an individual 'auteur'. What also emerged from the show was that, beginning in the late 1930s, original artwork from the Disney studio had been marketed and sold via the Courvoisier Gallery of San Francisco. This was due to the pressure of popular demand from collectors and enthusiasts who wanted to possess original fragments of Disney's animated movies and cartoons.

Kurtz's attitude to Disney was paralleled in Britain by television arts programmes which profiled pop music stars like Madonna, Michael Jackson and Prince, plus mainstream film stars and directors. Such programmes indicated that one possible response to the art/mass media divide is to reclassify those who work for and in the mass media as serious artists, to argue that they are the 'true' artists of the twentieth century.[4] (With the implication that most fine artists are insignificant relics from the past.) A plausible case for this point of view can be made, since creativity is exhibited by such individuals and groups. Once they have achieved popular success, mass culture stars are able to enjoy the same degree of freedom as fine artists, and because they have more money they can instigate lavish productions. In fact, they become patrons of other artists. (Madonna employs and commissions many specialists. She has founded her own creative company. She also collects works of art, is a friend of fine artists and plans a film about the Mexican painter Frida Kahlo.) However, as far as this text is concerned, such an approach sidesteps the problems facing fine

artists; it precludes consideration of the possibility that they can fulfil a critical function in respect of the mass media.

Although a distinction has been drawn between the fine arts and the mass media, this does not mean, of course, that no interaction takes place between them. Boundaries are permeable. Borrowings, influences and cross-overs occur in both directions, but it is the mass media which command a larger slice of economic resources, reach more people and have a greater social impact. More people than ever before are aware of the fine arts, but many have gained their knowledge via postcards and other reproductions, or via TV arts programmes, rather than by direct contact. Even those who do have contact with original works of art may not escape the influence of the mass media. For example, the perceptions of artists in looking at nature, and the perceptions of viewers in looking at art, are both likely to be conditioned by ways of seeing made familiar by the mass media. Nevertheless, the popularization of the arts which the mass media facilitates has surely contributed to the considerable increase in the size of the museum- and gallery-going public during recent decades. And as we shall see shortly, some fine artists have taken advantage of mass communication systems in order to reach larger, non-specialist audiences.

2. ART USES MASS CULTURE

Three possible attitudes on the part of fine artists towards mass media/culture can be distinguished: negative, positive and mixed (an ambiguous response). Negative responses can be explicit or implicit. Some artists have made works of art that are explicitly antagonistic. For example, Michael Sandle's 1988 sculpture 'A Mighty Blow for Freedom/ Fuck the Media'. There are grounds for criticizing the media but the weakness of this dynamic bronze is that it does not explain why Sandle resents them so much. His sculpture is a blanket condemnation, a simple statement of outright rejection.

An implicit, negative attitude towards mass culture (and indeed nature too) can be detected in the artistic tendency called minimal or fundamental painting (fashionable during the late 1960s and early 1970s). Fundamental painters, like the American Robert Ryman, emphasized the materials and processes of the painting; indeed their works had no other subject matter or content. Fulfilling the modernist painting theory associated with the critic Clement Greenberg, such artists aimed to isolate the characteristics they considered specific to the art of painting. In this way they sought to avoid any overlap with other pictorial media (still photography, film and television). Imagery, figuration, illusion, allegory, symbolism and the depiction of reality – once the stock-in-trade of painters – were renounced by the fundamentalists on the grounds that they were not unique to painting! This tendency can be regarded as a last-ditch attempt to secure the identity of painting in the face of overwhelming competition from the mass media. Painting reasserted itself – but only at the cost of impoverishment.

Let us now consider examples of artists who have manifested a positive attitude towards popular culture. Two nineteenth-century painters will be considered.

Courbet, Van Gogh and Popular Imagery

Gustave Courbet (1819–77) came from a relatively wealthy sector of the French peasantry. He was proud of his family, the folk and landscape of his native region (the Jura of eastern France). He was a republican and anti-cleric strongly influenced by the 1848 revolution and by the anarchist–socialist ideas of his day. A number of his paintings were deliberately political in intent, designed to offend the Catholic Church, to shock and arouse the consciences of the middle-class public who flocked to the annual Salon exhibitions in Paris. An example is 'The Stonebreakers', a picture which shows two peasants – an old man and a boy (symbolizing the cyclical character of such toil) – engaged in the lowest, most wretched form of labour.

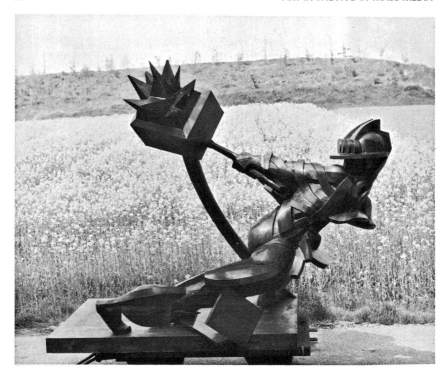

Michael Sandle, 'A Mighty Blow for Freedom/Fuck the Media', 1988.
Bronze, 300 x 130 x 220 cm. Photo by M. Sandle, reproduced courtesy of the artist.

Sandle (b. 1936) is a British sculptor who has lived and worked in Germany since 1973. He is noted for his dramatic but ominous bronze sculptures and public monuments which use allegorical figures and symbolism in order to explore such serious themes as war, death, violence and capitalist decay. Sandle's contempt for the modern electronic media – which he equates with manipulation, propaganda and mediocrity – is clear in this bronze: a surreal, over life-size female figure with 'a tremendous torque in the torso' smashes a TV set with great ferocity. (It seems the artist once destroyed his own TV set in a fit of anger prompted by poor picture reception and the triviality of the programmes.) In Sandle's view, the art of sculpture should 'not let itself be misused as an adjunct to the entertainment industry'.

Sandle's gesture of protest does not alter the fact that the fine arts still have to function within a culture dominated by the mass media, nor does it alter the fact that artists are embroiled in the mass media whether they like it or not (artists are profiled in magazines and TV arts programmes; documentary films are made about them and they are interviewed in the press and on radio; their works are recorded in photographs; and their exhibitions are advertised). As those who kick in their TV screens soon discover, the loss of a few sets has virtually no impact on the institution of television.

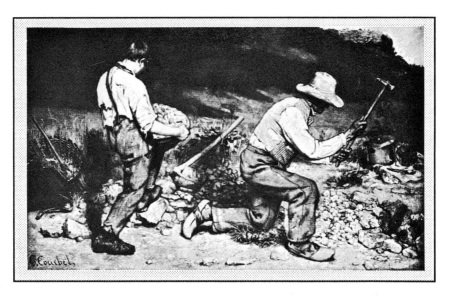

Gustave Courbet, 'The Stonebreakers', 1849.
Oil on canvas, 129 x 148.5 cm. Dresden Museum (the painting was destroyed during World War Two).

A friend of Courbet's, the anarchist philosopher Pierre-Joseph Proudhon, wrote an impassioned account of this painting in which he condemned the society which demanded such backbreaking and poorly paid work. He hailed 'The Stonebreakers' as the first successful *socialist* painting. Courbet developed an aggressive painting style and artistic ideology – realism. He favoured awkward compositions, foregrounded brush and palette-knife marks, and the materiality of his pigments. He refused to depict biblical and mythological subjects; instead he focused on contemporary life. Ordinary people, like peasants and firemen, he celebrated by painting on a scale worthy of history painting.

During the nineteenth century a number of intellectuals studied and glorified the people of France. They collected examples of folksongs, folklore and popular prints, and they praised the realistic depictions of peasants in the work of the Le Nain brothers and the scenes of everyday life in the work of the Dutch genre painters of the seventeenth century. That Courbet shared some of their enthusiasm for popular culture is confirmed by 'The Meeting' (1854), a painting which shows Courbet in the guise of a travelling journeyman being greeted by two men on the road (one of whom was his wealthy patron Alfred Bruyas). Both the theme and the composition of this painting were derived from a detail of a popular print, a wood engraving produced by Pierre Le Loup of Le Mans, recounting the ancient story of the wandering Jew.

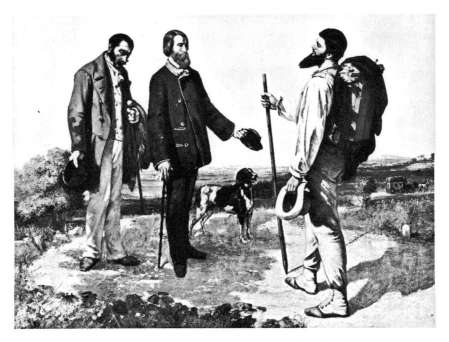

It is a matter of some complexity to evaluate Courbet's use of popular culture. In the view of T. J. Clark, a Courbet scholar and noted social historian of art, the painter's decision

> to adopt the procedures and even values of popular art ... was profoundly subversive. Instead of exploiting popular art to revive official culture and titillate its special, isolated audience, Courbet did the exact opposite. He exploited high art – its technique, its size and something of its sophistication – in order to revive popular art. His painting was addressed not to the connoisseur, but to a different hidden public; it stayed close to the pictorial forms and types of comedy which were basic to popular tradition; it transformed its source, but only in order to enforce their supremacy; not certainly to excuse their shortcomings. He made an art which claimed, by its scale and its proud title 'History Painting', a kind of hegemony over the culture of the dominant classes. [1]

Hélène Toussaint, another Courbet scholar, has argued that his debt to popular imagery has been exaggerated. In her view:

> When he professed, not without a measure of humbug, to be painting for the delectation of the common people, his object was not to reduce art to simple terms but rather to bring its highest manifestations within the reach of the masses. [2]

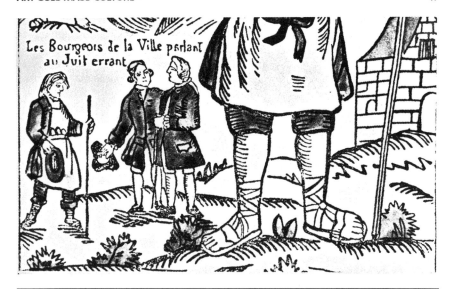

Pierre Le Loup of Le Mans, detail from a popular print showing a scene in which the two members of the urban bourgeoisie encounter the wandering Jew. Early nineteenth-century woodcut.

Perhaps one can resolve the issue of the 'popular' character of Courbet's oeuvre by arguing that, like other members of the petty bourgeoisie, Courbet's position was ambiguous – it was the fate of this class to oscillate between the two main classes of French society. On the one hand, Courbet sought to incorporate popular subjects and values into high art in order to remind the French establishment of the existence and needs of the people, while on the other he sought to transform the art of oil painting by means of realism in order to make it more accessible to more people. Certainly, one of Courbet's ambitions was to reach a wide public by painting murals inside railway stations.

In 1873 Vincent Van Gogh (1853–90) sold engravings of paintings in Goupil's, a shop in Covent Garden, London. There he learnt which artists were popular with the Victorians and he became aware of the role of reproduction in popularizing art. Later on, he came to admire and to collect the black and white wood engravings which enlivened the pages of such popular magazines as *Illustrated London News* and the *Graphic*.[3] During the 1860s and 1870s there was a strong vein of social or critical realism in these illustrations – images of workers, the unemployed and homeless, workhouses, soup kitchens, opium dens, prisons, industrial accidents – many scenes prompted by the vile conditions experienced by so many during this phase of capitalism. Van Gogh was profoundly moved by these images because he identified emotionally with peasants and workers, not with the Dutch middle class into which he had been born. Unlike Frans Hals, he refused to paint portraits of the Dutch

bourgeoisie (not even one of his brother Theo to whom he owed so much).

A series of illustrations featured in the *Graphic* especially appealed to him: 'Heads of the People'; it depicted workers from a variety of trades. Van Gogh consciously emulated this series when he produced a large number of oil and chalk studies of peasants' heads in the 1880s. Another image he found inspiring was by Luke Fildes. It showed Dickens's empty chair in the writer's study (the empty chair signified the presence/absence of Dickens following his death). Van Gogh realized that chairs could serve as 'portraits' of their regular users; hence the two 'portraits' of 1888 painted in Arles showing his own simple, yellow chair and the more elaborate armchair used by Paul Gauguin.

Luke Fildes, 'The empty chair, Gad's Hill, 9 June 1870'. Wood engraving, *Graphic,* Christmas number, 1870.

Van Gogh did not reproduce wood engravings in another medium. Rather, he appropriated specific motifs and reinterpreted them in terms of oil painting. (The themes and signs Van Gogh employed were in themselves commonplace; they were understood by millions. This is one reason why his art has become so popular.) However, his deliberately crude technique – bold drawing, angular shapes, thick paint, emphatic brushstrokes, bright, saturated colours – was highly significant. Van Gogh liked to compare himself to a humble shoemaker and he developed an artisan-like painting style – one that revealed the work of the artist – in order to represent the values of workers and peasants in a bourgeois artform and display context, and in order to represent the values of the countryside in the city.[4]

While at The Hague, in November 1882, Van Gogh had a number of drawings turned into lithographs. A workman asked if he could hang one of these prints on the wall of his workplace. Van Gogh was delighted – this was the audience he wanted to please – and for a while he entertained the

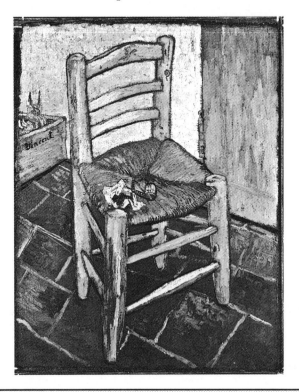

Vincent Van Gogh, 'The Chair and the Pipe', 1888. Oil on canvas, 92.7 x 73.6 cm. National Gallery, London.

idea of becoming a professional illustrator. (If he had done so his work would have reached a large audience in his lifetime.) At this time he wished to overcome the isolation of the radical artist from society and to democratize the production of art by setting up an artists' co-operative, the purpose of which would be to turn drawings into prints and to publish them in cheap editions. Van Gogh realized that otherwise works of art were commodities too expensive for the majority of the populace. Unfortunately nothing came of these schemes, but the idea of an artists' co-operative remained with him. The house and studio he and Gauguin shared for a while in Arles in 1888, with the financial assistance of the art dealer Theo Van Gogh, was another effort in this direction.

Both Courbet and Van Gogh understood the limitations of the mode of

production and distribution of easel painting in reaching a popular audience. They struggled against its élitism by shifting the medium in the direction of popular imagery and by incorporating craft values in their painting styles.

Pop Art Translates Mass Culture

Considered as a whole, pop exemplifies a mixed response to mass culture: some examples appear to celebrate consumer products and media stars, while others indicate a critical, analytical response. The term 'pop art' encompasses a wide variety of paintings, sculptures, prints and collages produced by professional artists who used popular culture and mass media material as sources of iconography, techniques and conventions of representation. Pop art can be characterized as a meta-art or meta-language (a meta-language is any language used to talk about another language) in that it takes as its object of scrutiny not reality perceived directly but existing representations of reality found in the realms of graphic design, packaging, the cinema, etc. The fact that the pop artists did not follow the impressionists and work directly from nature is an acknowledgement that, for modern city dwellers, 'nature' – in the sense of fields, trees and mountains – has been almost completely replaced by a humanly constructed world of buildings, interiors, motorways, signs, posters, newspapers, magazines, films, radio broadcasts, television trans-missions and computer simulations. In short, billions live in a media-saturated environment.

Peter Fuller (1947–90), the combative English art critic, once stated: 'Artists would do well to ignore the mass media entirely and to get on replenishing their own art in nature, in natural form, and in their imagina-tive response to the traditions which they are working with.'5 The trouble with this view is that it means artists would avoid a major feature of the world around them. It also ignores the fact that the artists' perceptions of nature might well be inflected by all the images of 'nature' that appear in the mass media. Even artists who draw from nature generally draw as well from the art of the past, and the history of art is partly available in the form of reproductions and TV documentaries. In other words, fine art images are also to be found in the ever-increasing bank of images.

In London during the early 1950s a small number of British intel-lectuals calling themselves 'The Independent Group' (IG) organized meet-ings at the Institute of Contemporary Arts in order to discuss popular culture (among other topics). The first use of the term 'pop art' is generally credited to one member of the IG, Lawrence Alloway, an art critic. Initially, however, Alloway was not referring to an art movement but to contemporary mass culture. What distinguished pop art in this sense from the folk or popular culture of the past was the fact that it was not culture 'by the people, for the people'. Instead, it was produced on their behalf by teams of highly skilled specialists. These specialists did not generally enjoy the same social status as fine artists – many of their names were unknown to the general public – and yet, in the opinion of the IG, their work fully merited respect and analysis.

The IG also reached the conclusion that the hierarchical conception of culture as a *pyramid* – with high culture at the apex and low culture at the base – was outmoded in a democratic, industrial society and should be replaced by a non-hierarchical *continuum*, that is, a horizontal band or spectrum in which the fine and popular arts existed side by side in a condition of equality. In other words, opera was not superior to rock music, simply a different kind of music. In such a continuum the traditional fine arts lost their canonical status. Crucial too were the ideas that the various media and artforms were interacting more and more, and that artistic expression was becoming more multi-media in character.

The two principal artist-members of the IG were the painter Richard Hamilton and the sculptor Eduardo Paolozzi. It was they – along with Peter Blake, who was not associated with the IG – who forged pop art from the raw material of mass culture during the mid and late 1950s. In the following decade varieties of pop art occurred in most of the main consumer societies of the west. The major centres, however, were London and New York. As the literature on pop art is now very extensive (see Biblio-graphy), no survey will be provided here. Instead, certain aspects of the work of Hamilton, Roy Lichtenstein and Andy Warhol will be discussed.

Richard Hamilton (b. 1922) is an articulate and self-aware pop artist who has lectured and written about his methods and iconography in a highly informative way. During the 1950s, Hamilton recalls, to be a fine artist was to suffer the divided personality of a schizophrenic: at 'work' in the life room painting a nude, the artist was preoccupied with the traditions of fine art and modernism; at 'leisure' the artist enjoyed pulp novels, CinemaScope and American car styling. The two worlds were sharply differentiated. There was a remarkable contrast in attitudes and iconography in the two realms. For instance, 'woman' as represented by an action painter like Willem De Kooning was very different from 'woman' as represented by advertising photographers. Hamilton, and the others who made up the Independent Group, were among the first to notice this cultural division and to make the barrier permeable.

'$he', a work consisting of oil paint on board, plus relief and collage elements, was one of Hamilton's earliest pop paintings. It was the result of an analysis of domestic appliances Hamilton undertook for an IG talk entitled 'Persuading Image'. The painting's title immediately evokes woman, the United States and money. An alternative title was 'WITH' or 'Woman-In-The-Home'. The picture's content derived from a series of American advertisements depicting housewives and models in association with appliances such as fridges and vacuum cleaners. As Hamilton explained, in the world of advertising, the woman projected a cool but sexual image, she was 'a styling accessory', an extension of the product, an ideal-type 'exquisitely at ease in her appliance setting'.[6] What the adverts showed was a human–machine interface. And the two realms overlapped in some respects: the sexuality of the woman's body was echoed in the streamlined forms and glamorous materials of the products.

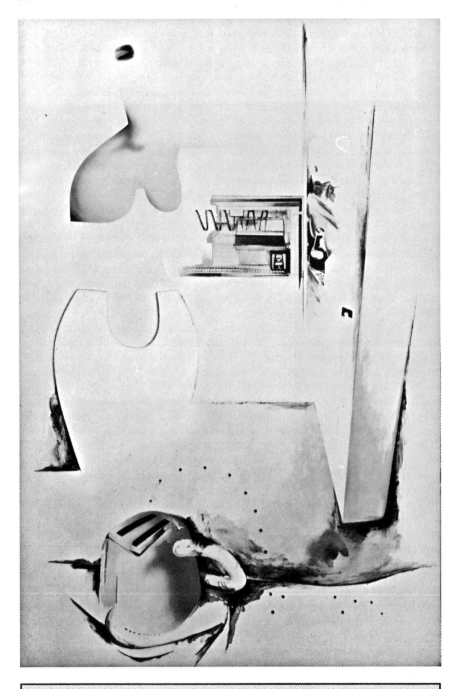

Richard Hamilton, '$he', 1958–61. Oil, cellulose and collage on panel, 122 x 81 cm. Tate Gallery, London.

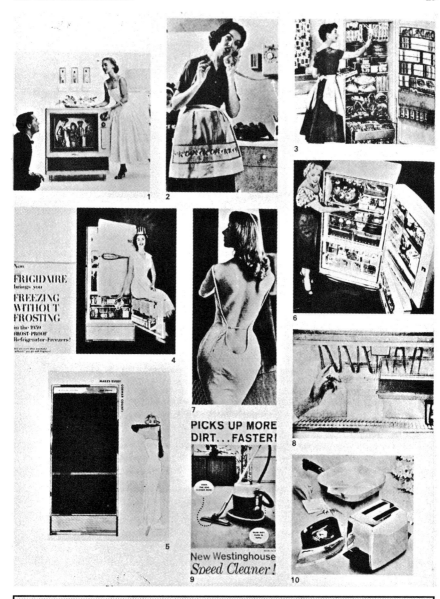

Advertisements of the 1950s.

To produce '$he' Hamilton selected details from the advertisements and incorporated them into a single composition. However, total integration of the parts was clearly not his intention, because the various elements retain a relative autonomy and float in an indeterminate, white space. Only fragments of machines and a woman are depicted – they

were intended to be tokens. In order to show both the breasts and the buttocks of the woman a front view and a rear view were used (the latter was derived from a photo of Vikky 'the back' Dougan). The odd machine at the bottom of the picture is a synthesis of a toaster and a vacuum cleaner. Top left there is a plastic eye which winks when the spectator moves; this was a last-minute addition.

Hamilton stressed the edges of forms in order to highlight the correspondence between metal and flesh. His approach to his source material can be described as 'quotational'. He not only quoted images but also the different media and representational techniques employed by commercial photographers and graphic designers (airbrushing, for example). In an essay on '$he' he explained how pains had been taken to exploit: 'the overlapping of presentation styles and methods. Photograph becomes diagram, diagram flows into text. This casual adhesion of disparate conventions has always been a factor in my painting ... the elements hold their integrity because they are voiced in different plastic dialects within the unified whole.[7]

Hamilton's use of different kinds of representation within the same picture, his delight in the pleasures of intertextuality, heralded the development of post-modernism. What distinguished '$he' from its photographic sources was the emphasis on the painting as a physical object: the tactile, low relief areas, the refined drawing and the painterly, linking passages.

According to its maker, '$he' was 'a sieved reflection of the ad man's paraphrase of the consumer's dream'. Hamilton was not, as some thought, making a sardonic comment on consumerism or mocking America; rather, he was searching for what was typical and epic in the common culture of his time. In this respect he fulfilled the brief laid down by the French poet Charles Baudelaire for visual artists in the nineteenth century: they should depict 'the heroism of modern life ... extract the epic from the kaleidoscope of appearances ... distil the eternal from the transitory'. A feminist might well argue that '$he' was a politically reactionary painting because it did not criticize the way women were represented in advertising during the 1950s, but it did call attention to the kinds of desire that underpinned consumerism. Hamilton's non-judgemental approach to his source material combined that of an intelligent consumer with that of a cultural anthropologist.

In a now-famous letter written to Peter and Alison Smithson in 1957, Hamilton identified the eleven commandments of mass culture:

(1) popular (designed for mass audiences);
(2) transient (short-term solution);
(3) expendable (easily forgotten);
(4) low cost;
(5) mass produced;
(6) young (aimed at youth);
(7) witty;
(8) sexy;
(9) gimmicky;
(10) glamorous;
(11) big business.

While at The Hague, in November 1882, Van Gogh had a number of drawings turned into lithographs. A workman asked if he could hang one of these prints on the wall of his workplace. Van Gogh was delighted – this was the audience he wanted to please – and for a while he entertained the

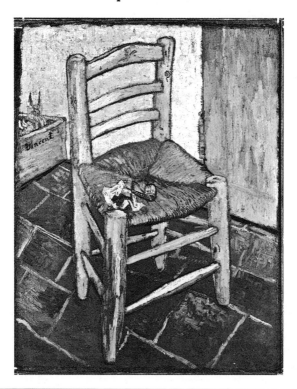

Vincent Van Gogh, 'The Chair and the Pipe', 1888. Oil on canvas, 92.7 x 73.6 cm. National Gallery, London.

idea of becoming a professional illustrator. (If he had done so his work would have reached a large audience in his lifetime.) At this time he wished to overcome the isolation of the radical artist from society and to democratize the production of art by setting up an artists' co-operative, the purpose of which would be to turn drawings into prints and to publish them in cheap editions. Van Gogh realized that otherwise works of art were commodities too expensive for the majority of the populace. Unfortunately nothing came of these schemes, but the idea of an artists' co-operative remained with him. The house and studio he and Gauguin shared for a while in Arles in 1888, with the financial assistance of the art dealer Theo Van Gogh, was another effort in this direction.

Both Courbet and Van Gogh understood the limitations of the mode of

production and distribution of easel painting in reaching a popular audience. They struggled against its élitism by shifting the medium in the direction of popular imagery and by incorporating craft values in their painting styles.

Pop Art Translates Mass Culture

Considered as a whole, pop exemplifies a mixed response to mass culture: some examples appear to celebrate consumer products and media stars, while others indicate a critical, analytical response. The term 'pop art' encompasses a wide variety of paintings, sculptures, prints and collages produced by professional artists who used popular culture and mass media material as sources of iconography, techniques and conventions of representation. Pop art can be characterized as a meta-art or meta-language (a meta-language is any language used to talk about another language) in that it takes as its object of scrutiny not reality perceived directly but existing representations of reality found in the realms of graphic design, packaging, the cinema, etc. The fact that the pop artists did not follow the impressionists and work directly from nature is an acknowledgement that, for modern city dwellers, 'nature' – in the sense of fields, trees and mountains – has been almost completely replaced by a humanly constructed world of buildings, interiors, motorways, signs, posters, newspapers, magazines, films, radio broadcasts, television transmissions and computer simulations. In short, billions live in a media-saturated environment.

Peter Fuller (1947–90), the combative English art critic, once stated: 'Artists would do well to ignore the mass media entirely and to get on replenishing their own art in nature, in natural form, and in their imaginative response to the traditions which they are working with.'5 The trouble with this view is that it means artists would avoid a major feature of the world around them. It also ignores the fact that the artists' perceptions of nature might well be inflected by all the images of 'nature' that appear in the mass media. Even artists who draw from nature generally draw as well from the art of the past, and the history of art is partly available in the form of reproductions and TV documentaries. In other words, fine art images are also to be found in the ever-increasing bank of images.

In London during the early 1950s a small number of British intellectuals calling themselves 'The Independent Group' (IG) organized meetings at the Institute of Contemporary Arts in order to discuss popular culture (among other topics). The first use of the term 'pop art' is generally credited to one member of the IG, Lawrence Alloway, an art critic. Initially, however, Alloway was not referring to an art movement but to contemporary mass culture. What distinguished pop art in this sense from the folk or popular culture of the past was the fact that it was not culture 'by the people, for the people'. Instead, it was produced on their behalf by teams of highly skilled specialists. These specialists did not generally enjoy the same social status as fine artists – many of their names were unknown to the general public – and yet, in the opinion of the IG, their work fully merited respect and analysis.

The IG also reached the conclusion that the hierarchical conception of culture as a *pyramid* – with high culture at the apex and low culture at the base – was outmoded in a democratic, industrial society and should be replaced by a non-hierarchical *continuum*, that is, a horizontal band or spectrum in which the fine and popular arts existed side by side in a condition of equality. In other words, opera was not superior to rock music, simply a different kind of music. In such a continuum the traditional fine arts lost their canonical status. Crucial too were the ideas that the various media and artforms were interacting more and more, and that artistic expression was becoming more multi-media in character.

The two principal artist-members of the IG were the painter Richard Hamilton and the sculptor Eduardo Paolozzi. It was they – along with Peter Blake, who was not associated with the IG – who forged pop art from the raw material of mass culture during the mid and late 1950s. In the following decade varieties of pop art occurred in most of the main consumer societies of the west. The major centres, however, were London and New York. As the literature on pop art is now very extensive (see Biblio-graphy), no survey will be provided here. Instead, certain aspects of the work of Hamilton, Roy Lichtenstein and Andy Warhol will be discussed.

Richard Hamilton (b. 1922) is an articulate and self-aware pop artist who has lectured and written about his methods and iconography in a highly informative way. During the 1950s, Hamilton recalls, to be a fine artist was to suffer the divided personality of a schizophrenic: at 'work' in the life room painting a nude, the artist was preoccupied with the traditions of fine art and modernism; at 'leisure' the artist enjoyed pulp novels, CinemaScope and American car styling. The two worlds were sharply differentiated. There was a remarkable contrast in attitudes and iconography in the two realms. For instance, 'woman' as represented by an action painter like Willem De Kooning was very different from 'woman' as represented by advertising photographers. Hamilton, and the others who made up the Independent Group, were among the first to notice this cultural division and to make the barrier permeable.

'$he', a work consisting of oil paint on board, plus relief and collage elements, was one of Hamilton's earliest pop paintings. It was the result of an analysis of domestic appliances Hamilton undertook for an IG talk entitled 'Persuading Image'. The painting's title immediately evokes woman, the United States and money. An alternative title was 'WITH' or 'Woman-In-The-Home'. The picture's content derived from a series of American advertisements depicting housewives and models in association with appliances such as fridges and vacuum cleaners. As Hamilton explained, in the world of advertising, the woman projected a cool but sexual image, she was 'a styling accessory', an extension of the product, an ideal-type 'exquisitely at ease in her appliance setting'.[6] What the adverts showed was a human–machine interface. And the two realms overlapped in some respects: the sexuality of the woman's body was echoed in the streamlined forms and glamorous materials of the products.

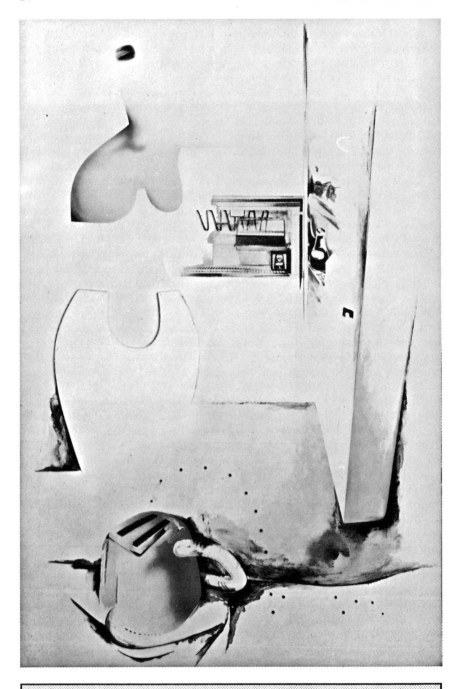

Richard Hamilton, '$he', 1958–61. Oil, cellulose and collage on panel, 122 x 81 cm.
Tate Gallery, London.

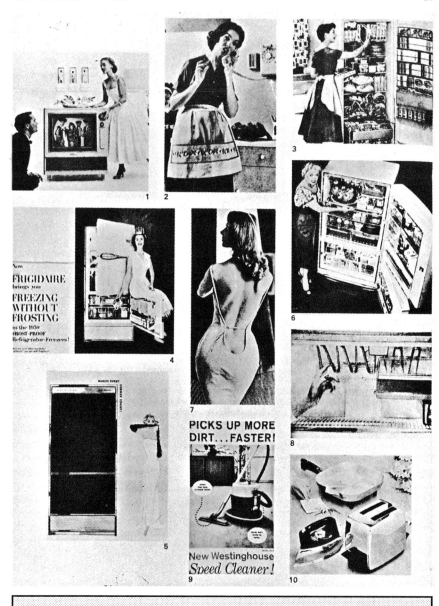

Advertisements of the 1950s.

To produce '$he' Hamilton selected details from the advertisements and incorporated them into a single composition. However, total integration of the parts was clearly not his intention, because the various elements retain a relative autonomy and float in an indeterminate, white space. Only fragments of machines and a woman are depicted – they

were intended to be tokens. In order to show both the breasts and the buttocks of the woman a front view and a rear view were used (the latter was derived from a photo of Vikky 'the back' Dougan). The odd machine at the bottom of the picture is a synthesis of a toaster and a vacuum cleaner. Top left there is a plastic eye which winks when the spectator moves; this was a last-minute addition.

Hamilton stressed the edges of forms in order to highlight the correspondence between metal and flesh. His approach to his source material can be described as 'quotational'. He not only quoted images but also the different media and representational techniques employed by commercial photographers and graphic designers (airbrushing, for example). In an essay on '$he' he explained how pains had been taken to exploit: 'the overlapping of presentation styles and methods. Photograph becomes diagram, diagram flows into text. This casual adhesion of disparate conventions has always been a factor in my painting ... the elements hold their integrity because they are voiced in different plastic dialects within the unified whole.[7]

Hamilton's use of different kinds of representation within the same picture, his delight in the pleasures of intertextuality, heralded the development of post-modernism. What distinguished '$he' from its photographic sources was the emphasis on the painting as a physical object: the tactile, low relief areas, the refined drawing and the painterly, linking passages.

According to its maker, '$he' was 'a sieved reflection of the ad man's paraphrase of the consumer's dream'. Hamilton was not, as some thought, making a sardonic comment on consumerism or mocking America; rather, he was searching for what was typical and epic in the common culture of his time. In this respect he fulfilled the brief laid down by the French poet Charles Baudelaire for visual artists in the nineteenth century: they should depict 'the heroism of modern life ... extract the epic from the kaleidoscope of appearances ... distil the eternal from the transitory'. A feminist might well argue that '$he' was a politically reactionary painting because it did not criticize the way women were represented in advertising during the 1950s, but it did call attention to the kinds of desire that underpinned consumerism. Hamilton's non-judgemental approach to his source material combined that of an intelligent consumer with that of a cultural anthropologist.

In a now-famous letter written to Peter and Alison Smithson in 1957, Hamilton identified the eleven commandments of mass culture:

(1) popular (designed for mass audiences);
(2) transient (short-term solution);
(3) expendable (easily forgotten);
(4) low cost;
(5) mass produced;
(6) young (aimed at youth);
(7) witty;
(8) sexy;
(9) gimmicky;
(10) glamorous;
(11) big business.

Important differences become apparent the moment we compare Hamilton's own works and practice with this list: his paintings were *not* mass produced, they were *not* cheap, they were *not* expendable, they were *not* aimed at a mass audience. Although Hamilton appropriated mass culture's iconography and styles, he did not adopt all its characteristics. This was because he wanted to remain a fine artist. Later on he did produce some works in editions – batch production – that is, prints, multiples and industrial design products. In 1968 he also designed a Beatles' album cover which reached an audience of millions. But, despite these examples, Hamilton's status was that of a fine artist.

It is not sufficient, therefore, for an artist to incorporate popular imagery to become part of mass culture; the whole mode of production and distribution also needs to change. If this were to happen then the artist would automatically cease to be part of the fine arts; he or she would have 'crossed-over' to another realm. A sound understanding of pop art is impossible unless we recognize the particular ways in which pop artists – and critics and curators who supported the movement – ensured that their work remained within the context of fine art rather than mass culture. This point was confirmed by a large-scale survey of pop art mounted at the Royal Academy, London in 1991: the exhibition was intended to re-affirm pop's status as art; it thereby served to reinforce the division between 'high' and 'low' culture.

Hamilton did not agree with those who thought his early pop paintings were satirical and critical responses to mass culture. However, during the 1960s he decided to experiment, to produce works that *were* satirical-critical in character. These works included 'Portrait of Hugh Gaitskell as a Famous Monster of Filmland' and the series 'Swingeing London '67'. Hamilton and his then wife Terry supported causes espoused by the left wing of the British Labour Party (for example, nuclear disarmament), but these causes had been hindered by the policies of Hugh Gaitskell, the right-wing leader of the Party. In 1962 Hamilton decided to paint a 'portrait' designed to assert that Gaitskell was really a monster in disguise. An enlarged press photograph of the politician's face was overpainted with an image of the actor Claude Rains wearing a mask for his role in the 1943 horror film *The Phantom of the Opera*. Gaitskell's brain was removed and his manic face was set against a blood-red background. Within the painting two media – painting and photography – and two character-types – monsters and politicians – uneasily coalesced. Gaitskell died in 1963, a year before the portrait was completed, so he was spared the sight of Hamilton's portrayal.

'Swingeing London '67' (1968–9) consisted of a series of seven silk-screen paintings, a watercolour study, an etching and a poster based on a collage of newspaper cuttings/photographs. Its title was a sardonic pun on the label 'swinging London' which had been given currency by a *Time* magazine article dated 15 April 1966. Hamilton's paintings were based on a press photograph taken on 28 June 1967 showing Mick Jagger, of the Rolling Stones, and Robert Fraser, a

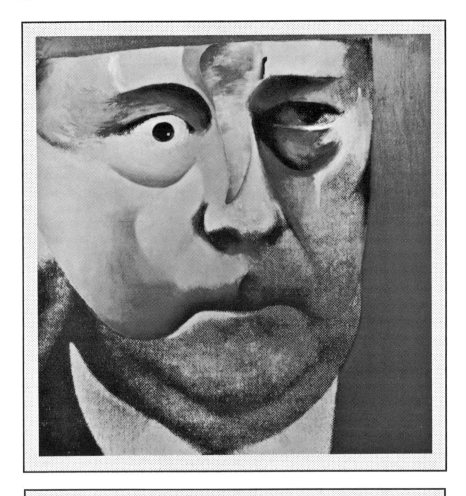

Richard Hamilton, 'Portrait of Hugh Gaitskell as a Famous Monster of Filmland', 1964. Oil and collage on photograph on panel, 61 x 61 cm. Arts Council Collection, South Bank Centre, London.

dealer in pop art, handcuffed together in a police van on their way to court to face the charge of possessing soft drugs. In one of the paintings the handcuffs were made from metal sculpted into a low relief. Inadvertently, they symbolized the intimate relationship that had developed between the worlds of pop art and rock music in London during the 1960s.

Fraser had been subjected to a campaign of police harassment following a complaint from a member of the public about an exhibition of erotic drawings by the American pop artist Jim Dine. Hamilton exhibited at Fraser's West End gallery and he was also a friend. While

Fraser was in prison, Hamilton and other artists mounted a show in the gallery as an expression of support. 'Swingeing London '67' serves as a corrective to the myth of a liberated, permissive society. It reminds us of the rearguard action fought by the British establishment against the youth and pop culture of the 1960s.

It is clear from the above that there were some paintings by pop artists which tackled political subjects or which were capable of social criticism. Subsequently, Hamilton produced other polemical works about the shooting of students at Kent State University, the condition of Britain's National Health Service, the conflict in Northern Ireland, and the Gulf War of 1991.[8]

Richard Hamilton, 'Swingeing London '67', 1968-69. Screenprint on canvas, acrylic and collage. 67 x 85 cm. Tate Gallery, London.

Richard Hamilton, 'Swingeing London '67', 1968. Poster, offset litho, published by Ed 912. In the top left-hand corner is the photo on which the painting series was based.

American Pop

When American pop art first appeared some critics accused the artists responsible for it of plagiarism, that is, copying the work of commercial artists. Such a response was understandable because at first sight many pop paintings look like straight copies of advertisements or comics. It is only when we undertake a rather laborious, point-by-point comparison that we discover the extent of the differences between pop and its sources.

It is surely evident from the comparison on page 32 that pop artists are by no means simple copyists. Artists are often said to 'reflect' the world around them in their art. This particular optical metaphor is unsatisfactory because it implies a passive mirroring of appearances. The word 'refraction' has also been used, but even better is 'translation' because it indicates that something of the original has been preserved but also that an active process of transformation from one language into another has occurred. When pop artists appropriate existing images they take them from one context and place them in another; hence the emergence of the term 'recontextualization'. Clearly, the meaning of an image can be changed simply by placing it alongside other images in a new composition. (A collage is such a new configuration.) 'Context' can also mean the artworld. As Marcel Duchamp demonstrated with his readymades, for a change of meaning to occur it may only be necessary to transpose a consumer product from a department store to a museum.

An oil painting by the American figurative artist Philip Pearlstein (b.1924) – 'Superman' (1952) – enables us to clarify one aspect of Lichtenstein's art. The picture's subject matter – the famous comic book hero invented by Jerry Siegal and Joe Shuster in the 1930s – was taken from popular culture, so it had that much in common with pop, but where it differed was in the manner in which it was painted. Pigment was applied generously to yield a succulent surface texture; brushmarks are clearly visible and the modelling of Superman's body is quasi-expressionist. Unlike Lichtenstein, Pearlstein made no attempt to imitate the graphic style of the comic book artist, or the appearance of the printed image.

Lichtenstein not only plundered mass culture for subject-matter, but also earlier styles of art. In 'Little Big Painting' his subject-matter is a detail of brushwork from an action painting. Action painting was a sub-category of abstract expressionism, the dominant art movement of the post-1945 period. At one and the same time, Lichtenstein pays homage to his forebears and renounces them by parodying their stylistic mannerisms.

Abstract expressionist painting was emotional, intuitive, spontaneous, autographic, personal, serious and morally committed – in short, a 'hot' or romantic style. American pop painting, by contrast, was unemotional, deliberate, systematic, impersonal, ironic, detached, non-autographic and amoral – a 'cool' or classical style. In action painting the violent, direct

Anonymous photographer/ graphic designer, advertisement from the Sunday *New York Times*, n.d. (right) Roy Lichtenstein, 'Girl with a Ball', 1961. Oil on canvas, 153.6 x 92.7 cm. Museum of Modern Art, New York.

On the left is a newspaper advertisement which Lichtenstein used as the starting point for the oil painting on the right. The differences can be listed as follows: one is an advert designed by a commercial artist for a mass circulation medium, the other is a work of art created by a fine artist for display in a home, gallery or museum; the advert is much smaller than the painting; one existed in thousands of copies, the other is unique; one was manufactured with the aid of machines, the other was made by hand; the advert was ephemeral, the painting is more permanent; the advert was cheap, the painting much more expensive; the advert is black and white, the painting brightly coloured (yellow, red and blue); the advert contains text which anchors the meaning of the image, the painting contains no text (apart from its purely descriptive title) and so its meaning is less specific; the image in the advert is a photograph that has been reproduced as a half tone composed of crude dots of ink, the painting's image has been drawn by hand and the dot impression of the original has only been simulated in the flesh areas by using a light coating of pigment to bring out the coarse grain of the canvas (later Lichtenstein would construct pictures from patterns of dots); various other compositional differences are evident, as well as changes in the way the girl has been depicted (for example, Lichtenstein has altered her hair considerably, he has also added the wavy line of the sea); finally, social function is different – one is intended to sell a holiday, the other to provide aesthetic pleasure and intellectual interest.

Philip Pearlstein, 'Superman', 1952. Oil on canvas, 101.6 x 91.4 cm. Collection Dorothy Pearlstein, New York.
Pearlstein is best known for his meticulously realistic paintings of nudes. 'Superman', an early canvas, is untypical of his mature work. Shortly before Pearlstein painted this picture he shared a New York loft with Andy Warhol. (They had been students together at the Carnegie Institute of Technology, Pittsburgh.) Pearlstein's use of popular culture thus anticipated Warhol's by a number of years.

brushstroke was the sign of an existential authenticity; Lichtenstein's painting presents us with *the sign of the sign* of authenticity. As a result, the mark is drained of all energy, its movement is frozen, it is transformed into a decorative emblem. The paint-thickness and sub-

stance of the original is denied by Lichtenstein who makes the stroke even more two-dimensional so that it does not sit on the surface of the canvas in the same way – it becomes more illusionistic. Lichtenstein takes a small detail and inflates it. He thereby implies that action painting has become overblown, that its pictorial rhetoric no longer carries conviction. The *automatism* of action painting, he seems to be saying, has become *automatic*.

By using the conventions of representation derived from graphic design, Lichtenstein presents us with brushstrokes which appear to have undergone mechanical reproduction and processing. (This suggests that his source material may have been a reproduction of an action painting rather than an actual action painting.) The pop painting looks mechanical but the irony is that it too was painted by hand – only Lichtenstein has gone to great trouble to hide the fact. Another irony: a painting whose subject-matter is *brushstrokes* is executed in such a way that the minute brushstrokes which formed the image are disguised.

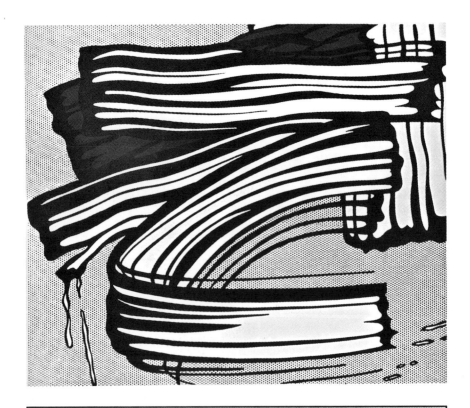

Roy Lichtenstein, 'Little Big Painting', 1965. Oil and magna on canvas, 172.7 x 203 cm. Whitney Museum of American Art, New York.

Lichtenstein's strategy was to translate the 'language' of abstract expressionism into the 'language' of graphic design. 'Non-commercial' fine art appears to have become commercial applied art. Again, the implication is that by the 1960s abstract expressionism had become hopelessly commercialized and mediatized, and therefore it had ceased to deserve its high moral and artistic status. It is relevant to add that the leading action painter, Jackson Pollock, was one of the first American artists to benefit from the full mass media treatment – an article and picture spread in *Life* magazine (8 August 1949). In an analysis of the marketing of the abstract expressionists, Bradford Collins has argued that they were sold on the basis of a bohemian legend.[9]

It is evident from the above analysis that some knowledge of painting and the history of American art since 1945 is required before the iconoclastic implications of 'Little Big Painting' can be understood. To generalize: works of art whose subject-matter is other works of art, or which employ self-referential devices, are likely to appeal mainly to an artworld audience, to those knowledgeable enough to be able to grasp the references and in-jokes. Works of art that take as their subject matter familiar media images, in contrast, have the possibility of being appreciated by people without specialist knowledge.

Formalism in Pop Art

Lichtenstein's fascination with the conventions and techniques of representation favoured by cartoonists and graphic designers can be seen most vividly in certain of his three-dimensional works, namely the ceramic dinnerware of the mid 1960s and the free-standing bronze objects of the late 1970s.

Superimposed on Lichtenstein's three-dimensional items of tableware are lines, patterns of dots and areas of colour – all derived from two-dimensional images. The graphic elements are highly schematized equivalents of shadows, reflections and tonal gradations. Thus, a representation of a shadow on the side of a cup may, or may not, coincide with the actual shadow of that cup. In the bronze sculptures the works consist of metal structures whose outlines are derived from linear, two-dimensional images. (Seen from the side these bronzes are flat.) It is as if the solid parts of objects had been dissolved leaving only a skeleton form consisting of line and tone.

In these sculptures representational conventions are foregrounded and/or made literal. Lichtenstein's intention is to focus our attention on the artist's 'language', the 'how' rather than the 'what', the form rather than the content. In interviews he has stated that it was the abstract qualities of form, colour and means of depiction that appealed to him about comic strips rather than their content. Lichtenstein's work is figurative, and yet it is a subtle kind of abstraction or formalism. For most viewers, however, the content of his work is still important.

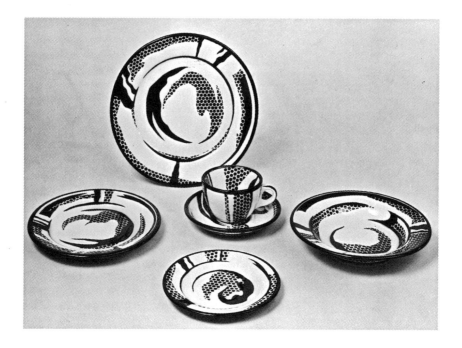

Roy Lichtenstein, 'Dinnerware Objects', 1966. Tate Gallery, London.

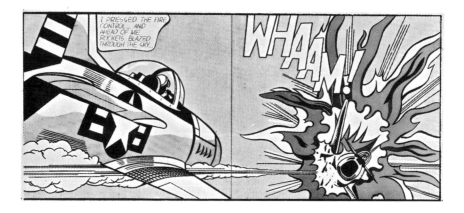

Roy Lichtenstein, 'Whaam!', 1963. Magna on two canvases, 172.7 x 406.4 cm. Tate Gallery, London.

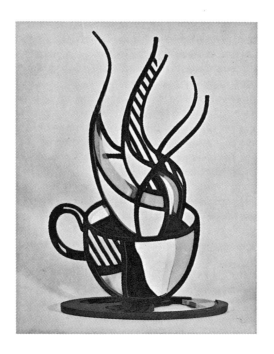

Roy Lichtenstein, 'Cup and Saucer 1' (Edition of three), 1977.
Painted bronze, 75 x 46 x 16.5cm. Photo by Eric Pollitzer, New York and courtesy of the Mayor Gallery, London.

'Whaam!', a painting which freezes the decisive moment of violent conflict between two jet fighters, is one of Lichtenstein's most famous works. War comics – the source for 'Whaam!' and several other, related paintings – utilize an emblematic style which precludes any sense of the actual horror and suffering of war. Lichtenstein's method of reworking such imagery pushes it even further towards the decorative. Both are examples of what Raymond Williams once called 'the culture of distance': the audience is distanced, shielded from the reality of war by the antiseptic style of representation. Viewers who can imagine what death in air combat must be like may well find the contradiction between 'Whaam!'s' violent content and the cheerful, decorative manner with which it is depicted, chilling. Later on, some very different artistic responses to the theme of war will be examined.

The Politics of Pop

Some critics have dismissed pop art as a superficial, inauthentic, decadent movement. They have renamed it 'reactionary realism' and 'consumerist realism'; they have accused it of mindlessly reproducing and celebrating the worst aspects of capitalism and consumerism.[10] There is something to be said for this point of view, but the rejection of pop is too hasty. It is more heterogeneous, complex and subtle than its attackers allow. In any case, there are ways of interpreting it which can yield valuable insights into the character of contemporary society. Pop can be instructive but only if it is studied as seriously as any other art movement.

Even pop paintings without overt political content can be read in ways that have a critical value. An analysis of certain paintings by Andy Warhol (1928–87), the most famous of all the pop artists, will confirm this point. Warhol was a successful illustrator and designer in New York before he became a painter and film-maker. His experience of business and publicity was to prove extremely useful to him later on. The slogan 'I consume, therefore I am' encapsulates the ethos of the American and European consumer societies of the 1950s and 1960s. As the iconography of pop art indicates, much of it was a positive response to the newly affluent society. Many of Warhol's canvases reveal an obsession with consumer goods, especially food and drink products such as cans of Campbell's soup and bottles of Coca Cola. Warhol has provided an ideological justification for his interest in such mundane objects:

> What's great about this country is that America started the tradition where the richest consumers buy essentially the same things as the poorest. You can be watching TV and see Coca Cola, and you know that the President drinks Coke, Liz Taylor drinks Coke, and, just think, you can drink Coke, too. A Coke is a Coke and no amount of money can get you a better Coke than the bum on the corner is drinking. All the Cokes are the same and all are good. Liz Taylor knows it, the bum knows it, and you know it.[11]

There are valid points here: factories and machine manufacture enable consumer goods to be mass produced and this ensures a huge increase in quantity plus a standardization of quality. The same basic goods can be enjoyed by virtually everyone in an industrial society, and this results in a levelling of culture, a uniformity of social habits, that cuts across class lines. Nevertheless, Warhol's understanding was limited: Coke is not a drink everyone enjoys; it is hardly essential to human life; it is not produced as some kind of social service but to generate profits for those who own the company; wealthy people can consume more Coke than bums; the fact that a poor person can afford a fizzy drink does not mean that they can afford more expensive, more essential items such as education, housing and health care. Shoppers in supermarkets are faced with a huge choice, but the freedom and choice associated with the sphere of consumption does not apply to the sphere of production (what is produced, in what quantities, for whom). Millions cannot even choose to be employed in the manufacturing or service sectors.

Crucial to an understanding of the pop paintings and boxes Warhol made from 1962 onwards is the silk-screen method he adopted to produce them. Silk-screen is a technique favoured by printmakers and textile designers, involving photographic and printing processes. Screens can be used to generate hundreds of identical images but variations of tone, colour and design can also be introduced by varying the placement of the screen, the hue and quantity of ink used, and by altering the pressure on the squeegee. Warhol adopted this technique for reasons of economy and speed: press photographs, packaging designs – readymade imagery of all kinds – could be transferred to screens by specialist companies; it then became easy to repeat the same image across a single canvas or across a series of canvases. In this way he was able to achieve a significant increase in output. Instead of creating one-off, unique paintings, he made works in series.

Silk-screen, therefore, was the means by which Warhol overcame some of the traditional limitations of the handicraft mode of production of easel painting. In effect, he partially 'mechanized' it so that batch production could occur. This in turn enabled him to employ assistants and to delegate work to them. When Warhol said he wanted to be 'like a machine' it was not a casual remark; nor was it an accident that his studio loft in New York was named 'The Factory', and his editions of screenprints called 'factory additions'. Photographs of the loft showing screenprinting in progress make it clear that the studio resembled, at times, a small factory.

It was audacious of Warhol to industrialize artistic production in order to generate industrial art (another term for pop art) for an industrial society. This was also an unorthodox and disturbing step to take because, ever since the advent of the industrial revolution, a succession of writers and social critics had regarded the machine as the very antithesis of art and therefore a terrible threat to it. Machines imply repetition, standardization, automation, the mass manufacture of identical objects, the loss of craft skills, the subordination of the worker to the regime and rhythm of the machine – noise, monotony, impersonality, boredom. Art, by contrast, stood for the values of individual or personal expression, originality, skilled handwork. In short, the machine equalled non-human or anti-human, while art equalled the quintessence of humanity.

By turning his studio into a factory, by professing to admire machines, by asking others what subjects he should paint or selecting the most banal and obvious imagery available, by denying that he had any special talents or skills, by celebrating repetition and boredom, Warhol effectively subverted the values conventionally associated with art and artists.

It is important to stress, however, that Warhol's silk-screen paintings were not identical to industrial products in all respects. When a commercial firm manufactures a batch of goods its aim is consistency: all the goods should be the same; those that fail to match the model or prototype are rejected as imperfect. In Warhol's case, the paintings were different from one another because he permitted variations to occur during the production process. He realized that if he wanted to sell them for high prices in the art

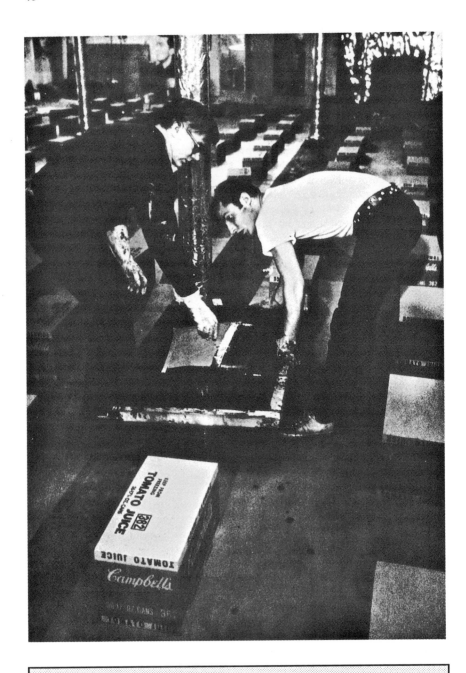

Photo of Warhol and an assistant silk-screening wooden boxes with Campbell's tomato juice carton packaging designs in 'The Factory', 5th floor, 231 East 47th Street, New York, 1964. Photo courtesy of the Andy Warhol estate.

market then he had to retain some degree of uniqueness. This was achieved by retaining any 'errors' in the printing process. (In this respect his paintings were like postage stamps: the really valuable ones are those with printing mistakes.) Warhol's silk-screen method was a compromise between artistic and industrial production; the resulting canvases were also a synthesis of three media: painting, photography and printing.

In a media-saturated environment the same image is encountered repeatedly in a variety of sizes, display contexts and media. This has two consequences: first, the surprise or shock-value of the image progressively diminishes as it becomes familiar; second, the image acquires the character of a stereotype or a pattern. Most people exposed to a succession of photos of starving African children will recognize the phenomenon of compassion fatigue. Those of Warhol's paintings which repeated a violent image over and over again were instructive because they made the process of dehumanization visible – they literally demonstrated the way repetition causes indifference, the way it reduces the most horrible scenes to a formal pattern. The paintings also called attention to the images as things in themselves, so that viewers could no longer treat them as windows on the world. Warhol foregrounded their formal and material qualities; he brought home the fact that they were abstractions from reality.

One consequence of the mass media is that millions of people become familiar with the appearance and lives of individuals they have never met face to face. Cinema and television have the power to transform actors – even news readers – into cult figures. Certain still photos of Hollywood movie stars have acquired the character of religious icons.

A case in point is Gene Kornman's publicity still of Marilyn Monroe taken for the 1953 film *Niagara*. Beginning in 1962 – the year Monroe died – Warhol employed this photograph as the basis for a sequence of silk-screen prints and paintings. By simplifying its design in order to emphasize lips, hair and eyeshadow, and by adding electric colours, Warhol intensified the icon-like, stereotypical qualities of the original. However miserable her private life, Monroe played the part of a cheerful sex goddess in public. Her make-up and smile constituted a mask, and Warhol showed this by making her face even more mask-like. In other paintings and prints of Marilyn, Warhol kept the same image but permutated colours. Thus he highlighted the 'difference within sameness' that characterizes consumer goods manufacture and the cinematic genres of Hollywood. In short, Warhol's images of Monroe revealed the processes of star-making in action. Simultaneously, his paintings and prints transformed the mechanisms of mythification into an aesthetic spectacle.

Warhol's indifference to originality in art, his willingness to represent the most obvious subjects and to embrace the stereotype, set him apart from the majority of his contemporaries. Stereotypes are generally regarded as inimical to art, even though the history of art demonstrates that they have played a crucial role in representation, some – like the image of a peasant sower seen from a three-quarter angle – have persisted for many centuries.

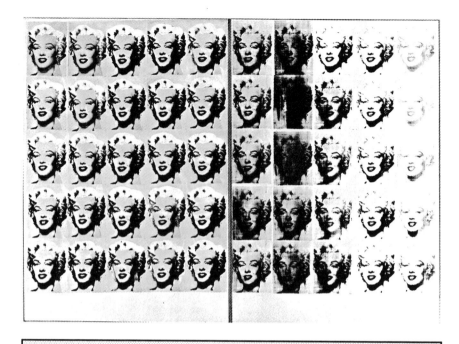

Andy Warhol, 'Marilyn Diptych', 1962. Silk-screen ink on synthetic polymer paint on canvas, 208.3 x 144.8 cm. each panel. The left-hand panel is brightly coloured; the right-hand panel is black and white. Tate Gallery, London.

Salvador Dali, 'Mao/Marilyn', 1971. Cover design for the French edition of *Vogue*, December–January 1971–2. Special surrealist issue. Reproduced courtesy of Condé Nast publications, Paris.

Dali (1904–89), the Spanish surrealist, achieved worldwide fame during his lifetime. He was a forerunner of Warhol in terms of his love of publicity, celebrity and money. Much twentieth-century advertising was influenced by Dali's weird, erotic paintings and he himself was happy to undertake commercial commissions such as shop window displays and set designs for Hollywood movies (for example, Hitchcock's *Spellbound*). This magazine cover wittily superimposes the faces of two of the world's superstars – Marilyn Monroe and Chairman Mao. The former was made famous by the capitalist mass media of the west, the latter by the communist propaganda machine of the east. Dali's image implied that the two political systems had more in common than people at the time were prepared to admit: both relied on mass communication methods to control the people; in both societies there were personality cults – the people felt compelled to worship the icons of certain superbeings. Dali's image was iconoclastic in its feminization of Chairman Mao's features – presumably, in communist China such a representation would have been regarded as an insult.

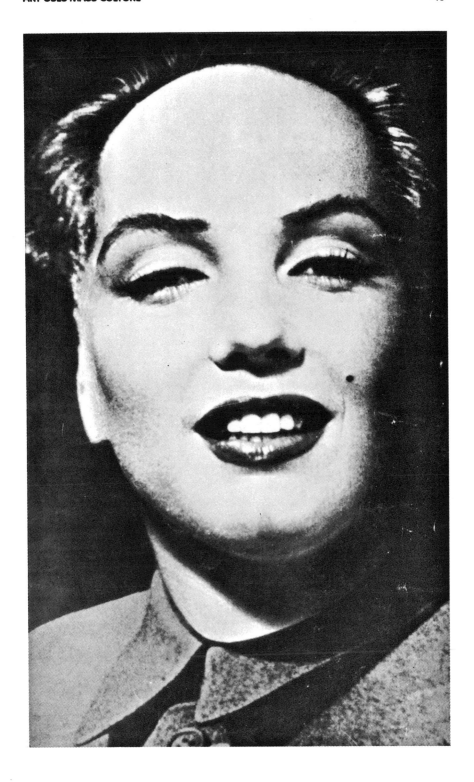

Western societies tend to be dominated by the ideology of individualism. As a result differences between people are more valued than similarities. The virtues of competition are stressed more than those of co-operation. For decades people in the west despised the so-called communist societies because 'everyone had to think and dress alike'. Yet ours is an age in which industry makes millions of blue jeans available to millions of wearers, while advertisements celebrate the individualism of choosing blue jeans (one could call this paradoxical conformism 'mass individualism'). The repetition of certain images, the prevalence of stereotypes, the cult of personality, these are the characteristics of mass culture which most artists find unacceptable, but which Warhol's work compelled us to confront. Such characteristics were also found in communist propaganda. At this point Salvador Dali's 1971 'Mao/Marilyn' is worth citing as an image which uses superimposition to sum up the overlap between capitalist America and communist China.

Those critics who dismissed Warhol were generally ignorant of, or indifferent to, the large number and range of activities, projects and media in which he was engaged. At one time or another he was involved with graphic and wallpaper design, prints, paintings, still photography, record production/rock music groups, multi-media discos, sculptures, films, air art, writing and publishing books and *Interview* magazine, museum and shop displays, TV commercials and programmes, collaborations with other artists, and pop music videos. In short, Warhol was given no credit for versatility and diversity.

From the early 1960s until his death in 1987 Warhol was an artist who worked in the full glare of publicity. Instead of being destroyed by it like so many other 1960s superstars, he exploited it for his own purposes. If any fine artist managed to span the divide between art and mass culture it was Andy Warhol. He became a mass media celebrity in his own right. Even after his death media interest persisted – an actor played the part of Warhol in Oliver Stone's 1991 movie *The Doors*.

Towards the end of his career Warhol virtually ceased to be an individual 'auteur' and became the head of a business enterprise with a large staff and suite of offices in New York. 'Warhol' became a brand name attached to a range of products. The philosophy of 'business art' he expounded made it crystal clear he was under no illusions as to his position:

> Business art is the step that comes after art. I started as a commercial artist and I want to finish as a business artist ... Being good in business is the most fascinating kind of art ... making money is art and working is art and good business is the best art.[12]

Warhol was one of the few artists of his time to acknowledge the capitalist nature of art under capitalism. Fine art used to be thought of as 'non-commercial', in contrast to the commercial or applied arts, but works of art offered for sale in private galleries are commodities. Art galleries are simply upmarket shops selling luxury goods. Furthermore, every 'priceless' masterpiece acquires a price in the auction room. (This is not to say that works of art with exchange-value have no use-value. As far as the analyst is concerned, the challenge is to show how the

economic dimension inflects the form and content, aesthetic value and social significance of modern works of art.)

Just as the socialist realist artists of the Soviet Union used to affirm the official values of their regime, so Warhol affirmed those of free-market America. Hence a legitimate description would have been 'capitalist realist'. His lessons were eagerly learnt by the younger generation of American artists who came to prominence in the mid 1980s; they either produced works of art about commodification and consumerism, or they outdid Warhol in their self-promotion, blatant commercialism and appropriation of popular culture and kitsch.

There was critical value in Warhol's brutal honesty. There was also critical content in certain of his artworks despite the fact that examples with a directly political message were rare. Some silk-screened canvases recorded white police with dogs in the southern states beating blacks demonstrating for civil rights. Although Warhol was probably more interested in the media representations of such events rather than the events themselves, such paintings were not exactly positive propaganda for the American way of life. Warhol's 'Thirteen Most Wanted Men' paintings for the 1964 New York World Fair were censored for this very reason. The amoral and 'immoral' content of his films – drugs, transvestism, homosexuality, erotic antics – also espoused values associated with a camp, New York sub-culture that were far removed from those of middle America. Some screenings of his films were banned outside of New York. In Britain even TV documentaries *about* him were subject to censorship attempts.

Warhol's detractors interpret his work as an uncritical celebration of consumerism but, as I have tried to show, this is a superficial response; there are alternative readings which demonstrate it has a value for those seeking to understand contemporary society.

Transubstantiation

Assessing the pop art movement as a whole, even with the advantage of hindsight, is problematic because of its heterogeneity, and because critics and historians have differed so widely in their interpretations and evaluations.[13] Dick Hebdige, in a 1983 article taking a fresh look at pop, argued that its celebration of consumerism was justified by historical circumstances because there was a significant improvement in living standards in Europe and the United States during the 1950s and 1960s.[14] He also claimed that pop was iconoclastic because its use of despised commercial art, pin-ups and soft core pornography (in the work of Peter Blake and Allen Jones) marked 'a return of the repressed' into the realm of high culture. Hebdige concluded that pop art eventually found its true fulfilment not in the realm of high culture but in the realm of mass culture – that is, when it was recycled by graphic designers, pop musicians and so on.

The phrase 'return of the repressed' suggests some kind of cultural breakthrough, but was this actually the case? Who despised commercial art

and pornography? What was the significance of the irony typical of so much pop art?

Most mass culture is the output of cultural industries and businesses owned by powerful individual entrepreneurs, corporations or groups of shareholders. They employ teams of specialists to devise the contents of the mass media. In order to succeed commercially, the cultural industries have to appeal to large audiences, and consequently they have to appeal to the working and lower middle classes. However, there is embarrassment on the part of those who control and manufacture certain kinds of material designed for mass markets. Can one imagine the publishers of the kind of violent war comics Lichtenstein appropriated admitting to their peers that such comics were their genuine culture? Can one envisage the trustees of the Tate Gallery or members of the Arts Council of Great Britain acknowledging the bondage and porn magazines Allen Jones used as their true culture? (The Tate Gallery will mount an exhibition devoted to 'the nude' but not an exhibition devoted to pornography.) The answer is 'no' because cultural snobbery would forbid such admissions.

In public, at least, what the cultured fraction of the bourgeoisie admires and patronizes is high culture (opera, classical music, the fine arts). To cite just one example: Charles Saatchi, a major British collector of contemporary art during the 1980s, obtained millions of pounds from advertising agency profits but, unlike the pop artists, he did not collect ads. He established a gallery to display his art collection; he did not found a museum of advertising.

Appreciation and knowledge of high culture is one of the things that distinguishes the upper classes from their social 'inferiors'. We are now in a position to understand one of the crucial aspects of pop art. Most pop artists came from petty bourgeois and working class backgrounds. Access to art college facilitated upward social mobility. They truly enjoyed popular culture but to raise it to the level of fine art often meant that a connoisseurial, camp or ironic attitude towards it had to be adopted. Once war comic and pornographic images had been transmuted into paintings and sculptures, and those works approved by high-cultural institutions such as the Tate Gallery, it became acceptable for the bourgeoisie to enjoy them, and to be seen enjoying them. Miraculously, the despised material had been transformed from cheap, commonplace trash into expensive, rare art. Miraculously, minority culture had appropriated its antithesis without abandoning its own élitist values. As we shall see later, the American neo-pop artist Jeff Koons set himself the task of persuading the bourgeoisie not to be ashamed of the kitsch and the porn they manufacture in such huge quantities.

Since the zenith of pop, thousands of artists have responded favourably to the existence of mass culture. Two further examples, one American and one British, will be cited. A highly respected modern painter whose work was rejuvenated, in part, by the influence of mass culture was Philip Guston (1913–80). Guston had been one of the principal figures of the abstract expressionist movement, but by the mid 1960s he had become dissatisfied with the kind of hesitant, gestural abstraction that had made

him famous: 'I got sick and tired of all that purity.' He wanted the freedom to paint badly, to depict everyday objects and activities again, to re-introduce figuration, story-telling and raw feelings. Despite the risk of failure and the risk to his career, Guston followed his instincts. The iconography of his new pictures was inspired partly by comic strips: a Cyclopean head was derived from Bald Iggle, a character in Al Capp's 1940s strip 'Li'l Abner' and other elements were borrowed from Gottfredson's version of Disney's Mickey Mouse. Perhaps he recalled the year-long correspondence course in cartooning he had taken at the age of twelve.

When Guston's new work was shown in New York in 1970 many critics were shocked at the drastic change of style and their responses were negative. He was described as 'a mandarin pretending to be a stumblebum'.

Philip Guston, 'Head and Bottle', 1975. Oil on canvas, 166.4 x 174 cm. Collection Mr and Mrs Philip Lilienthal, San Francisco.

Subsequently, his late work came to be seen as a majestic flowering. What was remarkable about these canvases was that they retained all the painterly bravura of the old Guston but they also had a new, absurd and at the same time tragic content, plus the energy, irreverence and humour associated with the funny papers. Guston once remarked that he wanted people who saw his pictures to burst out laughing. His aim, in other words, was the same as those in the realm of mass culture who draw comic strips or who make comedy and animated cartoon films.

The British painter Andrew Heard (1958–93) was a student at Chelsea School of Art, London during the late 1970s. Previously, he had studied history and art history at London University. In the main, the mass culture that fascinated him was British rather than American. (He was not anti-American, simply pro-British. Absurdly, his work was appreciated more abroad than at home.) Radio, television and cinema entertainers of the past, such as the comedians Arthur Askey, Benny Hill, Tony Hancock, Max Miller and Terry Thomas, appealed to him. The popular culture he experienced during childhood made a lasting impression. Heard's taste was rather camp and nostalgic. His artistic project was one of patriotism, retrieval and redemption: the 'low' culture of Britain's past was fondly remembered, celebrated and preserved in a 'high' culture medium. Heard's meticulously executed paintings were cleverly organized montages of images and words quoted from disparate sources, rendered in a variety of styles. They were capable of appealing simultaneously to a sophisticated art audience and to ordinary people who knew nothing about contemporary art but who shared his enthusiasm for popular entertainers.

Indirect Influences of the Mass Media

There are many contemporary artists, of course, whose work apparently ignores the presence of the mass media and mass culture. These artists continue to produce paintings within the established genres of portraiture, the nude, still life and landscape as if nothing had happened. (See, for example, the annual summer exhibitions held at the Royal Academy in London.) But even here new media technologies have had an impact. Many recent portraits, for example, are indebted to ways of representation made familiar by photography. The fact that Britain's National Portrait Gallery in London now collects and mounts exhibitions of portrait photographs is a sign that today it is the medium of photography which dominates the genre of portraiture. The social functions that portraits and statues of famous leaders performed in the past have now been largely superseded by poster-size photographs of movie and rock/pop music stars.

In the twentieth century thousands of figurative painters have attempted to add something of value to the fine art tradition but only a few have succeeded. The names of Francis Bacon, Max Beckmann, Lucien Freud, R. B. Kitaj, Henri Matisse and Pablo Picasso spring to mind. Even in these cases, influences from the mass media can often be detected. Their international fame is also partly dependent upon the

Andrew Heard, 'Coming Shortly', 1989. Acrylic on canvas, 150 x 150 cm. Reproduced courtesy of the artist and the Friedman-Guinness Gallery, Frankfurt.

Despite its somewhat old-fashioned imagery, this painting succinctly conveys the pleasures and promises associated with the cinema and pulp literature. Such mass entertainment media depend on a constant turnover of product. Consumers have to be persuaded to buy again and again; hence it is important to generate a sense of anticipation by promising future thrills. The silk-screened strips of images at the top and bottom of the canvas provide a typology of the different genres and excitements characteristic of popular culture: mystery, romance, adventure, etc. The painting has a childlike innocence. It represents popular culture as a means of diversion and escape from the boring routines of everyday life. There is no hint that more serious, ideological matters might be involved in mass entertainment.

mass media's ability to relay information about them and their art to billions.

What fine artists avoid doing is also significant. Certain kinds of subject-matter appear to have been conceded to the mass media. In 1990 Les Levine, a North American media artist, observed: 'Art never stays the same. It gets weaker.' One of the ways it became weaker was as a result of the growing power and speed of the news media. The vast majority of people now turn to their radios, television sets and news-papers for instant information about important current events; they watch documentary programmes and films for in-depth analyses of serious issues. In consequence, during the twentieth century, there has been a decline in history painting and sculpture. Picasso's 1937 mural-size picture 'Guernica' is the best-known exception to this generalization.

In recent decades some left-wing artists have bravely attempted to keep the tradition of history painting alive by tackling the subject of war. Such artists include Terry Atkinson, Leon Golub, John Keane, Richard Hamilton and Nancy Spero. (Some examples will be discussed in Chapter 10.) But their work generally uses mass media imagery as raw material.

As explained earlier, one of the reactions of artists to the power of the mass media was a pursuit of purity and reduction; hence the appeal of abstraction to so many modern artists; hence the emergence of such contentless styles as minimal art and fundamental painting; hence the self-referential character of so much avant-garde art. By such drastic means art's autonomy and difference were maintained but the price was an inability to comment on the events of everyday life. Meanwhile, as we shall see in the next chapter, the mass media exploited the fine arts for their own commercial and ideological ends.

3. THE MASS MEDIA USE ART

Twentieth-century mass media routinely employ the fine arts in various ways: as subject-matter; as a source of styles and formal innovations; and as a pool of skilled labour (whenever they employ fine artists to undertake specific commissions).

Art as Subject-matter

Advertising, publicity and packaging appropriate images from the art of the past and the present. The history of art constitutes an enormous bank of images that are out of copyright and that are familiar to millions of consumers. Record sleeve designers have generally been trained in the graphics departments of art and design colleges where they have been taught about the history of art, so it is not surprising they ransack the archive. Designers are under pressure of time to fulfil their design briefs, and it is therefore easier to borrow images than to create them from scratch. Use of familiar images facilitates rapid communication and permits parody. Nick Egan's and Andy Earl's album cover for Bow Wow Wow's 'See Jungle' can serve as an example of all those commercials that reference French, nineteenth-century painting, especially the ever-popular works of the impressionists.

Over several centuries western European painting evolved a 'language' of representation that was eventually automated by photography. According to the final part of John Berger's *Ways of Seeing* (1972), colour photography has replaced oil painting as the main medium of visual representation. This shift from painting to photography is exemplified in the album cover: the designers did not simply reproduce the original Manet painting – 'Le déjeuner sur l'herbe' (1863, Louvre, Paris) – they recreated its composition via 'staged photography'. There is a certain irony in the fact that Manet himself borrowed his composition from an earlier source, namely a Renaissance engraving by Marcantonio Raimondi after a painting by Raphael.

There are countless magazine adverts and TV commercials that employ works of art as props. Their role is to serve as tokens of high culture, superlative skill and supreme value, and to signify the good taste, the sophisticated lifestyle of the human beings appearing in the adverts. The product or service being advertised is supposed to acquire these qualities by association or contiguity.

Image of the Artist in Advertisements

Unlike film and television stars, the faces and voices of the majority of fine artists are not sufficiently known to the general public to warrant advertisers using them in advertisements and commercials to endorse

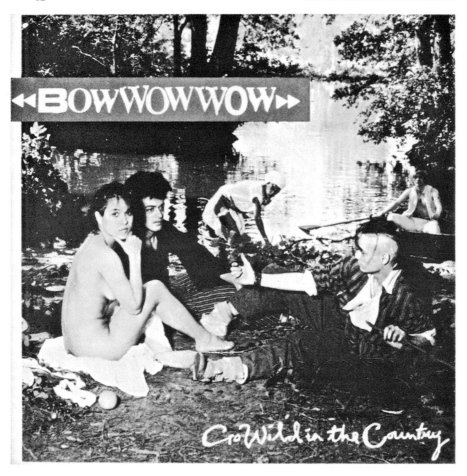

Bow Wow Wow, 'See Jungle! See Jungle! Go join your gang Yeah, City all over! Go ape crazy!', RCA, 1981. Design by Nick Egan, photo by Andy Earl.

The sleeve photo shows members of the band in a rural setting with Annabella Lwin, its 15-year-old lead singer, in the nude. Shock attended both the appearance of the Manet in 1863 and the release of the record in 1981: controversy occurred because Annabella's mother objected to her under-age daughter being treated as a sex object.

Malcolm McLaren, who was then the group's manager, was himself an ex-artschool student, well versed in the radical ideas of the situationists and the shock tactics of avant-garde art and punk rock (previously he had managed the Sex Pistols). He was an entrepreneur whose aim was to milk pop music, fashion and art for profit, but also for aesthetic and political ends. McLaren punned: 'We are only in it [the music business] for the Manet.' In 1988 the New Museum of Contemporary Art in New York mounted an exhibition about McLaren and the British new wave.

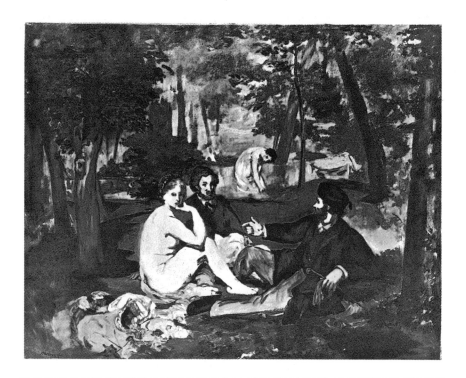

Edouard Manet, 'Le déjeuner sur l'herbe' (study for completed work in the Louvre, Paris), 1862–3. Oil on canvas, 89.5 x 116cm. Courtauld Institute Gallery, London.

products, services and corporations. In any case, most artists would probably be reluctant to lend their images to such a purpose because they would regard it as undignified. The product that artists are happy to endorse by means of photographs of themselves is their own work. (A carefully contrived photo-portrait taken in the artist's studio is standard in exhibition catalogues and art magazine profiles.) Some artists and designers are willing to endorse products they use in their professional capacity. For example, in March 1973 a photograph of June Wayne, the founder of the Tamarind Lithography workshop, appeared in an advertisement for Shiva artists' materials in the magazine *Art News*. Such advertisements are aimed at other artists and designers, and as a consequence are confined to the art press.

In spite of the above, there are a few artists who have been famous enough, and who have been willing, to endorse products – Andy Warhol, for instance. The pop and business artist had no qualms about associating himself with commerce. In 1969 Warhol endorsed Braniff Airlines by appearing in an advertisement with the boxer Sonny Liston. Part of the copy read: 'It happened on a Braniff plane: Big

ugly bear meets short chic artist ... Meanest man alive meets strangest artist alive.' During the 1970s Warhol endorsed the products and services of a range of companies, including Air France, Pioneer Electronics Corporation, Puerto Rican Rum and *US News and World Report.*

For endorsement purposes advertisers find images of the famous artists of the past more useful than images of living artists. Dead artists cannot object if their self-portraits, or drawings of them, are employed in advertisements. Another advantage is that dead artists do not require a fee. Famous artists are often associated with particular countries or cities – Rembrandt with Holland and Amsterdam, for example. This means they are ideal for the purposes of travel and tourist advertising aimed at the more cultured segment of the public. Artists are creative beings: this is a characteristic that advertisers – particularly advertising agencies – are keen to appropriate. In 1966 the American ad agency Leo Burnett Co., Inc ran an advert in *Fortune* magazine which featured images of the brothers Vincent and Theo Van Gogh in order to symbolize 'the combination of creative flair and business acumen' the agency claimed to provide.

According to popular legend Vincent Van Gogh was not only a genius but also a madman. A reproduction of Van Gogh's 'Self-portrait with Bandaged Ear and Pipe' (1889) appeared in a 1972 advert by the Osborne Group, produced on behalf of the Institute of Marketing, for a seminar entitled 'The Management of Creativity'. The main caption read 'It would have been mad to try and manage him [sic]'. What was especially pernicious about this use of Van Gogh's self-portrait – executed shortly after the act of self-mutilation – was that graphic designers had retouched Vincent's eyes to make him appear crazy.

Like other groups of workers, artists are a professional category or social type. From time to time, therefore, advertisers will represent anonymous or fictional artists simply in order to exploit the image of the artist as a social type. For instance, a Gordon's vodka advertisement appearing in a 1970s American, upmarket magazine showed a male sculptor standing next to a welded metal, abstract sculpture with a glass of vodka in his hand. This ad was clearly designed to appeal to sophisticated people, those capable of appreciating modern, abstract art. In this instance the artist represented a tough, independent spirit, a person who was discerning in his choice of alcohol.

Art as a Source of Styles and Formal Innovations

Avant-garde movements within twentieth-century modern art were notable for their questioning of traditional values, artistic conventions and systems of representation. As a result many works of modern art were judged difficult to understand; some indeed were dismissed by the public as silly nonsense (either because they were too complex or too simple). Modern artists wanted to delay recognition/reading on the part of

beholders in order to renew their perception of the world, to extend the pleasure of viewers and to challenge them intellectually. Therefore their aims were somewhat different from those of advertising designers who wanted to communicate messages and information rapidly to the general public. Such designers required images that were unusual enough to catch the eye and to stimulate interest but simple enough to be comprehensible without too much effort and time on the part of viewers. At first it seemed as if modern art was unsuitable for advertising. However, this proved not to be the case. Virtually every avant-garde movement has been pillaged for images, styles and ideas. As the Benson & Hedges advert illustrated overleaf indicates, surrealism and pop art were particularly popular with advertising agencies. In the design studios, the two favourite surrealists were Salvador Dali and René Magritte.[1]

To some degree, therefore, modern fine art has functioned as a 'research and development' department of the mass media; a department in which formal and technical experimentation has been actively encouraged. Any promising discoveries have then been introduced – after a suitable assimilation period – into the mass media.

Pop art was a movement that achieved rapid success in Europe and North America during the 1960s because it was brash and colourful, and because its imagery was already familiar to the public. Furthermore, as a result of the expanding mass media of the period, it reached a much younger, wider audience than earlier art movements. Since pop had cannibalized popular culture, much of it had the same visual impact as advertising and packaging. Graphic designers soon saw the potential for recycling and they imitated the look of leading pop artists such as Roy Lichtenstein and Andy Warhol. The 1978 cover design of the London listings magazine *Time Out*, which echoes Lichtenstein's comic-strip style, is simply one of many examples that could have been reproduced. Clearly, it was only poetic justice when the graphic designers reappropriated what had been taken from them by fine artists in the first place.

There is another, more subtle way in which advertising exploits fine art, that is, by aspiring to its condition. It does this by insisting upon the highest production standards in colour photography, and by allowing a great deal of freedom in terms of the designer's imagination and creativity. The advertising industry confirms this process by establishing annual award schemes and ceremonies for the best advertisements, a few of which thereby acquire the status of masterpieces. If a campaign accrues to itself values comparable to those of fine art, then it will become a talking point within the industry, within the world of designers, artists and art students. The acquisition of such prestige is always helpful to the advertising agency and client – especially when the product being sold is cigarettes and there is an anti-smoking lobby whose aim is to outlaw all forms of cigarette advertising.[2]

MIDDLE TAR EVERY PACKET CARRIES A GOVERNMENT HEALTH WARNING

'The Art Gallery', 1978. Cigarette advertisement. Photographer: David Montgomery; art director: Alan Waldie. Shot on location using a specially made 'prop' cigarette. Gallaher Ltd manufacture Benson & Hedges cigarettes and the agency responsible for the Benson & Hedges account were CDP (Collett, Dickenson, Pearce & Partners).

What was exceptional about the Benson & Hedges series of posters, magazine advertisements and cinema commercials dating from the late 1970s was first, the reliance upon purely pictorial means (no slogans or captions appeared); and second, the ingenuity with which variations were played upon the basic theme of a gold pack placed in unusual contexts. The series was highly regarded within the advertising industry and praised by Britain's design establishment. In 1978, for example, Design Council judges gave 'Best of the Year' awards to five Benson & Hedges posters (including the one illustrated). They wrote: 'We felt in many ways that the Benson & Hedges series was a milestone in poster advertising. The brilliant use of surrealism arouses curiousity and has created a talking point. The series has tremendous brand impact and illustrates, perhaps, how the constraints on cigarette advertising can act as a spur to creativity.'

In the above image the sleeping attendant endows the scene with a dream-like quality. The use of fine art is twofold: the setting is an art gallery and the iconography derives from the modern art movements surrealism and pop. Furthermore, the presence of the cigarette pack inside a painting and a gallery implies that it is a work of art in its own right. This idea was reiterated some years later in a lavish, expensive cinema commercial entitled 'Salvage' (1984), directed by Hugh Hudson, in which a massive gold pack discovered in the mud at the bottom of the River Thames ended up as an ancient monument in the British Museum surrounded by awe-struck crowds. This film also received awards from the advertising industry.

Cover illustration, *Time Out* magazine, January 1978.

In Britain during the 1980s the controversial thesis that adverts are art was given intellectual respectability by the cultural commentators Germaine Greer, Christopher Frayling and Edward Lucie-Smith, who appeared on television and radio in order to celebrate TV commercials and billboard adverts.[3] It is undeniable that great skill and imagination are manifested in the finest advertisements, and that increasingly self-reflexive and formal devices derived from avant-garde art are employed to catch and hold the viewer's attention, but there remains a disturbing discrepancy between their formal innovations and their trivial content, between the artistry of the means employed and the commercialism of the ends served. Furthermore, however entertaining adverts may be, the majority are, ideologically speaking, conservative or reactionary in their values; hence, the pictorial and poetic pleasure and humour that adverts provide cannot be enjoyed or praised unreservedly.

At this point it should be acknowledged that formal experimentation takes place within the mass media as well as within the fine arts. The history of the cinema is marked by technological developments that yielded greater and greater illusionism in terms of the reproduction of sounds and images. But it is also the story of more and more fantastic special effects. At the time of writing the fashionable effect is a computer-graphics one called 'morphing' (the word was derived from metamorphosis); it involves human and humanoid figures capable of infinite transformations of shape. The effect appears in TV commercials and in the popular, science-fiction movie *Terminator 2* (1991). However, the extent to which formal experimentation is encouraged varies from mass medium to mass medium. In British television experimentation was frowned upon for several decades, then play with the medium was limited to 'light' entertainment programmes – zany comedy shows and pop music programmes/videos – and to advertisements on commercial channels. Although some music videos demonstrated a high degree of artistic creativity, in the majority of cases the optical pleasure provided by the visuals was designed to compensate the viewer for the banality of the music, lyrics and performances.

During the 1980s departures from naturalism spread to some drama series. However, serious programmes about reality – news and documentaries – still relied upon a naturalistic mode of representation which tended to disguise the ideological, constructed character of the programmes. For many years avant-garde artists experimenting with the media of film and video found it virtually impossible to gain access to mainstream television because TV professionals kept tight editorial control and refused outsiders the chance to address audiences directly. The situation improved somewhat in 1982 when Channel 4 – a minority channel with a brief to innovate – appeared and arts programmes consisting of anthologies of video art and animation were transmitted.

Art as Subject-matter in the Cinema

Art as subject-matter can also be found in the cinema. In addition to the thousands of documentary films about the arts, there are a number of feature films about artists and architects, both fictional and real. (This topic is more fully described in my book *Art and Artists on Screen*, 1993.) Two examples will be briefly considered: *The Fountainhead*, about a fictional modern architect, and *Lust for Life*, about the Dutch painter Van Gogh. Both films were adapted from successful novels, which suggests that the cinematic genre of artist-films was predated by a literary genre. Ayn Rand's *The Fountainhead* was published in the United States in 1943; she also wrote the script for the subsequent movie. In 1948–9 the novel was turned into a Hollywood film directed by King Vidor and starring Gary Cooper and Patricia Neal. This film now appears on television from time to time.

The Fountainhead's plot concerns the career of an extreme individualist, an ultra-modernist architect called Howard Roark. The man has such strict artistic principles that he is prepared to dynamite a public housing scheme that he designed because it was not being built according to his specifications. In *The Fountainhead* the ideals and standards of modernist architecture are praised even though the way the book is written (and the film made) is by no means modernist in style. (Both the film and the book are commercial products designed for the mass market, and as such they are entirely conventional in their construction.) Since the subject of modernism was exploited by the mass media for reasons of profit and propaganda, one could say *The Fountainhead* was the revenge of mass culture upon modernism in the guise of its opposite.

Gary Cooper in *The Fountainhead*, 1949. Publicity still reproduced courtesy of United Artists.

Irving Stone's *Lust for Life*, a best-selling novelized biography of Van Gogh first published in 1934, was turned into a Hollywood movie by MGM in 1956. Directed by Vincente Minnelli, this CinemaScope film starred Kirk Douglas as Van Gogh and Anthony Quinn as Gauguin. A fundamental difficulty of films about art is the representation of one medium in terms of another: the *still* art of painting in a *motion* picture. Popular cinema

audiences expect drama, action, movement and sound; they do not expect to linger over a shot of a silent, static oil painting. Even when a film is in colour, the colour values of the original paintings (assuming they are originals) are inevitably transformed. Dramatic changes of scale occur too when small drawings are enlarged to the size of a cinema screen. If the artist is a figurative painter – and one cannot imagine Hollywood being willing to make a film about an abstractionist (unless the artist's life-story was as melodramatic as Jackson Pollock's) – then a spurious sense of realism may be communicated by filming paintings in the settings they depict (these very settings having been reconstructed by set designers from the paintings themselves!).

In bio-pics about artists, works of art receive short shrift because the emphasis is on the personality, life and loves of the artist; however, the film-makers usually need some half-finished pictures – which have to be commissioned from contemporary painters or art directors – hence the semi-completed 'Van Goghs' are not genuine. Indeed, other completed paintings are either crude copies or enlarged photos. The main drawback of such films, therefore, is that viewers leave the cinema with a false impression of the quality of the real artist's work.

Cover of a 1966 paperback edition of Irving Stone's *Lust for life* reproduced courtesy of Four Square Books, New English Library Ltd, London.

One consequence of the mass media is that *simulations can replace the very thing they simulate.* For example, the publishers of the above paperback could have reproduced one of Van Gogh's self-portraits on the cover, but they preferred to use an illustration showing Kirk Douglas simulating Van Gogh in the film *Lust for Life.*

All biographical films confront the problem of compression, of what to include and what to exclude: an artistic career spanning decades is reduced to two hours. Given the shortage of time, and the necessity to attract a mass audience, the temptation is to focus on melodramatic incident rather than upon the less exciting hours of work and practice. A film aimed at a mass audience cannot afford to pay much attention to

the art theories which informed an artist's work. Another problem is the translation into visual terms of the internal mental processes of creation. A major difficulty of the genre is the division between the artist and the art, or the life versus the work. Artists become famous because of their work; the film, by focusing upon the life, inverts this order of priority. Can one film – especially one organized in terms of a chronological narrative – adequately deal with both life and work? Can such a film explain the complex relationship between life and work?

Another drawback of the biographical film (and history of art texts adopting the same approach) is that a single individual is presented as the sole source of origin of the works of art. Other factors – such as traditions, conventions, influences, training, patronage and social, political and historical determinants – are neglected. The way in which the artist is represented generally conforms to one of a few stereotypes of the artist current in our culture (for example, 'the mad genius'). In this regard, much depends upon how the actor decides to play the part of the artist. In *Lust for Life* Kirk Douglas emphasized the emotional intensity of Van Gogh, but not the rational side of his character. Films about historical figures raise the question of how truthful they are to the past. Some degree of poetic licence is, no doubt, inevitable. Although the accuracy of such a film cannot be checked against reality directly – since the past no longer exists – it can be checked against other historical evidence surviving from the past.

All forms of communication place a twofold responsibility upon the sender: to do justice to the material or object of study, and to meet the needs of the presumed audience. In practice these two demands often conflict. What normally triumphs in the mass media is the low level of taste ascribed, rightly or wrongly, to the putative audience.

Artists as a Pool of Skilled Labour

A number of fine artists have worked in or for mass culture industries such as advertising. Andy Warhol, for example, was a successful freelance illustrator and designer before he crossed over to the realm of fine art. Like Henri Toulouse-Lautrec, a French painter who was happy to design posters and to illustrate books, many other artists have been willing from time to time to accept commissions from the mass media as a way of supplementing their incomes.

In Britain during the 1930s the oil company Shell-Mex and BP Ltd became noted for its advertisements with landscapes painted by young contemporary artists. Jack Beddington, the company's publicity manager, was responsible for commissioning such artists as John Armstrong, Tristram Hillier, Cedric Morris, Paul Nash, Ben Nicholson and Graham Sutherland. This early example of corporate patronage had the twin aims of enhancing Shell's reputation and fostering the appreciation of contemporary art among the general public.

Graham Sutherland: 'Everywhere you go ... The great globe Swanage', 1932.

Poster no. 352/lithographic print, 76.2 x 114.3 cm. Reproduced by kind permission of Shell UK Ltd; photo courtesy of E. Sheppard, Shell's Advertising Archive consultant. Sutherland's original was a gouache; it is now in possession of British Petroleum.

The above poster was one of 600 in a series which appeared between 1920 and 1954. It was the second poster Sutherland created for Shell; it depicts a curiosity of Swanage, Dorset: a ten-feet in diameter stone globe of the world surrounded by quotations, dating from the 1880s. Shell posters were mobile – they appeared on the sides of petrol lorries.

A comparable scheme in the United States was prompted by Walter Paepcke, founder of the Container Corporation of America (CCA). Fired by his wife's taste for modern art and design, Paepcke employed an art director, Egbert Jacobson, in 1935 to endow the CCA with an up-to-date corporate image and unified design style. Later, leading modern artists such as Fernand Léger, Man Ray, Richard Lindner and Willem De Kooning were commissioned to create prestige advertisements. In 1945 De Kooning, who was later to become a leading abstract expressionist, produced an illustration showing his native Holland for a CCA magazine advertisement (United Nations series).

The fascinating story of how a major business sought to use art and culture to improve its corporate image and to redeem 'a vulgar technological and philistine civilization' is told in James Sloan Allen's book *The Romance of Commerce and Culture* (1983). Allen's history explains in detail how during the Cold War 1950s American businessmen and scholars – 'the power élite' – joined forces to claim hegemony over the humanist tradition of western civilization in order to legitimate the United States' role as the world's leading nation and policeman.

Relations between artists and business have not always been harmonious. Sir John Everett Millais's 1886 oil painting 'Bubbles' – a saccharine portrait of his grandson blowing soap bubbles – was adapted for the purposes of advertising by Pears' Soap without his knowledge or permission. Millais was angered by this development but he had sold the painting, plus the right to reproduce it, to Sir William Ingram who published it as a presentation plate in the popular magazine *The Illustrated London News*. (From William Hogarth onwards, British painters had created oil paintings with a view to earning money from the sale of prints based on their pictures or from the sale of the pictures' reproduction rights.) Even before the plate appeared in 1887 Ingram sold the painting to Messrs A. & F. Pears, who subsequently added a bar of soap and the words 'Pears' soap' to a coloured reproduction of it. Since Millais had failed to register his ownership of copyright, he could do nothing to prevent the use of his painting in an advert. Salt was rubbed in his wounds when unkind critics accused him of commercialism. However, the painting's appearance in an advert did serve to make it famous.

The paradoxes and contradictions that can occur when the different value systems of fine art and industrial production are combined is demonstrated in the BMW advert showing German cars that have been decorated by three leading American artists.

Earlier it was argued that colour photography had replaced painting as the dominant visual medium of our times. (In this instance photography should be taken to include other mechanical systems of representation, such as the moving pictures media of cinematography, television/video and computer-generated imagery.) This argument is valid but it does not follow that the mass media has no further use for such ancient hand-skills as drawing, painting, sculpting and model-making. Such skills survive in the preliminary stages of the making of mass media products. For example, designers frequently make sketches and drawings during the early, ideas phase of devising an advert; film-makers regularly employ artists and designers to produce detailed storyboards and designs for sets and costumes in order to visualize how the film will look. Drawing facilitates the creative process; drawings are quick, cheap and flexible.

In addition, many printed adverts and animated cartoons consist of drawings or paintings or modelled figures that have been mechanically reproduced.

A notable example of the way an artist can influence the look of a film is provided by *Alien* (1979). (At the time of writing there have been two sequels.) The grotesque, bio-mechanical imagery found in this

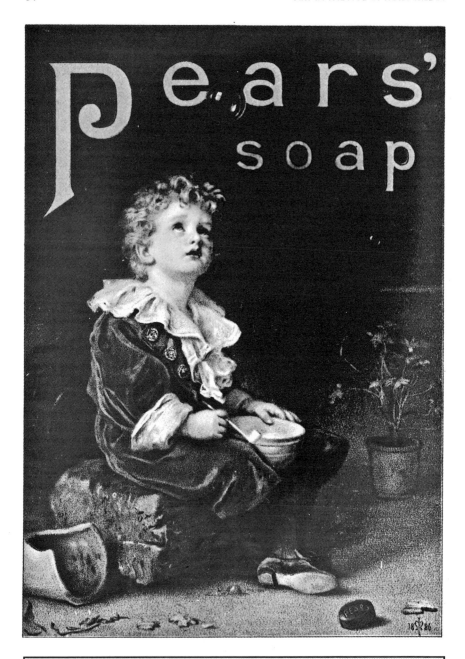

Advertisement for Pears' Soap, after Millais, 1887. Colour lithograph, 22.2 x 14.6 cm. Victoria & Albert Museum, London. 'Bubbles', the original oil painting, is still in possession of A. & F. Pears Ltd.

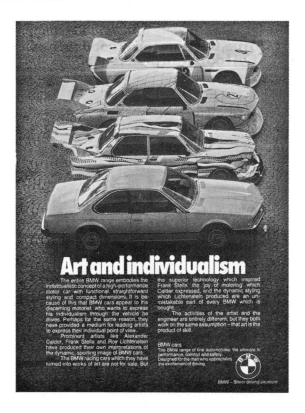

Art and individualism

The entire BMW range embodies the individualistic concept of a high-performance motor car with functional, straightforward styling and compact dimensions. It is because of this that BMW cars appeal to the discerning motorist, who wants to express his individualism through the vehicle he drives. Perhaps for the same reason, they have provided a medium for leading artists to express their individual point of view.

Prominent artists like Alexander Calder, Frank Stella and Roy Lichtenstein have produced their own interpretations of the dynamic, sporting image of BMW cars.

The BMW racing cars which they have turned into works of art are not for sale. But the superior technology which inspired Frank Stella, the joy of motoring which Calder expressed, and the dynamic styling which Lichtenstein produced are an unmistakable part of every BMW which is bought.

The activities of the artist and the engineer are entirely different, but they both work on the same assumption – that art is the product of skill.

BMW cars
The BMW range of fine automobiles: the ultimate in performance, comfort and safety.
Designed for the man who appreciates the excitement of driving.

BMW – Sheer driving pleasure

Advertisement for BMW cars, *Time*, 13 March 1978.

Three BMW racing cars have been decorated with designs by three noted American artists – Alexander Calder, Frank Stella and Roy Lichtenstein – in order to make them original, unique. (The advertisers were careful to select artists with distinctive styles.) Cars are mass-produced objects; thousands of identical cars exist, consequently thousands of individuals own the same model. Rather than admit this fact, the advertisers seek to persuade buyers that their choice of car expresses their individuality (and not group behaviour). Since the advertisers consider art to be the epitome of individualism, art is used to individualize the product. Paradoxically, the decorated cars are not for sale: they have become 'works of art' and are therefore 'priceless'. Thus, the fact that works of art – just as much as cars – are commodities under capitalism is denied. Another paradox: the modern car is normally undecorated because it is manufactured according to the modernist principle 'form follows function', which itself derived from engineering. The addition of ornament by artists is anachronistic because it attempts to endow the mass-produced, engineered object with the qualities of a hand-crafted object.

It is the function of ideology to disguise contradictions within society. This advert attempts to reconcile the irreconcilable: art and industry, individualism and mass production.

popular space-horror movie was the work of the Swiss artist Hans Rudi Giger (b. 1941). In 1981 he also collaborated with the American popular singer Debbie Harry, formally of Blondie, to make a promotional video and he designed the controversial record cover for her first solo album entitled 'Koo Koo'.

H. R. Giger, study for the monster that appeared in the film *Alien* (20th Century Fox), directed by Ridley Scott, 1979.

There are times when the mass media cannot – for reasons of censorship – obtain photographs and films of important events. At such times they have to fall back on pre-industrial methods of representation. For example, during the 1982 war between Britain and Argentina over the Falkland Islands, the British news media experienced a frustrating dearth of pictures. To fill the image-gap Independent Television News commissioned a series of action illustrations from Bob Williams, who had to rely on his imagination. (The Imperial War Museum in London also sent an official war artist – Linda Kitson – to record her impressions.) Another example of drawings being used on TV and in the press are the artists' impressions of criminals based on descriptions provided by victims or witnesses.

The art of drawing continues to flourish in the cartoons and strips that appear in virtually all newspapers and in specially published comic books and magazines. What distinguishes such drawings from those made by fine artists is that they are produced with mechanical reproduction, mass circulation and popular appeal in mind. Cartoons and comics also tend to have a shorter life than fine art drawings. This means they are generally excluded from the collections of major art museums no matter how excellent their

Bob Williams, action illustration for Independent Television News, 1982. Felt-tip pen drawing.

draughtsmanship. (Many cartoonists have satirized modern art as if in revenge for their lower, cultural status.) Nevertheless, original drawings and artwork are bought and sold via specialist outlets. Mel Calman, a noted British cartoonist, is the proprietor of the Cartoon Gallery in London. He thinks the omission of cartoons from major art collections is unjust and so, as vice chairman of the Cartoon Art Trust, he is campaigning for the establishment of a National Museum of Cartoon Art. Several museums, study centres and international, annual festivals/conventions devoted to comics already exist in countries such as Belgium, France and Spain.

– – –

Today's mass media have a voracious appetite for news, information and images which are processed in various ways and then regurgitated. Of course, only a small part of this enormous throughput concerns the fine arts. Nevertheless, we have only to consider the case of Van Gogh to gauge the extent of the media's influence: his life story, letters, paintings and drawings have formed the basis for a spate of exhibitions, art-history books and catalogues, periodical and press articles, biographies, films, plays, TV and radio programmes, cartoons, advertisements and reproductions in their millions.[4] As a result, Van Gogh has become a world famous artist. Van Gogh himself may well have welcomed this development because he certainly wanted to reach a popular audience. However, I think we can be sure he would have wanted people to respond to his work, not pry into the tragic incidents of his private life.

Undoubtedly, the mass media – along with arts councils and public museums – have brought about a significant democratization of the high culture of the past. For decades British television channels have transmitted arts programmes and series that have greatly contributed to the public's knowledge and understanding of traditional and contemporary fine art, and to the marked increase in the number of people visiting museums. Yet there are some negative aspects to these developments: the museums and the media detach works of art from their physical, social, historical and religious contexts; and reproduction alters the look of originals. When illustrating an advert, a Van Gogh is made to serve commercial purposes that distort its meanings and debase its values. Those looking at original paintings may well find that all the secondary material and imagery obscures rather than clarifies their aesthetic experience.

Furthermore, the treatment contemporary avant-garde art receives in the mass media is not uniformly sympathetic. Although modern art is now the official culture of developed societies, radical and experimental contemporary art still poses problems for the mass circulation newspapers. Such art generally receives serious consideration in the quality press but in the popular press it is either ignored or pilloried – witness the 1976 reaction of Britain's *Daily Mirror* to Carl Andre's minimalist sculpture. The very distinction between 'quality' and 'tabloid' newspapers itself reflects long-standing differences of social class, education and taste in Britain.[5]

Front page of the *Daily Mirror*, 16 February 1976, with an article attacking the brick sculpture 'Equivalent VIII', 1966, by the American artist Carl Andre, purchased by the Tate Gallery in 1974 for an estimated £4,000.

Normally the cultural divide between the popular press and avant-garde art circles is so wide that neither acknowledges the existence of the other. However, in 1976 an exception to this rule occurred. A recession in the British economy alerted the popular press to the news value of stories exposing wasteful public expenditure. In condemning the Andre sculpture the popular press was able to pander to the philistinism of its readers in respect of modern art, while simultaneously gaining moral kudos as the watchdog of the public purse. The British art establishment, used to a condition of autonomy, was disturbed to find itself subjected to public ridicule from such an unexpected quarter. Its defence of Andre's work was unconvincing: the challenge that the emperor had no clothes was, in this instance, difficult to refute. This incident was of value in highlighting the immense gap which exists between the taste of the majority and the taste of the minority in British society.

In the opinion of some critics, contemporary art is being changed for the worse as a result of its incorporation within a system of entertainment, business sponsorship, publicity and tourism. Even artists have expressed concern about this process. For instance, in 1992 the Belgian artist Jan Vercruysse wrote a critical article about the organization and hype surrounding the Documenta exhibition at Kassel in Germany (one of the world's largest exhibitions of contemporary art that now attracts tens of thousands of middle class tourists to Kassel). Vercruysse argued:

> ... our culture is sliding into a culture of spectacle. Media and spectacle-orientated performance and events with reference to art create a *negative energy*, turning art into an 'art event', a spectacle to be consumed for and by everyone. The attention for art roused by spectacle is bad since it is not founded on content, but on the effect of its media existence. I contest the idea that all these media operations 'serve' art, resulting in an increase of real interest for art from more and more people.[6]

In my view, Vercruysse's fears are confirmed by a media pseudo-event designed to popularize contemporary British art – namely, the annual Turner Prize competition currently sponsored by Channel 4 Television. Four shortlisted artists compete with one another for a prize of £20,000. The winner is announced at a ceremony held at the Tate Gallery; simultaneously a television arts programme is transmitted. Serious, art-historical television programmes about significant works of art – such as those produced by the Open University – can help to further the public's appreciation of art but not this kind of publicity gimmick.

Vercruysse's analysis is probably correct, but the clock cannot be turned back. Art cannot return to a pre-industrial situation in which there were no mass media to contend with. A radical response to media events is to use them in ways not intended by their organizers. In 1991, for example, the Turner Prize ceremony at the Tate Gallery was picketed by art students protesting against Tory government cuts in their grants and in the funding of art education. When Robert Hughes, the art critic engaged to present the prize-winner's cheque, appeared on television he drew attention to the student protest and he supported their cause.

Having reviewed the various ways in which the mass media make use of fine art, it is now necessary to examine, in more detail, the impact of industrialization – in the form of mechanical reproduction – upon art's production and reception.

4. MECHANICAL REPRODUCTION
AND THE FINE ARTS

Contemporary works of art, and those from the past which have survived the ravages of time, currently exist alongside billions of images produced and reproduced with the aid of machines. What are the consequences for fine art of the technological revolution that has taken since place since the invention of photography in the nineteenth century?

One obvious result is the emergence of a secondary system of recording and dissemination which is now more extensive and powerful than the primary system on which it is based: through the agency of colour illustrations in art books and magazines, documentary films and television programmes about art, advertisements featuring familiar masterpieces, three-dimensional replicas of sculptures sold in museum shops, etc., knowledge concerning the arts reaches more people than ever before.

Before the age of mechanical reproduction, duplicates of exceptional works of art were made by copying them by hand. Artists themselves sometimes produced several versions of the same painting or made replicas, but more often copies were made by followers, students, assistants, apprentices or forgers. The drawback of handmade copies is that they are labour-intensive, time-consuming and expensive; there are few of them and they are never exact. (Strictly speaking, copies are interpretations or 'translations' of the original.)

To be able to multiply an image or design for purposes of wider dissemination and/or profit has been an ambition of artists and others for centuries. In the ancient world two main methods of reproduction were known: first, impressions produced by stamping soft metals with an intaglio design enabled editions of coins and medals featuring the same image to be issued; second, by casting molten metal (gold, silver or bronze) via sand, wax or plaster moulds, smiths and sculptors were able to manufacture editions of three-dimensional objects. Such editions were small or limited in order to preserve a high standard of reproduction.

In Europe, from the fifteenth century onwards, images were printed on sheets of paper, using ink, presses and woodcut blocks and etched metal plates. Again, editions of prints were restricted in order to maintain quality. Subsequently, reproduction processes proliferated – line engraving, mezzotint, lithography, aquatint, carving machines capable of making three-dimensional facsimiles – until we reach the modern age of photo-mechanical and electronic methods (photography, cinematography, photocopying, tele-vision and videotape recording, computer-generated images). The latter methods have not entirely superseded the earlier processes, but colour images on the pages of magazines, on billboards and on cinema and TV screens certainly dominate. Even buildings can be reproduced: thorough photo-documentation makes it possible to reconstruct old buildings that have been destroyed by war or fire.

Reproduction is a topic that has been examined by a number of scholars.[1] Estelle Jussim's 1974 text *Visual Communication and the Graphic Arts* provides a close analysis of the various reproductive processes employed in the nineteenth century. Building on ideas first expounded by William Ivins in *Prints and Visual Communication* (1953), Jussim explained that all reproduction was a 'translation' from one medium into another and that such 'translations' relied upon graphic codes. These codes were particularly evident in engravings where the tones, forms and colours of a painting were rendered by means of black lines, dots and cross-hatchings. Since engraving was done by hand, a subjective, interpretative factor was inescapable; a black-and-white engraving of a painting was virtually a new work of art. Furthermore, as the examples illustrated in Jussim's book demonstrate, the same painting reproduced by five different processes resulted in five significantly different images.

Ivins believed that the invention of photography was crucial because, for the first time in history, reproduction without an intervening code – without the subjective handwork of the engraver – became possible. Jussim qualified this view by showing that codes did appear in photography: all photographs had a grain and the half-tone screen used during the printing of photos resulted in images made up of small dots of ink. According to Jussim, the medium appeared to be code-free because the grain and dots, generally occurred below the threshold of human vision.

In our society, photographs are generally considered to be more truthful and objective than drawings or paintings. The superior objectivity of the camera was the result of mechanizing and automating the recording of visual appearances; the modern photograph has a fine quality of resolution, but above all it is an *indexical* sign (light from the object being photographed alters the chemicals on the film to be developed, and therefore the resulting negative/print is a direct reflection of the external world). Photographs rapidly acquired a privileged status in our society: they came to be regarded as more reliable and accurate than images drawn or painted by the hand of a human being. (Passports carry photographs of their holders, not drawings.) The invention of photography was bound to precipitate a decline in the art of portraiture. Portrait painting has continued, but far more people possess photographs of themselves and their families than possess painted portraits.

There is a need, at this point, to distinguish between those works of art which are conceived of from the outset as one-off productions, and those which are conceived of from the outset in terms of an edition. In the first case there is an original which can be copied later, but whose character can never be exactly duplicated. In the second case there is no original, only a set of identical objects. It is obvious that lower unit costs are made possible with editions: the larger the edition, the cheaper each item is to manufacture. Artists face a choice: either they can decide to produce a few original works of art per year which then possess the values of rarity and handwork, and which must be sold to a collector or a museum at high prices, or they can decide to produce works of art in editions for the benefit of large numbers of people. Those who take the

second option are likely to be treated with disdain by the artworld because mass production is antithetical to that world – it is concerned with the rare and the exceptional, not the commonplace. Artists whose aim is to reach beyond the artworld will probably not care.

There is a third option which is acceptable to the art market: a print is conceived in terms of a *limited* edition. Once approved by the artist each print is numbered and signed. The metal plate or lithographic stone is then destroyed to prevent further, unauthorized prints being made. Ostensibly, the reason for small editions is to preserve a high standard of reproduction, but economic factors are also crucial, as is the necessity to preserve a distinction between fine art and outright industrial manufacture. Another solution to the original or edition dilemma can be found in the practices of artists like Bruegel and Hogarth: they painted canvases for wealthy buyers but they also had engravings based on the paintings made for those who could not afford the originals. The history of this subject has been explored in detail by Susan Lambert in her 1987 exhibition catalogue/book *The Image Multiplied: Five Centuries of Printed Reproductions of Paintings and Drawings*. As Lambert points out, the very conception of 'the original' depends on the existence of copies and reproductions.

Thus far, the examples cited have been mainly paintings or prints. Some consideration has to be given to sculpture because this is an art which does lend itself to production in terms of limited editions. Sculptures made from clay, wax, plaster and terracotta can be reproduced by being cast into bronze. Existing metal sculptures can also be recast via the technique called 'surmoulage', a method of casting using moulds. Sculpture's reproductive potential has been exploited by unscrupulous dealers and speculators seeking profit from the rising prices of modern masters: casting and recasting has taken place without the artist's authorization; also, some works have been changed by being enlarged or reduced in scale, or cast in materials not envisaged by the artist. At the same time, the real democratic potential of reproduction – which surfaced briefly in the vogue for multiples that occurred in the late 1960s – has generally failed because the mass production of art in 'unlimited' editions has been regarded as a contradiction in terms.

To generalize: mass replication via modern manufacturing methods undermines the whole value-structure of the fine arts. Mechanization threatens to destroy their mystique. For this reason, the industrialization that marked the beginning of the modern era provoked a debate among artists and critics, such as William Morris and John Ruskin, about the impact of the machine on art. Machines have been portrayed by some theorists as the deadly enemy of art, despite the fact that they have been devised by human beings to meet their needs. Artists have always used tools of various kinds, and machines are surely complex tools. If it was legitimate for Vermeer to use a camera obscura in order to produce a painting, then it is legitimate for Richard Hamilton to use a Quantel Paintbox for the same purpose.

Without doubt the key twentieth-century text discussing these matters was Walter Benjamin's 1936 essay 'Das Kunstwerk im Zeitalter seiner

technischen Reproduzierbarkeit'. (This is usually translated as 'The Work of Art in the Age of Mechanical Reproduction', but a more precise version is 'The Work of Art in the Age of its Technical Reproducibility'). To summarize Benjamin's arguments: the traditional work of art had a presence or *aura* that was the consequence of its authenticity, its uniqueness, and its existence in one geographical location. Although in principle works of art had always been reproducible, the advent of mechanical reproduction was unprecedented. Its impact was to destroy the work's aura, to emancipate it from tradition and ritual (that is, magic and religion).

Benjamin concluded that the invention of photography had transformed the nature of art. Unlike some critics, Benjamin did not regret these developments because he believed new technology had a progressive potential. It made possible the democratization of culture and artistic production. According to Benjamin, when art ceased to be based on ritual, it became based on another practice, namely, politics.

Today, original works of art are more likely to be encountered in museums and galleries than in churches. Benjamin argued that 'cult value' had been replaced by 'exhibition value', but many museums remind viewers of temples or churches with the result that objects in museums are treated with quasi-religious awe. Glass cases or screens, 'Do not touch' signs, security guards and an awareness of high monetary values, all contribute to the impression that these are precious objects in contrast to the postcards of the same objects on sale in the museum's shop. Arguably, by taking works of art out of circulation, museums *eternalize* them. (One critic has compared museums to national banks that hold stock of gold bars in order to sustain the value of the currency outside.) Not only is aura still a function of originals, it has even been extended – courtesy of museums and auction houses – to those products which, it was predicted, would destroy aura altogether – namely photographs. Museums now collect and mount exhibitions of photographs. Some prints of photographs by 'master' photographers are regarded as unique or very rare and command high prices in the salerooms.

After World War Two Benjamin's ideas were developed by such writers as André Malraux, Edgar Wind and John Berger. Malraux, in the first part of his book *Voices of Silence* (English edn. 1954), put forward his museum-without-walls theory. His argument was that: (a) museums had irrevocably altered the way in which art is experienced; (b) the millions of art reproductions constituted a 'musée imaginaire' (a museum of the imagination, hence a museum-without-walls); and (c) it followed that the imaginary museum continued the process set in motion by the physical museum – making available to the private individual the art of all times and of all peoples. There were, however, certain negative aspects to the museum-without-walls. The viewer had to be content with small-scale substitutes rather than original works of art. Unless they were accompanied by a written commentary, the images were decontextualized. As far as the owner of reproductions was concerned, the museum-without-walls had a flattening effect: the manifold material, social and historical differences between works of art that had been produced in different places and periods were neutralized. An

impression of homogeneity and universality was generated in respect of objects that were, in reality, far more disparate than they appeared in reproductions. Decontextualization, whether via museums or reproductions, produced a stress on the form and style of artefacts rather than their content, meanings and original social functions. (Witness, for example, the writings of the formalist critic Clive Bell.)

Wind, in his 1960 Reith lecture 'The Mechanization of Art', re-examined the idea that photography and reproduction have transformed the way we see art objects. Because 'the medium of diffusion' tended to take precedence over direct experience of the object, Wind argued, art was being changed retroactively. For example, colour reproductions and prints fostered a rawness of vision, a crudity of taste, which influenced the way original works of art were received. (Viewers who become familiar with a painting via inaccurate, garish colour reproductions may well find that when they finally encounter the original, they experience a sense of anti-climax because the original appears dull in comparison.) Wind also contended that reproduction was having an influence on living artists – they were producing new work in one medium with a second medium of diffusion in mind, that is, novels were being written with a view to being filmed, canvases were being painted with a view to being reproduced as colour illustrations in art magazines. It is certainly the case that contemporary art which reproduces badly is less likely to be featured in art books and magazines and therefore less likely to become well known.

In the twentieth century not everyone has agreed that the benefits of reproductions of works of art outweigh their disadvantages. One of the last bastions of resistance to the spread of reproductions was the Barnes Foundation, a superb collection of modern art established in 1922 by the eccentric chemist and businessman Dr Albert C. Barnes (1872–1951). Barnes used his fortune, acquired by selling an antiseptic called Argyrol, to buy African sculptures and paintings by Van Gogh, Cézanne, Renoir, Matisse, Picasso, Soutine, etc. His collection was housed in a purpose-built gallery at Merion, near Philadelphia. Barnes believed passionately in the education of 'plain people' (especially black, working-class Americans) through direct exposure to great works of art. He was contemptuous of academics, experts and the art establishment and refused them access to his collection. Only once, in 1942, did he allow his treasures to be photographed in colour. The negatives were later destroyed by Violette de Mazia (1899–1988), Barnes's chief collaborator, because she believed colour reproductions distorted the originals. No catalogues or inventories were provided either. It was not until 1992 that a photographic documentation of the Barnes collection was undertaken.

The reproduction of art was a central theme of John Berger's four-part television series *Ways of Seeing* (BBC 2, 1972, produced and directed by Michael Dibb). Indeed, programme one was a reprise of Benjamin's essay. Articles based on the scripts of the arts programmes appeared in *The Listener* and a paperback version was later published by Penguin Press. (At the time of writing this book is still in print; several hundred thousand copies have been sold.)

John Berger as he appeared in *Ways of Seeing*, BBC 2, 1972. Photo by Simon Bradford, reproduced courtesy of the BBC.

In the years that followed, *Ways of Seeing* was screened in many artschools around the world in the form of 16 mm. films and videotape recordings. The fact that it appeared in several different forms exemplified one of Berger's cardinal points, namely, that reproduction methods make it possible to disseminate the same words and images though a variety of media. *Ways of Seeing* was highly influential; it provoked much commentary and it influenced artists as well as theorists.[2]

Berger reiterated Wind's view when he argued that art reproductions transform the uniqueness/meaning of originals by making them the prototypes of reproductions. He also pointed out that pictorial reproduction enabled images and details to be detached from their primary physical supports. Once detached, they became 'a species of information' which, through the processes of montage and editing, entered into discourses and lent themselves to uses their makers never envisaged. Again, the manipulation of images derived from the history of European art in *Ways of Seeing* exemplified the point that Berger, like Benjamin before him, saw a radical political potential in the new situation of an 'environment' or 'language' of images.

During the 1960s Marshall McLuhan's theories about literature, the visual arts and the mass media became fashionable. Though his many books are too long and diffuse to summarize here, their central points are pertinent. McLuhan believed that the invention of major new media altered

our existing sensory modalities and, furthermore, that new media changed the standing and interrelationship of older media, for example, by upsetting the balance of power between them, by taking over some of their social functions, by endowing them with a classic or art-like status.

Books on popular and mass culture abound but we still await a comprehensive history of the mass media and the technologies for recording and transmitting images and sounds. Such a history is needed before the full story of the interaction between art and the mass media can be told. However, one medium's relation to fine art has been documented in some detail, that is, photography's. Three surveys can be cited: Aaron Scharf's *Art and Photography* (1968), Van Deren Coke's *The Painter and the Photograph* (1964) and A. Grundberg's and K. Gauss's *Photography as Art: Interactions Since 1946* (1987).

When photography first appeared some artists predicted it would cause the death of painting. Photography certainly had negative effects – it replaced miniature portrait painting, for example – but the activity of painting did not cease altogether. In fact, photography stimulated painting in several ways: pictures of horse races became more accurate because the camera showed how horses' legs really moved; pictorial compositions became more daring in response to snapshots whose framing edge cut across figures in dramatic ways; some painters left the task of recording reality to the camera and moved towards symbolism and abstraction; others began to copy photographs and to take photos instead of making sketches.

From 1839 onwards painting entered into a dialogue with photography which continues sporadically even to this day. But while photography by itself did not bring about the demise of painting, the subsequent proliferation of image-generating media did have a profound impact on its status and social function. For instance, its virtual monopoly over the production of colour images was broken. In terms of speed, quantity and verisimilitude, painting was out-distanced. Today people turn to newspaper photos and TV news programmes for images showing the latest events, not to painting. The art of drawing in the form of caricatures and cartoons has fared better because cartoonists work quickly and their drawings lend themselves to reproduction in the press, comics and magazines.

In the age of mass media, the labour-intensive practice of painting may well seem obsolete or at least archaic. However, the impersonality and standardization of machine-made goods has also given rise to a taste for artisan values, for the crafts. The handmade and subjective/individual qualities of paintings, therefore, makes them desirable to many people. It is also worth stating that however accurate a colour reproduction of a painting is, it always lacks the sensuous materiality and surface texture of the original. Lovers of the fine arts can always argue that they supply aesthetic and intellectual experiences that no mass media product can entirely supplant.

But what of the contemporary artist who wishes to exploit the new technologies of reproduction for ideological-political ends? To answer this question we shall have to return to the writings of Walter Benjamin. The essay in which he discussed this topic was 'The Author as Producer' (1934).[3] Benjamin argued that social relations are determined by the

relations of production, therefore the committed artist should attempt to revolutionize them. It was not sufficient for artists to manifest a correct (that is, left-wing) political tendency in their work; they also had to develop a progressive artistic technique and a progressive attitude towards the means of production. In other words, artists should not simply *supply* an existing apparatus of production without simultaneously trying to change it in the direction of socialism. What artist-intellectuals and factory/office workers had in common was that both groups worked and both found themselves situated within certain relations of production. Artists could best demonstrate their solidarity with the working class by means of struggle in that sphere. Benjamin called this process 'functional transformation'.

As a concrete example of what he meant, Benjamin cited the experimental newspapers of the Soviet Union. He pointed out that traditional literary forms such as the novel were not eternal, and argued that the newspaper was a modern medium of mass communication socialist writers could use to reach a wide audience. Furthermore, the new Soviet papers were being produced jointly by intellectuals and workers; the barriers between professionals and amateurs, writers and readers were being broken down.

Benjamin also recommended that a writer's works and practice should have an *organizing* function: 'a writer's production must have the character of a model: it must be able to instruct other writers in their production and, secondly, it must be able to place an improved apparatus at their disposal.' Brecht's epic theatre was an exemplar of the kind of artistic practice Benjamin had in mind. Twentieth-century examples taken from the visual arts will be considered in Chapter 7.

– – –

Many living artists are aware of the theoretical debate concerning the relation between art and mechanical reproduction, and some of these artists have made works of art that comment on the matter. Two examples will be cited: a sculpture by Julian Opie and an installation piece by Allan McCollum.

Opie (b. 1958) is a British artist, trained at Goldsmith's College, London, who first came to prominence in the early 1980s as part of the 'New British Sculpture' tendency. At that time his work consisted of witty, colourful constructions made from cut and welded steel that had been crudely painted by hand. Loose in form and pictorial in content, Opie's constructions disregarded the conventions associated with the modernist sculpture of Anthony Caro. 'Eat Dirt Art History' is a wall sculpture about the condition of art in the age of mechanical reproduction. It provides a schematic history of art from Stonehenge to minimalism in terms of a cascade of images fluttering down from an art book. The work has a circular logic: the end of the sculpture refers back to its beginning – the final (meta-linguistic) illustration depicts the volume that is the source of all the previous images. By making reproductions into sculpture, Opie sought to invert the process by which art ends up as reproductions in art books.

Julian Opie, 'Eat Dirt Art History', 1982. Oil paint on steel, 150 x 150 x 70 cm. Private Collection, Switzerland. Photo courtesy of the Lisson Gallery, London.

During the 1980s Allan McCollum (b. 1944), an American artist based in New York, produced an intriguing body of work prompted by, and about, the conditions under which art is produced, exchanged, consumed and mediated within a society based on industry and commerce. 'Perpetual Photos', a series he started in 1982, consisted of photographs of paintings

that appeared on TV. Snaps were taken of scenes in which framed paintings could be seen hanging on walls in the background; details showing the paintings were then enlarged to normal size. So, McCollum's starting point was the art of painting as reproduced by a mass medium. His view was that such TV images were emblematic of the 'background' character of works of art: 'their real place in the world is to be in the background functioning as a prop, or a token, and to remain secondary to the social behaviour of making, buying and selling art, and of having art and looking at art.'[4] The enlargement process generally resulted in images that were blurred and abstracted to the point where their content was unintelligible; they became 'ghosts of the original artwork'.

Another series relevant to this text was called 'Individual Works' (1987–). The works in question were small plaster objects produced by combining casts of elements of ordinary household objects (such as bottle caps and toys); these were then painted with blue enamel so that they looked like plastic (another set was coloured pink). As many as 10,000

Allan McCollum, 'Individual Works', 1987–88.
Installation view of John Weber Gallery, New York, in 1988 showing 10,000 cast objects each approximately 5 x 12cm., enamel on plaster/hydrocal.
Photo by F. Scruton, reproduced courtesy of the John Weber Gallery.

of these objects were produced by hand by teams of assistants in craft workshops and then presented *en masse* on flat surfaces covered with black velvet.

At first glance the objects looked as if they were identical but on closer inspection it emerged that no two were exactly alike. McCollum's point was that assembly-line type production can result in batches of goods that are both very similar and yet marked by difference: 'objects both mass produced *and* each unique at the same time'. Automobile manufacturers also vary their basic models in order to offer customers a measure of choice.

'Individual Works' were extremely paradoxical things because although they looked functional they weren't; although they looked as though they had been manufactured by machine they had been made by hand (but not necessarily the artist's hand). Their forms, however, had been copied from machine-made goods. Their status as art was also uncertain: they were three-dimensional objects made from a material conventionally associated with sculpture, but they resembled industrial goods more than traditional sculptures. They were shown in private art galleries but proved virtually unsaleable because individual ones were too small, while altogether there were too many.

The objects had no obvious bases – they simply rested on their sides. They seemed to be made so that they could be held in the hand and circulated – passed from hand to hand – like most goods and works of art. McCollum's displays somewhat resembled the accumulations of similar artefacts found in factories, supermarkets and ethnographic museums. Indeed, he once worked in a museum and his approach to art is quasi-anthropological. By presenting the viewer with a sea of objects, his intention was to counter the alienation associated with high culture artefacts (out of reach of the majority of people because of their rarity and expense) by basing the value of his work on 'a model of abundance and availability', rather than one of 'scarcity, uniqueness and exclusivity'.

As McCollum himself has explained, his intention in making 'Individual Works' was to challenge what he regards as the false dichotomies that structure our world: art and industry, handwork and machine production, the unique and the common, the irreplaceable and the expendable. His objects were hybrids that bridged existing categories. This is why they were so odd, ambiguous and difficult to place.

McCollum's aims were admirable but understanding his *oeuvre* required familiarity with the theoretical discourse surrounding contemporary art. One wonders how much of his utopian project was communicated to visitors to his exhibitions held in European public galleries in 1989–90.

5. HIGH CULTURE: AFFIRMATIVE OR NEGATIVE?

Some of the most provocative and influential writers on art, aesthetics and mass culture in the twentieth century have been the neo-Marxist theorists associated with the Frankfurt School of philosophy, that is, Theodor Adorno, Walter Benjamin, Max Horkheimer, Leo Lowenthal and Herbert Marcuse. Some of Benjamin's ideas have just been discussed; this chapter will concentrate on certain ideas formulated by Marcuse and Adorno.

In a 1937 essay Marcuse defined 'affirmative culture' as follows:

> that culture of the bourgeois epoch which led in the course of its own development to the segregation from civilization [by 'civilization' he meant the material life process] of the mental and spiritual world as an independent realm of value that is also considered superior to civilization. Its decisive characteristic is the assertion of a universally obligatory, eternally better and more valuable world that must be unconditionally affirmed: a world essentially different from the factual world of daily struggle for existence, and yet realizable by every individual for himself 'from within', without any transformation of the state of fact. It is only in this culture that cultural activities and objects gain that value which elevates them above the everyday sphere. Their reception becomes an act of celebration and exaltation.[1]

Great bourgeois art, Marcuse contended, represented the ideals of happiness and beauty which bourgeois society claimed it could realize for all humanity but which it was, in practice, incapable of providing. (Imagine a starving African child viewing a reproduction of a Dutch seventeenth-century still life depicting meat, fruit and wine in abundance.) On the one hand, therefore, such art keeps a vision of utopia alive, but, on the other hand, 'by exhibiting beauty as present' it 'pacifies rebellious desire' (hence it would appear to be negative and affirmative simultaneously).

Marcuse opposed the diffusion of bourgeois art among the masses because this would merely confirm the social order that such art affirms. He called instead for the abolition of affirmative culture. From this essay it is clear that Marcuse did not think that art could play a radical, critical role within bourgeois society, even though there are many examples of artists – Courbet, Daumier, Goya, Grosz, Heartfield, Kollwitz, etc. – who have in fact performed such a function.[2]

Marcuse's essay on affirmative culture ignored the emergence of the mass media – also a consequence of the rise of bourgeois society – and so, for him, the question of the relationship between fine art and mass culture did not arise. However, other Frankfurt School theorists – Horkheimer and Adorno – did tackle the issue. In their view what was crucial was not so much the particular character of art and mass culture considered in isolation, but the division which assigned them to different realms.

Commenting on the division between high and low culture, serious and light art, Horkheimer and Adorno wrote:

> Light art has been the shadow of autonomous art. It is the social bad conscience of serious art. The truth which the latter necessarily lacked because of its social premises gives the other a semblance of legitimacy. The division itself is the truth: it does at least express the negativity of the culture which the different spheres constitute. Least of all can the antithesis be reconciled by absorbing light into serious art, or vice versa. But this is what the culture industry attempts.[3]

This quotation, typical of the Frankfurt School philosophers, reveals their acute understanding of certain social problems on the one hand and, on the other, their profound pessimism as to what can be done about them. If the abolition of existing cultural hierarchies and categories requires a social revolution, and that revolution is endlessly deferred, what do socialist artists do in the meantime? Can art and artists contribute to a radical transformation of society? Is it possible for sectors of the working class to evolve a culture of their own, a culture distinct from that provided by the mass media? One suspects that only Walter Benjamin among the thinkers of the Frankfurt School would have given positive answers to these questions.

Adorno was sceptical about the oppositional value of committed or partisan art. In his view advanced works of art – for example, the music of Arnold Schönberg – served a critical, negative function by virtue of their autonomy from everyday reality, their functionlessness and their uncom-promising aesthetic form. Modern atonal music was alienated and alien-ating: the general public found its dissonances repulsive because such sounds testified to the truth of their social condition. According to Adorno:

> In our totally organized bourgeois society, which has been forcibly made over into a totality, the spiritual potential of another society could lie only in that which bears no resemblance to the prevailing society.[4]

This line of argument, it seems to me, incorporates defeat from the very outset: the most oppositional works of music are those which displease the majority of listeners; therefore, the smaller the work's audience, the greater its political radicalism! It is obvious that the only audience for such extreme works would be intellectuals like Adorno himself. Of course, there is a risk that a socialist artist who seeks to incorporate popular values in order to appeal to a wider audience will make concessions to prevailing norms of thought. It is this danger which underlies Adorno's observation that 'just as theory as a whole goes beyond the prevailing consciousness of the masses, so too must music go beyond it'.[5] However, what this comment fails to consider is the possibility that difficult theory can be simplified and popularized, and the possibility, which Brecht perceived, that an advanced work can in time *become* popular.

Adorno was on much surer ground when he argued that a valuable

critical function was performed whenever bourgeois fine art made social contradictions visible:

> A successful work ... is not one which resolves objective contradictions in a spurious harmony, but one which expresses the idea of harmony negatively by embodying the contradictions, pure and uncompromised, in its innermost structure.[6]

Pablo Picasso's famous painting 'Les Demoiselles d'Avignon' may be cited as an example taken from the visual arts. Although executed as long ago

Pablo Picasso, 'Les Demoiselles d'Avignon', 1907. Oil on canvas, 2.43 x 2.33 m. Museum of Modern Art, New York (acquired though the Lillie P. Bliss bequest).

as 1907, this canvas still retains a glimmer of its original shock value. One reason for this is surely that the 'primitive' art elements – particularly the mask-like faces of the two figures on the right – are not harmoniously integrated into the composition. As a result, the viewer has difficulty reconciling the various parts and styles. Modernism was considered, by its advocates, as the style of the future. Yet, paradoxically, this forward-looking movement was to be based, in part, upon ancient and 'primitive' styles (that is, pre-historic art, tribal art, peasant and folk cultures, child art, etc.). The nineteenth-century vogue for collecting tribal artefacts was a cultural phenomenon closely linked to Europe's colonial and imperialist exploitation of vast areas of the globe. In this way Europe renewed itself both spiritually and economically. Many European artists admired the skills of African carvers. They collected tribal artefacts and were fascinated by the strange forms and symbolic power of African sculptures. They were among the groups of western intellectuals who preserved African material culture rather than destroying it; even so, they were citizens of the very colonial powers responsible for the exploitation and destruction of native cultures.

Picasso's proto-cubist painting embodied the collision of two alien cultures and traditions: first, the female nude study of classical European art (itself subverted by depicting the nudes as whores in a brothel), and second, the tribal sculpture of Africa. Picasso's 'failure' to produce a harmonious composition was salutary because the clash of styles made visible the mutually contradictory nature of the two cultures. Europe incorporated the 'primitive' but it remained undigested, a foreign body within western culture.[7]

Feminist critiques of 'Les Demoiselles' pay particular attention to the depiction of females. In contrast to the reading of the painting given above, Carol Duncan perceives a deep structural unity beneath the stylistic contradictions. She has argued that the European male artist's obsession with images of naked women and *femme fatales* reflects patriarchal society's equation of woman with nature, instinct and sex. (Man, on the other hand, is equated with art and culture.) According to Duncan:

> The 'Demoiselles' pursues and recapitulates the Western European history of the woman/nature phantom back to her historical and primal sisters in Egypt, ancient Europe and Africa in order to reveal their oneness. Only in primitive art is woman as sub- and superhuman as this. Many later works by Picasso, Miró and De Kooning would recall this primal mother-whore. But no other modern work reveals more of the rock foundation of sexist antihumanism or goes further and deeper to justify and celebrate the domination of woman by man.[8]

Adorno's conviction that art should represent social contradictions may be taken as a prescription that artists should be realists, that they should tell the truth about the world in which they live. (This does not mean, however, that to be realists they have to adopt a naturalistic or photographic mode of representation.) Another valuable function that artists can perform is that of reflecting upon the nature of pictorial representation. Artists – being as it were specialists in representation – are in a

unique position to expose the ways in which imagery directs and manipulates people's thoughts and emotions. In short, the socialist artist ought to engage with the politics of representation as well as the representation of politics.

Finally, in regard to the question of the diffusion of bourgeois art among the masses, there is surely no reason to agree with Marcuse on this matter. The pleasures of high culture should not be confined to the middle class and the intelligentsia. The art and architecture of all past ages should be made widely available and accessible, especially since public buildings and collections are preserved at the expense of all taxpayers. Furthermore, the monuments of the past were not only the achievements of artists and wealthy patrons – often, teams of labourers and skilled artisans were also involved.

What is essential, however, is that any diffusion should go beyond mere art appreciation and unreflective celebration. Aesthetic enjoyment needs to be supplemented by knowledge about the work's content, the meanings and significance it had for the people at the time it was made, the social and historic context within which it was produced, in order to promote a critical and historical understanding of art. (This is the goal social historians of art have set themselves.) Without such knowledge, appreciation is likely to be restricted to the work's overt content and its formal aspects. The pleasure that tourists take in Ancient Egyptian, Greek and Roman architecture, wall painting, sculpture and pottery should be tempered by an awareness that these were all slave societies. Cultural treasures, Benjamin reminds us, 'owe their existence not only to the efforts of the great minds and talents who have created them, but also to the anonymous toil of their contemporaries. There is no document of civilisation which is not at the same time a document of barbarism'.[9] When visitors to Rome pause to admire the magnificent structure of the Colosseum, they should also recall that this was an amphitheatre in which human beings and animals were killed as a form of popular entertainment.

As far as contemporary artists engaged in cultural struggle are concerned, the Frankfurt School's writings on art and mass culture are valuable in terms of deepening theoretical understanding, but they are less useful in terms of actual practice. In this respect, it is more helpful to consider the artistic practices evolved by leading socialist artists, such as John Heartfield, Käthe Kollwitz and Diego Rivera. To a limited extent this is undertaken in Chapter 7. Before then, however, it will be necessary to update the Frankfurt School's analysis by reviewing developments signified by the terms 'cultural pluralism' and 'post-modernism'.

6. CULTURAL PLURALISM AND POST-MODERNISM

Discussions of the arts, design, fashion and sub-cultures during the late 1970s and early 1980s were notable for the frequency with which the terms/concepts 'pluralism' and 'post-modernism' occurred. Before these concepts can be defined it will be necessary to examine, briefly, the earlier term/concept 'modernism'.

Modernism was an aesthetic ideology which developed during the nineteenth and twentieth centuries and which informed the thinking and practice of many radical artists. Modern architecture, art and design encompassed a variety of movements, styles and groups. While they did not all share the same checklist of essential characteristics, certain assumptions and principles did recur:

1. Modernists reacted against the blandness, sentimentality and historicism of the academic art of the nineteenth century. They also rejected the stylistic anarchism and eclecticism typical of Victorian art and design on the grounds that a new age of machines and technology had been born which demanded a fresh beginning. Some modernists thought it was essential to create a new style, based upon such engineering principles as 'form follows function' and the dictates of new materials, machines and methods of construction; others believed that any art and design based on such principles would be styleless.

2. Since modernists believed a new age had dawned – the modern age – they insisted on a break with the past, with history and tradition. Experiment, innovation, novelty and originality became overriding values as far as the shock troops of modernism – the avant-garde – were concerned. 'Rebel, reject what has gone before' became the rule which new generations of artists were expected to obey. Soon this became a tradition in itself (which explains Harold Rosenberg's paradoxical phrase 'the tradition of the new').

3. Some modernists rejected ornament on the grounds that it was superfluous and a residue of primitive habits such as tattooing. They preferred geometric to organic forms; they espoused the values of simplicity, clarity, uniformity, purity, order and rationality. Others sought to rejuvenate modern art by appropriating the styles and motifs of 'primitive' and exotic arts (tribal art, Japanese art, the art of the insane, naive art, folk art, and so on).

4. Modernists rejected national, regional and vernacular styles. They favoured an international style because, in their view, the tenets of modernism were universally applicable.

5. Modernists were orientated towards the future. Some were inspired by utopian visions and socialist ideals and wished to sweep away the old order in order to create a brave new environment which would in itself improve human behaviour. They saw themselves as experts who knew

best, and as a consequence tended to impose their architectural and town planning solutions on the masses without regard to popular tastes, and without any consultation. Some impressive modern buildings were constructed but the cruder, cheaper, system-built tower blocks and public housing estates which appeared in the 1960s were hated by those condemned to live in them.

By the 1960s disillusionment with modernism had become widespread. On the one hand, it was a success: despite its revolutionary rhetoric, it had become the official culture of the ruling élites in western democracies; it was preserved in the very museums the futurists had sworn to destroy; it was now an orthodoxy. On the other hand, it had failed: the disasters of modern architecture; the rapid turnover of art movements and styles of little or no substance, typical of the post-1945 period. At this point, the term 'post-modernism' began to gain ground.

As Charles Jencks, a leading architectural historian and theorist, has explained, the term 'post-modernism' signifies a half-way house: it is clear what is being left behind, but it is not yet clear what is replacing it.[1] (The label does not supply any information about the characteristics of the works subsumed by it.) Jencks went on to argue that in the post-modern era, modernism continues – he employed the expression 'late modernism' – but it loses its dominant position as *the* authentic style of the modern age and becomes simply one style among a range of styles from which artists can choose.

What then were the recurrent features of post-modernism? As one might expect, they reversed or modified many of the tenets of modernism:

1. The modernist idea that there was only one authentic style for the modern age was rejected in favour of the idea that a *plurality* of styles – some old, some new – existed. Eclecticism, hybrid styles became fashionable again. No one style appeared to be dominant.

2. History and tradition – including the history of modernism itself – became available again; hence, 'retro-style', recycling old styles, the use of 'quotations' from the art of the past, parodies and pastiches of earlier works.

3. Ornament and decoration made a comeback.

4. Complexity and contradiction (the title of a highly influential book by the American architect Robert Venturi) and ambiguity were the values which replaced simplicity, purity and rationality. Mixtures of high and low culture, fine art and commercial art styles were encouraged as a way of producing buildings with multiple meanings capable of pleasing audiences with different levels of sophistication and degrees of knowledge.

5. In post-modern architecture and design, issues of form, space and function became less important. Architecture and design were regarded as 'languages' or sign systems capable of communicating messages. Pleasure was emphasized by means of playfulness, humour, bright colour and ornament.

6. A basic characteristic of art – intertextuality – was heightened in post-modernism. 'Intertextuality' is a term used mainly by literary theo-

Cover of *Architectural Design*, profile no. 4, 1977.
The building illustrated – Ni-Ban-Kahn – is a collection of 14 bars in an entertainments district of Tokyo. It dates from 1970 and was designed by Minoru Takeyama. Charles Jencks categorized the building as 'commercial vernacular' and claimed it reflected 'the commercial slang of the neighbourhood through its "building board" of colourful advertisements, neon, flags and graphic devices in a way characteristic of much post-modern architecture'. Also characteristic was 'the hybrid nature of the building: part commercial and vernacular but part, too, the geometric shape typical of what we know as modernism'. (*Sunday Times colour supplement*, 29 May 1977.)

rists to signify the fact that most literary texts allude to, cite or quote, other texts. Aesthetic pleasure is often to be derived from the inter-textual play of different styles within, say, a collage.

It is difficult to evaluate a cultural phenomenon before it has run its course. There were, however, a number of positive aspects to post-modernism. First, it was only sensible to recognize the unprecedented complexity and diversity of contemporary culture. (The urban environment had become multi-media, multi-racial, multi-cultural.) Second, it was only sensible to acknowledge that at any one moment various generations were alive, that artefacts and buildings dating from many different ages co-existed – the present contained within it a multitude of pasts – and that therefore any new project should pay some regard to this situation, should take history and tradition into account. The modernist architect's dream of building a brand new city on a greenfield site occurred only rarely (Brasilia was one example). Consequently, the task most architects faced was integrating the new with the old.

Art critics were bemused by the 1970s. Several critics claimed – and bemoaned the fact – that there were no major artists or art styles during the 1970s. They regretted 'the breakdown of the modernist mainstream' and were confused by the proliferation of styles. However, the demise of an autonomous realm of avant-garde art feeding off its own past was welcomed in some quarters. Much of the new art produced in the 1970s was not recognized as such by the artworld. One reason for this was that it deliberately absented itself from the milieu of the museum, the private gallery and the art market. For example, community murals appeared in the streets; they avoided becoming art commodities because they could not be purchased by a succession of dealers and collectors for the purposes of profit and investment.

An exhibition held in London at the tail-end of the decade merits some attention because it represented an attempt to overcome the élitism of avant-garde art, its isolation from everyday life, and to transcend the divisions between the various media and between high and low culture. The show, entitled *Lives: an Exhibition of Artists whose Work is Based on Other People's Lives*, was selected by the British painter and art college lecturer Derek Boshier and funded by the Arts Council of Great Britain. In his introduction to the catalogue, Boshier explained that his intention was to mount a 'popularist [sic] exhibition' defined as 'concerning or open to all or any people'. Since everyone can relate to images of other people without the need for specialist art-historical knowledge, Boshier argued, an exhibition with figurative-humanist content was bound to be popular. *Lives* presented a disparate collection of material: figurative paintings; a society portrait; a feminist work about rape; examples of photo-journalism; videos of people at work; information on fads; punk graphics; family photo-albums; art created as therapy in psychiatric hospitals; cartoons from national newspapers; torn-up photos collected from photo-booths, and so on.

Lives was a well-meaning effort on Boshier's part but it was surely

Duggie Fields with self-portrait, palette chair and Jackson Pollock-style carpet, 1978. Photograph by Chris Davies.

Fields is an obsessive British painter whose highly mannered work and lifestyle were hailed in the early 1980s as the epitome of post-modernism. Within a single canvas he combined figuration and abstraction, mixed styles and 'quoted' from the masters of modern art. However, he tended to borrow from art already debased by mass reproduction and interior decoration, rather than from the originals. His paintings often made use of popular images – such as the famous photograph of Marilyn Monroe with a billowing skirt – and colour photos of British royalty. Some critics thought Fields's paintings were fashionable kitsch, but his art was significant in the sense that it was symptomatic of 'the world of stylistic co-existence which reproduction and mass production brings about' (Rosetta Brooks, ZG (1), 1980). Fields's concern with style appealed to the Japanese (a style-conscious people). His work was collected by them and used to decorate Japan's nightclubs and shops. It was also used in TV and billboard advertising campaigns to promote 'Perky Jean', a brand of cosmetics.

Lives exhibition catalogue cover, 1979. Designed by Derek Boshier and Barney Bubbles.

It is possible to combine many different images, points of view, styles, and cultures in a collage (such as the one above), or in the name of a pop music group (Culture Club) or in an advertising campaign (United Colours of Benetton). Such representations have a utopian quality because they strive for unity and harmony while at the same time retaining cultural diversity and difference. They can also seem simplistic and over-optimistic because resolving antagonisms and contradictions is much more difficult to achieve in reality. Tragically, every nation, race, religion, ethnic group seems to value difference and at the same time to use it as an excuse for discrimination, hatred and killing.

significant he had been one of the leading pop artists in Britain during the early 1960s. The Arts Council was prepared to permit low-culture material to enter the Hayward Gallery providing it had been selected by an ex-pop artist. (In the event, the Council was not prepared to exhibit two left-wing political works chosen by Boshier. This incident revealed who the real selectors were.) Furthermore, a single exhibition juxtaposing different kinds of material could not by itself make much of an impression on the policies of the Arts Council, or change the character of the Hayward Gallery's clientele, or dismantle a hierarchy of culture that was centuries old.

Reporting the Zeitgeist

Two significant and influential magazines relevant to the theme of this chapter were founded in London in 1980. Nick Logan's style magazine *The Face* and Rosetta Brook's ZG (the latter subsequently published from New York). Both set out to cover a wide range of new art, design and pop culture. *The Face*, designed by the radical graphic designer and typographer Neville Brody, was more lavishly produced and more commercially successful than ZG, which was more theoretical in character and appealed mainly to art college lecturers and students.

In its first editorial ZG declared its intention to encompass 'diverse areas of cultural activity': new fine art, photography, film, fashion, video, performance, music, etc. However, this kind of list is misleading because many of the articles discussed material which cut across more than one category. After the first issue, ZG became thematic. Issue two, for example, examined the politics of sex and sado-masochism as represented in a variety of media.

The editorial discerned a situation of 'cultural fragmentation' and then continued: 'The loss of mainstream has given the impression of a culture of ghettos. This has meant the erection of false barriers between the different worlds of cultural experience.' It then argued: 'certain self-consciously borderline activities have grown up which aim to work *between* "styles" and their worlds ... Hybrid styles abound ... these new tendencies ... challenge our most deep-rooted orientations to the world whether they are in terms of art/culture, élite/popular or male/female'.

The magazine's strange, two-letter title was derived from the Hegelian term 'Zeitgeist', meaning spirit of the age. In other words, ZG claimed to reflect the essential characteristics of culture in the 1980s. Indeed, it claimed more than this: by adopting the name 'Zeitgeist' it asserted that it *was* the spirit of the age, and it *knew* that it was. ZG was indeed emblematic of post-modernism in that it was concerned to explore the gaps between media, styles, genres, etc., and to juxtapose articles in a collage manner, to play with culture and cultural analysis in a highly self-conscious way. Arguably, the quintessential post-modern artists were those who became aware of the situation of cultural and stylistic pluralism, and who decided to revel in

that situation (for example, Duggie Fields and David Salle), rather than those artists who simply worked unconsciously within one of the existing stylistic options.

Discussions of culture in the pages of ZG highlighted its dynamic character: visual signs are subject to changes of meaning and association through time, from generation to generation; they can be endlessly recontextualized. For example, the swastikas worn by punks in combination with various other, unrelated emblems, did not signify 'I am a neo-Nazi' but rather 'I like this sign's aesthetic power. There is a taboo against wearing it which I want to break. It has great shock value.' To employ signs in this way certainly called attention to their mutability and revealed the difference between sign-meaning and actual beliefs (all signs can be used to tell lies, hence they can be as much a mask, a disguise, as a means of telling the truth). However, it was absurd to imagine that one could destroy political ideologies merely by scrambling their insignia. Racism was not eliminated; neo-Nazi activities continued in Europe. When the latter group wore the swastika, it retained the evil meaning it had acquired during the time of Nazi power in Germany from 1933 to 1945.

The Politics of Pluralism

At the two extremes, reactions to the post-modern situation of stylistic and cultural pluralism were as follows:

1. Positive: a rich and healthy variety; demonstrated the wealth of culture and freedom of choice typical of western democracies as against the lack of choice and uniformity of totalitarian regimes; cross-fertilization and hybrid styles were interesting and amusing; it was good to break down hierarchies.
2. Negative: stylistic anarchism; resulted in mannerist, shallow and superficial works of art; mixtures of high and low culture and relativism caused a loss of artistic standards; the obsession with the past was unhealthy; post-modernism revealed a decadent, divided society which had lost its faith in the 'grand narratives' of history (for example, a belief in progress, the benefits of science and technology).

Politically speaking, pluralism is a liberal philosophy, one which recognizes that most societies consist of a number of different political ideologies, religions and cultures. Pluralism implies that all these tendencies are of equal status, merit and power, whereas of course some are more powerful than others; also, some are progressive and some are reactionary. Pluralism also implies that the different factions co-exist peacefully, whereas in fact they often conflict with one another (there is a struggle for supremacy). Pluralism takes no account of class struggle, of the antagonisms and contradictions which constantly disturb the harmony and stability of human societies.

Even dress styles are not exempt from the divisions and conflicts which mar society. In the realm of youth sub-cultures a particular style of dress signifies a certain set of values and tastes, a specific lifestyle, and in some cases a particular political outlook. In Britain the skinhead mode of dress

Cover of ZG (7) 1982 (Desire issue), featuring the American artist Cindy Sherman impersonating Marilyn Monroe. (The photo was originally made for a poster for *Marilyn*, an opera by Lorenzo Sevrero in Kassel, Germany.)

Sherman uses a camera to record herself and various invented tableaux but her work counts as fine art rather than photography. Inspired by the film still genre of Hollywood, Sherman began to dress up and to impersonate movie stars. She made literal our subjective identification with such mass media creations. Although her photographs were self-portraits, they were not concerned with unique personal experiences but rather with the way in which the self consists, in part, of the images, desires and stereotypes associated with the mass media. By acting out these roles, by objectifying them and making them visible, Sherman emancipated herself, to some degree, from the alienating grip of the stereotype. One reason why this kind of art was welcomed in the 1980s was that it served as a kind of digestible illustration of difficult feminist theory.

functioned as a uniform. It enabled members of the sub-culture to recognize one another. But it was not neutral in respect of other styles of dress. Skinheads banded together in order to persecute other groups with different racial and dress characteristics. The skinhead look was designed to intimidate their victims. Similarly, the punk style of the late 1970s was intended to outrage those who wore conventional clothes.

Although it is true that an incredible variety of cultures and styles now exist and interact, it does not follow that all categories and distinctions have become blurred, or that they have been transcended. On the contrary, it would not be possible for a person to appreciate the irony of a particular juxtaposition, a witty mixture of styles, unless the viewer was fully cognizant of the categories which were being contrasted or combined. Indeed, a sophisticated knowledge of past and present cultures, genres, styles and images is required of the connoisseur of post-modern art and fashion. Again, although it may seem at times that cultural hierarchies, such as highbrow, middlebrow and lowbrow, have broken down altogether, this is not the case. It is simply that the situation has become more complex and that a more sophisticated analysis is needed to explain the relationships between styles, tastes and economic factors.

In western Europe and the United States the advent of cultural pluralism did not mean that overall social control ceased because power had been devolved to the various factions within society. (In the old Soviet Union, Romania and in Yugoslavia, economic failure resulted in a loss of control by the ruling Communist Parties. A fragmentation occurred and the various nations and ethnic groups engaged in violent struggles to assert control over their territories.) Domination by the wealthiest groups, multi-national companies and major entertainment corporations continued.

As the British artist John Stezaker explained in 1977, dominant groups maintained their hegemony by accommodating cultural differentiation and diversity, by 'orchestrating and articulating a complex symbolic universe which permits a high order of differentiation and stratification.'[2] He went on to argue that social cohesion continued not because people shared a common view of the world but because they shared a common relationship to the plurality of imaginary worlds conveyed to them by the mass media. What remained constant was 'the currency of mediation itself and the subjective relationships imposed by dominant forms of cultural communication'.

Cultural pluralism did have the positive effect of putting multiculturalism on the education agenda and some power and influence did accrue to minority groups – feminists, gays and blacks – during the late 1960s and the 1970s. One consequence was that forms of art developed which were created by and for such groups.

Two opposite movements marked the era of post-modernism, one convergent and one divergent. On the one hand there was a tendency towards cultural homogeneity caused by the globalization of travel, communication systems, financial markets and industrial companies; on

the other hand there was a tendency for nations either to resist convergence (as in the case of the resistance to the aim of a united Europe) or to fragment into contending factions (as in the case of Yugoslavia during the early 1990s).

According to the British artist Peter Dunn, the 'digital highways' of international communication networks resulted in an undemocratic 'corporate culture' that ignored the needs of disenfranchised minorities. In an article that echoed the ecological slogan 'Think global, act local', he argued that artists should encourage 'local narratives' – defined as 'the voices of all those suppressed and marginalized'. Such communities would not necessarily be local in a geographical sense; what connected them was 'a communion of interest'.[3]

7. ALTERNATIVES

In an age when culture is dominated by the output of the mass media, making art can still be regarded as a socially positive activity because artists are active producers, rather than passive consumers, of images. Because artists exercise their imaginations, develop practical and intellectual skills, and generate their own representations of reality, they are not as reliant as non-artists on the representations supplied by the media organizations. Furthermore, through their practice artists gain an insight into how such representations are constructed. This inside knowledge may well foster a healthy scepticism in regard to mass media pictures of the world. (That the practice of art can serve as a means of spiritual resistance and as an aid to survival in conditions of oppression is most vividly demonstrated by the examples of 'Art of the Holocaust' produced by artists interned in Nazi concentration camps during World War Two, and by the Arpilleras or patchwork pictures made from scraps of cloth by the poor women of Chile following Pinochet's right-wing military coup of 1973.)

However, in spite of the above, artists are not a specially privileged social group who escape the influence of dominant ideology altogether. Indeed, there are many artists whose work is bland, politically conformist or reactionary. (Some artists were happy to serve the dictators Franco, Hitler, Hussein, Mussolini and Stalin.) It follows that an uncritical celebration of art in general, art in the abstract, is mystifying. We always need to ask: what kind of art? For whom? Serving what purpose? Also, a high proportion of the art produced at any one time is bad or mediocre, and inconsequential. A crisis of subject-matter afflicts the arts of the west as a result of the long-term decline of the Christian religion and the inroads made by the mass media.

In general, it is those artists who are critical of contemporary society (for example, anarchists, socialists, feminists, gays, ecologists, artists of ethnic origin who have experienced racial prejudice) who feel the need for an alternative to the fine art favoured by the art market, on the one hand, and commercial mass culture, on the other. They are aware of the indifference of the vast majority of working-class people towards the fine arts of the past and the present. They feel uncomfortable supplying luxury goods to private galleries and to museums patronized primarily by the rich and the middle class. They are also conscious of the condition of crisis in the fine arts brought about by the advent of mass culture.

Such artists are not interested in making art for art's sake, for aesthetic pleasure alone; they wish to use art in order to make ideological/political interventions; they want to reach, influence and persuade particular audiences. Ideally, they want to establish a relation-ship with viewers which is more reciprocal than that typical of the mass communication systems. Hence, issues such as the medium to be employed, the size of edition, the price, the venue and manner of display, the means of distribution, become as important as questions of form and

content. In certain respects, activist artists and those who serve the commercial media face similar difficulties, but generally speaking activists lack the massive financial and technical resources available to the latter. Even so, several different strategies are available to such artists; these will now be considered.

Within western democracies three principal kinds of socialist artistic practice can be identified (different situations arise in revolutionary and post-revolutionary societies):

1. *Labour movement.* Artists establish links with the labour movement, that is, trade unions and associations, and left-wing political parties, and they assist particular struggles (such as strikes), causes and campaigns. Modern media and technologies such as photography, printing, film, videotape and sound recording are used to produce posters and photo-montages, cheaply and in large editions, plus films, videotapes and records. Education, agitation and propaganda are their aims. The mass media often serve as a source of imagery which is then satirized or reworked in order to effect an ideological critique. Methods of distribution and communication generally avoid the art commodity/market/ gallery system. Artists may receive wages or expenses from the organizations they serve, but they may also have to donate their time, skills and energy.

2. *Community.* Artists establish links with particular communities, groups and organizations. Often the 'community' in question lives or works in a specific geographical area or neighbourhood. Artists adopt a flexible approach to media, that is, they may use photography, radio, television, video, multi-media buses, posters, murals, publications or street theatre. The artists see themselves as catalysts, encouraging and training ordinary and deprived people so that they can make their own images, poetry or music. Their aims are to improve the cultural level of the people and to enhance their physical environment, to raise levels of consciousness and to stimulate political action on specific issues. Collaborative or collective methods of production are favoured; for instance, professional artists and non-artists may work together to paint a mural. Income is derived from various sources: grants from charitable foundations, local government, arts councils, community fund-raising schemes, gifts of materials from companies, job creation schemes.

3. *Artworld.* Independent, professional artists continue to use the fine art context – especially public galleries and spaces – but introduce political content into their work. The subjects addressed range from war, torture, economic exploitation, censorship, to issues of race, gender and sex. Such artists rely on various sources of income: grants, sales, wages from part-time teaching, artist-in-residence schemes (artschools and other institutions often provide a base for their activities). Artists employ a wide range of media. Traditional ones such as painting and sculpture are not excluded but artworks based on montage and mixed-media are very popular. Individual production is more common than collective work, but some artists do band together into groups.

While the art commodity/market/gallery system is not rejected alto-
gether, it is often subjected to an internal critique (for example, artists
like Hans Haacke and Daniel Buren exhibit in museums but some of
their work is also critical of such institutions). Often, the mass media
are a prime source of information and imagery. This source is especially
important when the work is concerned with the politics of representa-
tion. A number of artists in this category engage in theoretical work –
they give lectures, write articles and books – besides making visual
artefacts. The aims of these artists are to highlight social problems,
contradictions and injustices, to represent the interests and viewpoints
of the exploited and underprivileged, and to educate and disturb the
predominantly middle-class audience who attend art galleries.

These three kinds of practice are not, of course, mutually exclusive. There
are many artists who have worked in more than one way. A more detailed
examination of these practices will now be undertaken with reference to a
few twentieth-century examples.

John Heartfield and Photo-montage

John Heartfield (1891–1968) was a German artist and designer who
joined the German Communist Party in 1918 and who then served the
cause of the Party for the rest of his life. This did not mean, however,
that his work was the result of Party directives. As a young man he
trained for a time as a designer. Later he contributed to the Berlin dada
movement of the late 1910s. Dada was a subversive, anarchistic, anti-art
movement that was highly critical of the German bourgeoisie and their
militaristic state. During this period Heartfield began to develop a
mastery of the technique of photo-montage for which he is now justly
famous. In 1933 the Nazis came to power in Germany. Heartfield
responded to the rise of fascism in Italy, Spain and Germany with a
striking series of satirical photo-montages that were published on the
covers of magazines such as *A-I-Z* (Workers' Illustrated Newspaper). At
its peak this pictorial magazine had a circulation of half a million and
was read by the most revolutionary sector of the German working class.
Naturally, the Nazis were not pleased and Heartfield soon had to flee
Germany to escape the stormtroopers.

Although photo-montage is not a technique exclusive to left-wing
artists – after all, examples appear every day in advertisements and in
mainstream newspapers – it has a special appeal to them because it
enables the reality-effect of photographs to be combined with the
analytical and synthetic skills of the political commentator. The simple
juxtaposition of two photographs will generate a 'third effect' meaning
not inherent in either image encountered separately. Heartfield did not
take his own photographs: he appropriated existing images – from the
mass media and from the history of art – and he also arranged for
photographs to be taken (that is, he used the method of 'staged
photography' popular with photographers employed by advertising agen-

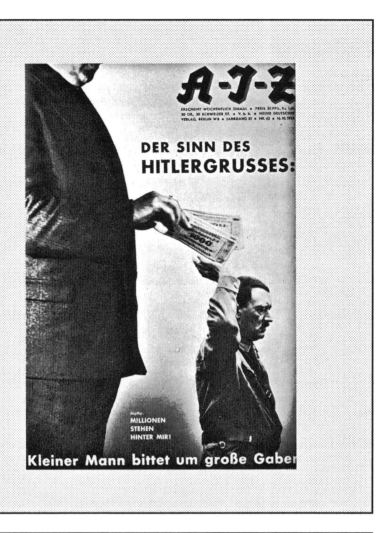

John Heartfield, 'The Meaning of the Hitler Salute. Motto: millions stand behind me! A little man asks for large gifts'. Photo-montage reproduced on the cover of *A-I-Z*, 11 (42) October 16, 1932. Akademie der Künste zu Berlin.

Black-and-white illustrations do not do justice to the appearance of the front covers of *A-I-Z* – in reality they were an attractive sepia colour. In this montage Heartfield used a Nazi photograph of Hitler making one of his hand gestures plus a quote from one of his speeches: 'Millions stand behind me'. By placing the huge figure of a capitalist behind Hitler, Heartfield gave the hand gesture a new meaning: backhanders; millions in terms of money is being given by big business to fund the Nazi movement. German industrialists did finance Hitler because they thought he would smash the trade unions, the socialists and the communists.

cies). In addition, he worked closely with skilled people such as retouchers and printers.

The 'quotational' technique of photo-montage (with the addition of captions) and the printing process of copperplate photo-gravure, enabled Heartfield to reach a mass audience, to speak to them in a contemporary medium which had at the same time roots in the earlier popular traditions of cartoons, caricature and emblem books. By cutting up existing photographs and texts, and by re-assembling them in new, unexpected ways, Heartfield directly engaged with the official culture, the dominant ideologies – bourgeois and fascist – of European society. He did not attempt, as some avant-garde artists do, to invent a completely new symbolic language, but to deconstruct and subvert those which already existed. For Heartfield, pictorial representation was not merely an opportunity for formal innovation but a site of political agitation and class struggle. While bourgeois artists sought to produce timeless and universal works of art, Heartfield worked hard to generate topical and partisan images. Despite their age and historical subjects, many are still relevant because the injustices they attacked remain unsolved.

Although Heartfield's position as an artist-intellectual distinguished him from the bulk of the readership of *A-I-Z*, his work was popular in the sense that it served the interests and articulated the class standpoint of the German proletariat. In his case, political commitment and artistic practice were fully integrated. Some of his images of workers and the Soviet Union (which he visited in 1931) were positive and there are art critics who have condemned him because his savage critique did not extend to the failings of the Communist Party and the Soviet Union under Stalin.

Heartfield's output was not confined to photo-montages: he also designed book jackets and stage sets. Arguably, he was a designer rather than a fine artist. His intention was certainly to overcome the limitations and élitism of the art gallery system, the problem of art as unique objects sold as expensive commodities. He did this by using reproductive processes and designing work for mass reproduction and circulation. A collection of his work is now preserved in a Berlin archive.[1]

A significant number of contemporary artists in Europe and North America are indebted to Heartfield and contribute to the evolving tradition of political photo-montage. For example, in Germany there are Klaus Staeck, Ernst Volland and Jürgen Holtfreter, in Italy Giovanni Ziliani, in Holland Paul Kooijman and Hans Zoete, in Sweden Christer Themptander, in Britain Peter Kennard, Michael Bennett, Yve Lomax, Martin Lovis, Jamie Reid, Jonathan Miles, John Stezaker, Peter Dunn and Loraine Leeson, and in the United States Barbara Kruger and Les Levine. These artists regularly support particular causes and campaigns but, unlike Heartfield, they generally avoid aligning themselves to the policies of a single political party.

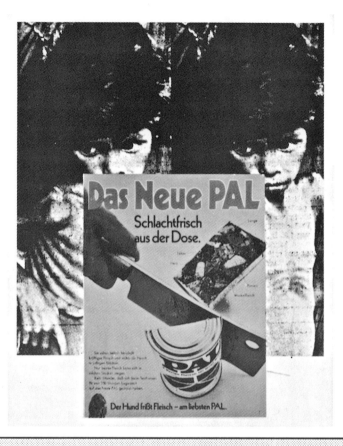

Klaus Staeck, 'Das Neue Pal', 1971. Poster and postcard. Edition of 22,000. Reproduced courtesy of the artist.

This disturbing montage consists of a full-colour pet-food advert pasted on top of two black-and-white photos of an emaciated child. Even such a simple juxtaposition is sufficient to expose the criminal imbalance which exists between the affluent, developed countries – where huge sums are expended annually on pet foods and on advertising – and those poor countries where children starve. The disparity between the two worlds is signalled by the colour/black-white contrast, and by the contrast of photographic genres (advertising and photo-journalism). Furthermore, because the advert is superimposed on the news photos, it takes precedence and literally obscures the child beneath. In the advert a meat cleaver slices a tin of pet food into two equal halves – Staeck uses a double image of the child in order to generate a pictorial rhyme. In addition, the conjunction of the clenched fist holding the heavy, sharp, metal cleaver and the naked, fragile body of the child is very telling: the cleaver seems intended for the child. Also unsettling is the implied link between tinned meat and the child's flesh: it seems to say 'children of the developing world are just meat anyway'.

Peter Kennard (b. 1949) is one of the best-known and effective political artists in Britain. He trained as a painter at the Slade School and the Royal College of Art in London during the 1960s. He was radicalized by the media coverage given to the Vietnam war. Since the mid 1970s Kennard has made hundreds of montages in support of many different causes, campaigns and issues. They have appeared in a wide cross-section of media: the left-wing press, mainstream magazines and newspapers, posters, placards, postcards, pamphlets, books, in films and on television. Kennard's work has also been exhibited in private and public galleries. Despite the fact that he has received many commissions he still has to rely on teaching for a living.

Kennard's declared aim is to 'rip apart the smooth, apparently seamless surface of official deceit to expose the conflict underneath'. Making visual connections allows him to 'break through the sea of media images in which sometimes I feel I am drowning'.[2] While Kennard's

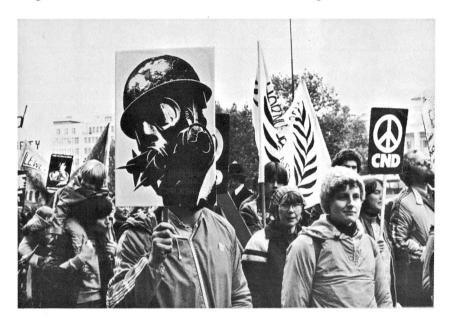

Peter Kennard, a placard with one of his photo-montages used during a CND (Campaign for Nuclear Disarmament) demonstration, Hyde Park, London, 1981. Photo reproduced courtesy of the artist.

Kennard's anti-war montage shows the head of a sinister military figure whose face is hidden by a protection mask. The figure's helmet is constructed from a photograph of the Earth taken from space. Missiles are stuffed inside the figure's mouth. Nuclear weapons, Kennard makes clear, pose a threat to the planet; they also dehumanize. The appearance of the montage in a march is one example of the role which visual art can play outside the gallery.

montages are not entirely free of clichés, they include a number of eye-catching and memorable images that reflect a keen political and visual intelligence, and a passionate commitment to peace and social justice.

John Stezaker (b. 1949), a British artist and art college lecturer who began his career as a conceptualist, devoted a number of years from the mid 1970s onwards to the practice and analysis of photo-montage and collage. At this time his output of montages was immense, and through his writings he significantly enlarged our theoretical understanding of pictorial rhetoric. Although Stezaker produced a series of montages in response to political events in Britain, his principal concern was with the politics of representation as manifested in such mass media as advertising, films, comics and photo-novels. What he explored and highlighted were the artistic devices and conventions through which this imagery functions (for example framing, point of view, the structure of looks between depicted characters). Stezaker cut into and tore images in order to disrupt the coherence of their spaces and narratives.

John Stezaker, montage from 'Is it the Night which Makes Things Dark, or is it the Darkness?', 1976. 23 x 33 cm. Reproduced courtesy of the artist.

Stezaker's dissection of images with scalpels was followed by a process of reconstruction in which pictorial mechanisms were often intensified. In some instances the depicted interior spaces of flat images were opened up so that they became, literally, three-dimensional; photo-montage aspired to the condition of cubism. Stezaker's project was not merely formalist, however, because by immersing himself in mass culture material he necessarily engaged with the clichéd plots, stereotypes and symbolic meanings associated with it. Rather than rejecting stereotypes and symbols out of hand as worthless, Stezaker embraced them in order to grasp the part they play in all our lives. Arguably, during the period of the 1970s and 1980s, Stezaker contributed a whole new dimension to the technique of photo-montage.

During the 1970s, as a result of the desire by certain artists to work more closely with the labour movement, a renewed interest in banners occurred. The artists included Conrad Atkinson, Ken Sprague, Andrew

John Dugger, 'A Vitória É Certa', 1976. Banner with five colour-dyed canvas appliqué hanging in 27 strips, 4.1 x 7.3 m.

This banner is being used during a meeting with representatives of ZANU, ANC, SWAPO, and BPP Third World Fund on African Liberation Day, 1976, at the National HQ of the Black Panther Party, Oakland, California.

Turner (all British), John Dugger (American), Peter Kennedy (Australian) and Jer O'Leary (Irish). In Britain, banners had been carried in processions and marches by trade unionists and suffragettes. Most Victorian trade union banners were designed and manufactured by commercial firms (ironically, the workers in the best-known company were not unionized) and they were usually conservative and backward-looking in their form and iconography.

Dugger, an American artist who was resident in Britain from 1968 to 1988, founded the Banner Arts Project in London in 1978 with the aim of modernizing banner design. Some very large banners, divided into a series of vertical strips, were produced; their simple, colourful, decorative designs were influenced by Oriental art and the late, paper cut-outs of Henri Matisse. Dugger designed commercial banners for sports events and trade fairs in order to subsidize his fine art banners and those made for community and political groups. When banners are carried in mass marches they become mobile signs; they also change shape when they flutter in the wind. In other words, in the street they have a live quality absent from the static art objects preserved in museums. Banners are a popular form of culture which avoid the distanced, alienated character of so much mass entertainment. Their contributions to group identity and solidarity, and to public communication are obvious.

Another popular form of communication that has been used for propaganda and commercial purposes for over a century is the pictorial poster. During the 1960s a renaissance in poster design occurred in London and San Francisco (the so-called 'head' or 'psychedelic' posters that served the rock 'n' roll industry). Many students decorated their rooms with such posters. Even today firms such as Athena that publish photographs in a poster format enjoy huge sales. Commercial poster designers generally employ illusionistic types of representation and pictorial conventions that are familiar to the public. The opportunity arises for radical artists to imitate those pictorial codes in order to convey alternative messages, as in the anti-Vietnam war poster by Nordahl.

Community Art/Murals

Community art encompassed a wide variety of activities and media: local radio, cable television, video and photography workshops, poster print-shops, street theatre, etc. Here, discussion will be limited to murals. During the 1970s, a new kind of outdoor wall painting appeared in deprived, decayed, inner areas of cities in Europe and the United States. These wall paintings or community murals have to be distinguished from other kinds of art and imagery also found in streets and public spaces, that is, commercial signs and billboards, statues, war memorials, fountains, artists' murals and graffiti.

What distinguished them was a consultation process and dialogue between their makers and their immediate audience. Often, members of the community participated in the conception, design and execution of the murals. The process of production was as important as the final

Nordahl, 'Vietnam - an Eastern Theatre Production', 1968. Offset lithograph, 108 x 104 cm. Gross National Product.

This late 1960s poster, critical of the American military intervention in South East Asia, is a brilliant pastiche of a certain type of movie poster - those with massive stone lettering surrounded by a *mélange* of scenes from the film rendered in a naturalistic manner typical of magazine illustration. It captures the mass media style so convincingly that at first glance we are deceived about what it is we are seeing. With relentless irony, Nordahl presents the war in Vietnam as a Hollywood spectacular. There is a double critical thrust to this poster: in addition to the attack on America's political and military actions there is a critique of American mass culture, that is, the way in which the mass media transforms tragic historical events into epics for consumption as entertainment. Nordahl's poster was prescient: later on, Hollywood studios made a spate of films about the war in Vietnam.

product. In terms of content, community murals reflected the history, aspirations, pleasures and problems of people who lived in a particular locality whether unified by shared culture, values or issues. The market forces of capitalist economies tend to undermine such values as community, co-operation and collectivism (people must compete, only the fittest survive, the market decides, individualism is all). In retrospect, therefore, community art can be regarded as an attempt to preserve or nurture a sense of community that was in danger of being lost for ever.

Community muralists were usually left-wing, professional artists with some fine art training and experience who had become disillusioned with the art gallery/museum system. Their desire to establish an alternative artistic practice, to help and empower deprived sectors of society, was admirable but on the street their murals had to compete for attention with a grass-roots upsurge of graffiti that was vibrant and energetic (especially in New York), and a highly sophisticated type of imagery devised by advertising agencies. Regrettably, the pictorial rhetoric of most community murals was not up to the challenge. Nor, in most instances, did the quality of the painting reach the high level previously achieved in the Mexican murals by Diego Rivera, José Clemente Orozco and David Alfaro Siqueiros executed in the 1920s and 1930s.

There were, however, a few impressive and politically effective community murals. 'Morgan's Wall' or 'The Good, the Bad and the Ugly', near the Thames in London, painted by Brian Barnes and a team of helpers was one such mural. The left-hand side of this huge painting celebrated the daily lives and desires of local people, while the right-hand side depicted the social problems of the area and questioned the various development plans for the riverside site. The mural attracted much public attention and press coverage. Its criticisms proved so embarrassing to local Conservative politicians and the industrial company that owned the wall, that they knocked it down in the middle of the night.

In terms of the political struggle at national and international levels, community art's local character was a limitation. The authorities were able to maintain their control because protest was scattered and piecemeal. Furthermore, public money spent on community projects was to some degree a palliative, a way of avoiding the root causes of ill health, poverty, unemployment and slum dwellings. Large, brightly coloured murals represented a dramatic intervention into the drab environments of the inner cities, but in many instances they served a cosmetic function, that is, their role was to decorate or 'improve' council housing that was cheap, shoddily built and brutal in appearance. A successful relationship between art and architecture surely requires artists to be involved during the planning stage of any new building or redevelopment scheme.

A few community artists became salaried employees of local councils. Like other community workers, they found themselves caught

Brian Barnes and others (the Wandsworth Mural Workshop) 'Morgan's Wall' or 'The Good, the Bad and the Ugly', 1979. Near Battersea Bridge, London. Destroyed in 1979. Photo: J. A. Walker.

Detail of the 'bad' half of the mural showing a criticism of perhaps the greatest figure in the history of mass culture: Walt Disney and his famous cartoon character Mickey Mouse. This pictorial attack was prompted by a proposal to establish a Disney entertainments world on the Thames riverside site. The Wandsworth Mural Workshop was threatened with legal action by the Disney Entertainments empire for its unauthorized use of the image of Mickey Mouse. The mural was destroyed by the owners of the wall in June 1979 and Brian Barnes was arrested and imprisoned for his attempts to prevent the destruction taking place.

between the needs and demands of citizens and the requirement of the local state to manage social problems rather than to solve them.[3] Most community artists received financial backing from a variety of sources. Funds tended to be given for specific projects or for a limited period. Eventually, community artists found they had to spend more and more time filling in grant application forms and in fund raising.

As a result of the election of right-wing governments in Britain and the United States during the 1980s, support for community initiatives dwindled. Instead, there was a shift of emphasis towards 'public art'. The term/concept 'public' is even more nebulous than 'community'.

Since it encompasses everybody who uses public spaces, it is not as politically contentious as 'community'. However, as we shall see later, it was still possible for works with a critical content to be made under the rubric of public art. The artists involved tended not to paint murals but to employ ephemeral forms of communication such as posters on billboards, messages on electronic sign boards, and slide-images projected on to buildings.

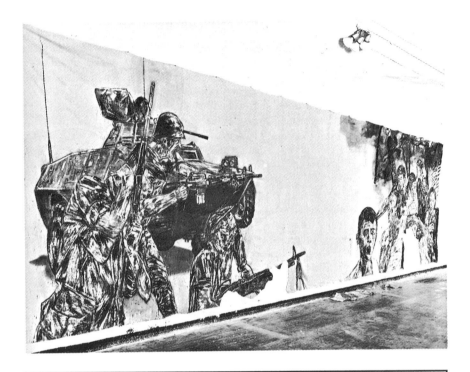

Leon Golub, 'Assassins II', 1973. Acrylic on canvas, 3 x 12.1 m. Artist's collection. Photo courtesy of Leon Golub and Jon Bird.

Golub (b. 1922) is a left-wing American artist, teacher and activist who has for many years demonstrated a commitment both to politics and to political art. His contemporary history paintings are generally huge and executed on unstretched, irregularly shaped pieces of canvas. The 1970s series called 'Assassins' (later renamed 'Vietnam') was provoked by the atrocities committed by American troops in Vietnam. Golub relied upon photographic records of the Vietnam war for his source imagery. Other works of the 1970s and 1980s (exhibited at the ICA, London in 1982) concerned repressive power relations: they depicted political leaders, brutal mercenaries and scenes of interrogation and torture. Since photographs of torture are not normally taken or published, in this instance Golub depended on the imagery found in pornographic, sado-masochistic magazines.

Political Art in the Galleries

During the 1970s there was a resurgence of interest in ideological and political issues by many young, visual artists. The kind of work that was produced as a result was not socialist realist in character because the artists concerned had assimilated the lessons of modernism. Radical political art, they realized, had to be radical in its form as well as its content; the issue of visual representation was kept under constant review. They were also aware of theoretical developments in such fields as art history, cultural studies, anthropology, linguistics, semiotics, film theory, Marxism, feminism and psychoanalysis. Some of the artists were ex-conceptualists; they had a knowledge of theory and they engaged in theoretical as well as practical work. Often, the artists' subsidized their studio practice by lecturing in artschools and other institutions of higher education or by writing art criticism.

Following the example of such writers as Roland Barthes and John Berger, many artists became 'image decoders', they undertook a critique of images derived from both the history of art and the contemporary news media. Such analyses fed back into their artwork. In some cases complicated, theoretically demanding and turgid works of art were the result. However, American female artists such as Cindy Sherman and Barbara Kruger later proved it was possible to generate simple, powerful, direct images that were at the same time informed by difficult theory.

Victor Burgin (b. 1941) is a British artist/lecturer, now resident in the United States, whose teachings, writings and photo-text works have been highly influential. Burgin is one of those artists whose practice during the 1970s and 1980s was as much theoretical as practical. He was particularly interested in the semiotics and politics of photographic representations, and in psycho-analysis. Burgin decided to employ photography as a medium of communication because he felt it was more accessible to the general public than painting. Although he used and took photographs, he did not consider himself a professional photographer, partly because language was equally important to him. Like advertisements, most of Burgin's works combined a photograph with a short caption or a longer text. Two contrasting examples dating from the mid 1970s are illustrated.

As explained earlier, some socialist artists managed to utilize their base in higher education and the artworld in order to make connections with the society outside. Conrad Atkinson (b. 1940), a British artist who taught at the Slade School of Art in London, is a case in point. Like so many others, Atkinson was radicalized by events of the 1960s. He abandoned abstract painting for a different, documentary-style practice. In 1972 he organized an exhibition at the ICA, London, of factual material concerning a strike at Brannon's factory, Cleator Moor, West Cumbria. As a result the cause of the strikers received national publicity and workers at Brannon's London factory became unionized. This example demonstrates that exhibitions can have an impact outside the realm of art. Another of Atkinson's works focused the attention of the press and a government minister on the issue of industrial injuries to workers. He has also designed five new banners for the General and Municipal Workers' Union. Other issues tackled in his art

Victor Burgin, 'What does possession mean to you?', 1976. Poster, 119 x 83.8 cm. Published in an edition of 500 which were pasted up in Newcastle upon Tyne during an exhibition of Burgin's work. Reproduced courtesy of the artist.

This poster combined an advertising-type photograph of a loving couple with a question and a statistical statement about the unequal distribution of wealth in British society. The familiar, romantic image gave the impression this was a run of the mill advert, but the non-commercial information in the lower caption undermined this expectation. Also, the concept 'possession' was problematized. The poster was discussed in the local press and public reactions to it were broadcast on local radio. Burgin's experimental intervention into the public realm was not repeated because of lack of funds.

include: the environmental effects of the nuclear power industry, the com-
mercial use of the British Royal Family, civil strife in Northern Ireland. In
Britain Atkinson's work has been subject to censorship on several occa-
sions. A New York dealer has proved, however, that in the United States a
market exists for Atkinson's politically-motivated art. (He has since moved
to the USA.)

Victor Burgin, 'US '77', 1977. Photograph with text, 101.6 x 152.4 cm. Reproduced
courtesy of the artist.

The text in the bottom left-hand corner reads: 'Police-of-mind. Several times military
power passed into the hands of soldiers. The soldiers wavered. A few hours after
they had disposed of a hated superior they released the others, entered into
negotiations with the authorities and then had themselves shot.'

'US '77' was one of a series of documentary-style photographs Burgin took in the
United States during 1977. Set in New York, the image presents with great economy
a complex conjunction of sculpture, architecture and graphic design. The statue,
skyscraper and cinema poster are all icons of male power associated with war,
big business and mass entertainment. The monumental war hero of the past is
confronted by a movie star of the present: the photo implies that the power of the
mass media is now greater than that of more traditional forms of art such as
public sculpture.

Burgin's text appears to be a quote from a history of a revolution. His captions
and texts usually establish ironic or paradoxical relationships to the photographs;
words are used to extend, rather than to limit meaning.

Conrad Atkinson, one of the series 'The Wall Street Journal and The Financial Times posterworks', 1987. Produced in collaboration with the Artangel Trust, London, and Projects UK, Newcastle upon Tyne. Photo: Garrard Martin, courtesy of the Artangel Trust.

Many of Atkinson's works of art reflect a keen awareness of the role of the mass media in contemporary society. In 1987 he devised a number of large posters that satirized the appearance and contents of newspapers such as *The Wall Street Journal* and *The Financial Times*. Hand-lettered news items carried bizarre stories and headlines (for example, 'Michelangelo questions U.N. priorities on famine relief and cash cropping in Third World') that irreverently combined the worlds of art, news, economics and politics. Atkinson's sardonic, witty posters were seen by millions of commuters when they were pasted up on the walls of stations in the London Underground and those of the Metro transit system of Tyne and Wear. Later, one of Atkinson's simulated page layouts even became part of the very medium it was mocking: a page entitled 'Daily Consumernica' was reproduced full size by the British daily the *Guardian* (19 November, 1988, p. 25).

Atkinson's career shows that although the boundary which separates the artworld from society as a whole cannot, at present, be abolished, this need not condemn the artist to political and social impotence.

As the slogan 'the personal is political' indicates, feminists think politics should be about private life as well as public affairs. Throughout the 1970s, female artists whose awareness had been raised by feminism produced work about subjects of concern to women. Works of art were made in a variety of media about the wages and working conditions of women cleaners and factory employees, the home and housework, menstruation and childbirth, images of women and men, important but neglected women of the past, the social formation of gender differences, and the crime of rape.

Organization and mobilization are essential to any group seeking political power. From 1969 onwards feminist artists banded together in order to form discussion and pressure groups, to establish workshops, slide libraries, courses in art colleges, art magazines, exhibiting societies, and to open art galleries. One of the largest and most ambitious feminist artworks – a mixed-media environmental piece called 'The Dinner Party' (1979) – was a testimony to the value of co-operation and collaboration: it was created by a team of American artists and craftswomen headed by Judy Chicago and Susan Hill. A fascinating documentary film was made about the making of 'The Dinner Party' and when the work was exhibited in the United States and Britain it received much press and TV coverage. A book was also published about it.

Today, political effectiveness depends upon an understanding and manipulation of the ubiquitous news media. Feminist critiques of male dominance in the artworld often adopted publicity methods designed to take advantage of the news media's appetite for sensation and eye-catching photographs. For example, the anonymous women activists who formed the pressure group called 'Guerrilla Girls' in 1985 in order to oppose sexism and racism in the New York artworld staged public demonstrations while wearing gorilla masks and costumes, in addition to the more usual tactics of posters, letters, magazine statements, videos and exhibitions. A similar group operating in Britain is called 'Fanny Adams'.

Within non-socialist societies it is difficult to develop a feminist and socialist art practice that is effective for more than a short time because economic and political conditions change so rapidly. What is possible in one decade often proves impossible in the next. In the last instance, the realization of this goal is not dependent on the skills, energy and willpower of dedicated artists. Rather it is dependent upon the emergence of new material and social circumstances favourable to the left. Even so, a critical art produced by professional artists sympathetic to those less fortunate can play a part in stimulating change. There is no shortage of socially beneficial causes that art can serve. Artists can help to raise the cultural and educational levels of particular communities, and they can share their skills. They can also assist in the demystification of reactionary examples of mass culture.

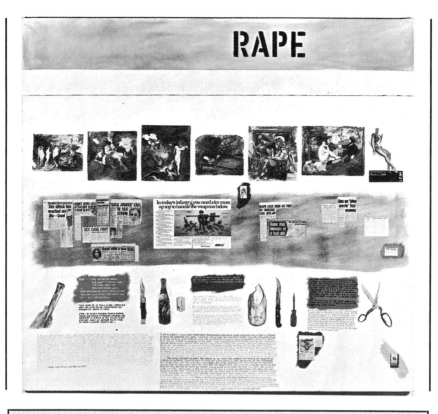

Margaret Harrison, 'Rape', 1978. Acrylic on canvas, 1.7 x 2.4 m. Artist's collection. Photo by John Webb, courtesy of the Arts Council.

Harrison is a British artist and college lecturer whose work since the early 1970s has been inseparable from the struggles of the women's movement. This painting/collage concerns a crime – rape – of great concern to women, since they are usually the victims. The main canvas is divided into three horizontal bands which, reading from top to bottom, contain the following: (1) pastiches of paintings produced by European male painters over the centuries illustrating male attitudes to women and the subject of rape; (2) news reports about rape cases, the attitudes of the police and the courts, plus military adverts; (3) information via images and words about the horrific physical violence men inflict on women during rapes. The subject matter is highly emotive but Harrison employs a cool, factographic approach.

What distinguishes this work from others on the same theme is the attention paid to the issue of representation itself: images of women and rape in art and in the mass media help to form male attitudes towards women and contribute to the crime of rape. 'Rape' is a deliberately fragmented work. Its mixture of painted images, collaged newsprint and hand-drawn lettering (which have to be read at close quarters) seem designed, like the content itself, to disturb the viewer.

There are those who believe that politics and art do not mix, that political subjects and political aims on the part of the artist are inimical to aesthetically good art. While it remains to be seen if the works by contemporary artists cited in this book will be valued by future generations, there exist sufficient historical examples of aesthetically satisfying political works by Courbet, Daumier, Delacroix, Dix, Goya, Grosz, Kollwitz, Manet, Picasso and Rivera (to name but a few), to refute the argument that politics is antithetical to high-quality art.

8. ART AND MASS MEDIA IN THE 1980s

Cross-overs and Mass Avant-gardism

During the 1960s there was a convergence, particularly in London, between the worlds of rock music, fashion, photography, graphic design and the visual arts. In 1967, for example, the British pop artist Peter Blake and his then wife Jann Haworth were commissioned to design a cover for a record that was to become world famous: the Beatles' 'Sergeant Pepper' LP. Since then Blake has undertaken many commercial assignments. Nevertheless, it is true to say he has remained primarily a painter.

A more radical shift – one that merits the description 'cross-over' – occurred in the case of Laurie Anderson. Anderson (b. 1947), a New York multi-media artist, used the sounds of a violin and her voice (transmuted by electronic means), projected slides, film and shadow play in her avant-garde performances.[1] In 1981, one of her recordings – 'O Superman' – topped the music charts and as a result she made the transition from the art gallery to the concert hall/music business. This breakthrough into the mass market (hence 'mass avant-gardism') was remarkable because it was achieved without loss of artistic integrity.

Anderson was a hypnotic storyteller. Her stage acts lasted for several hours and their themes were equally ambitious: the United States – politics, money, love, transportation. Another aspect of her work relevant to this text was its awareness of language and other communication codes, of the ways the mass media filter information, mediate between us and reality. In short, a central concern was the phenomenon of mediation itself.

Anderson's popular success demonstrated that the barrier between fine art and mass culture was permeable, that avant-garde artists could reach a much wider public if they were willing to use modern audio-visual technology to make their art, industrial means to record and mass produce it, and commercial distribution systems to disseminate it.

In part, Anderson's achievement was due to the fact that a relatively closer relationship existed between experimental music, performance art and pop music than existed between the visual arts and the visual mass media. Pop music was enjoyed by a much larger and wider public than pop art; it was a bigger industry; it had a more direct emotional and physiological impact. For these and other reasons many British art and design students formed bands and were drawn into the music business. (The manifold interactions between the visual arts and pop music that took place between the late 1950s and the early 1980s are documented in my 1987 book *Cross-overs: Art into Pop, Pop into Art*.)

In the realm of music, the fetish made of the original work is not as great as in the visual arts. The difference between a live performance and

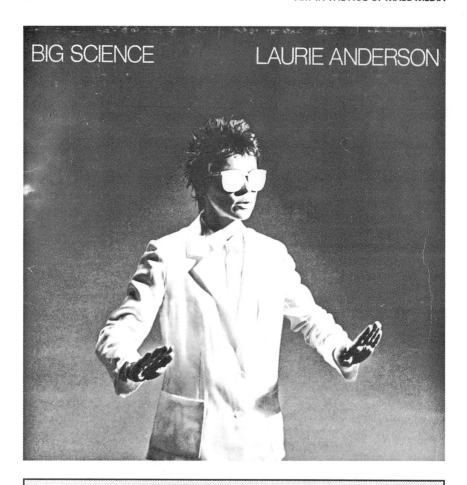

Laurie Anderson, cover of 'Big Science' LP, Warner Bros. Records, 1982. Designer
Cindy Brown, photographer Greg Shifrin, art director Perry Hoberman.

a broadcast or recording is not that great. However, it is the case that
even the mass produced merchandise associated with pop music –
records, posters, concert programmes, photographs, T-shirts, and so on –
can become rare, collector's items. At the time of writing, more and
more rock 'n' roll memorabilia sales are being held by prestigious auction
houses such as Sotheby's, and the prices fetched are rising. More and
more rock music museums and archives are also being formed around the
world. So it would appear that the fetishism associated with antiques and
fine art objects is spreading to the supposedly ephemeral culture of
popular music.

Another American artist who made a breakthrough into popular
consciousness during the early 1980s was Keith Haring (1958–90).[2] He

came to New York from Pennsylvania in 1978 to study at the School of
Visual Arts and soon gained street credibility by drawing in the subway.
His vibrant, primitivistic, chalk drawings of barking dogs, flying saucers
and radioactive babies were strongly influenced by the graffiti movement
or 'spraycan art' that reached a peak in New York during the late 70s,
early 80s. The motifs Haring invented and repeated were similar to the
'tags' of the graffiti writers and to the trademarks and logos of industrial
companies. They gave him a unique visual identity and brought him fame.
Within a few years Haring had developed his basic iconography into a
complex, macabre, symbolic language.

Haring was an immensely prolific and energetic artist until struck down
by AIDS. His hieroglyphic 'new wave Aztec' graphic style represented a
convergence of fine art and popular culture, that is, the linear skills of
Picasso and Pollock with graffiti and cartooning. Like Warhol, Haring was
willing to transgress the boundary separating art and design: he painted the
bodies of the singer Grace Jones and the dancer Bill T. Jones, he designed
Vodka advertisements, decorated pots, statues, clothes, record sleeves for
Malcolm McLaren, T-shirts, badges and the interiors of night clubs and
shops. The return of ornament manifested by Haring's work was a sign of
the paradigm shift from modernism to post-modernism.

Once established, Haring also created more elaborate and complex
paintings in Day-Glo colours on large industrial tarpaulins ('tarps'). He
made use of the Spectacolor sign in Times Square and produced street
murals in the United States and in Europe; the latter were public events
that attracted enthusiastic crowds. Haring's openness, his vivid hues and
accessible style, appeal to youth, friendship (and collaborations) with
black and Latin graffiti writers and with pop music stars such as
Madonna, exhibitions mounted in nightclubs instead of art galleries,
meant that he established a genuinely popular following among young
people who otherwise would not have taken an interest in fine art.
Apparently, this popular appeal was some hindrance to his acceptance by
the New York gallery system (which prefers to make its own stars).

Exhibitions did take place in private art galleries but Haring also
wanted his art to be available to ordinary people, not just the rich, and
so he opened retail outlets – 'Pop shops' – in New York (1986) and in
Tokyo (1988) to sell merchandise he had designed or ornamented. This
led to accusations of commercialism, but at least Haring's commercialism
was intended to benefit lower income groups rather than dealers and
wealthy collectors. He was also an artist with a social conscience, an
artist who was willing to place his skills at the service of particular
causes: a mural warning against the drug crack; works in support of Act
Up, the campaign to help gays suffering from the disease AIDS; an
anti-nuclear poster (20,000 were printed and distributed free).

As Haring's short but intensely active career showed, it was possible for
fine artists to reach a broader public provided they were willing to adopt a
popular style, to apply their art, to organize their own exhibitions in non-art
venues, and to step outside the artworld in order to involve themselves with
the lives of ethnic minorities, sub-cultures and local communities.

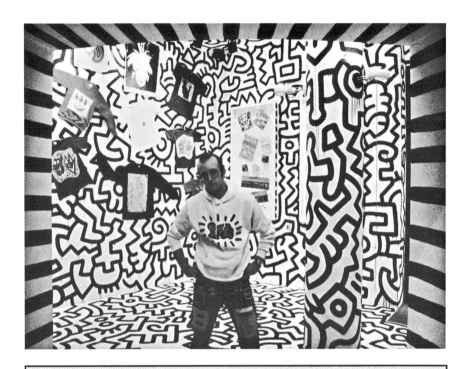

Keith Haring in his Pop shop, 292 Lafayette St, New York, 1986. Photo courtesy of the Estate of Tseng Kwong Chi.

Simulacra

In 1982 a prescient exhibition of work by four British artists – Jonathan Miles, John Stezaker, Jan Wandja and John Wilkins – was held at the Riverside Studios, London. The show, curated by the critic Michael Newman, was entitled *Simulacra*.[3] This word, along with 'simulation' and 'hyperreality', was made fashionable by the French philosopher Jean Baudrillard.[4] (Baudrillard became the most influential theorist in terms of the development of the visual arts during the 1980s.) Simulating is pretending, imitating something real or a possible future event. Computer simulations can model actual events but they can also model fictional events, consequently one can have simulations with no real referents. Baudrillard's controversial argument was that simulations – in the form of images, media – had replaced reality, creating a new hyperreality. He outlined four phases in the development of the image: (1) it was a reflection of a basic reality; (2) it was a mask and perversion of a basic reality; (3) it was the mask of the absence of a basic reality; (4) it bore no relation to any reality whatsoever, it was its own pure simulacrum.

Baudrillard tended to carry his ideas to an absurd extreme. However, it is clear that the mass media now constitute an environment that rivals nature, and this environment contains a mixture of factual representations, fictional representations and the intermediary category 'faction'. Media images of various kinds were the starting point of the four British artists, but no celebration of popular culture was intended. They collected trivial images and scrutinized them as a way of freezing the rapid flow and turnover of images typical of our consumer society. They used artistic procedures such as drawing, painting and screenprinting in order to analyse and explore the nature and power of their source images. It was a means of understanding and coming to terms with the collective myths of society. In the case of Jan Wandja's 'Sebastian' series, for example, the strained face of a runner derived from a sports photo was reproduced by hand using a pointillist technique and then placed within the Union Jack. The suffering face and the cross design of the flag implied a link between sport and the Christian religion. It also evoked the pain, physical effort, patriotism and fervent nationalism associated with Britain's Falklands War of 1982 against Argentina.

Wilkins's subject was the bucolic dairymaid that adorns cans of Ovaltine, a comforting drink. This female stereotype is so familiar it is hardly noticed anymore (except to identify the product and company). It is an image most consumers discard without a second thought. Wilkins distorted the source image by photographing it from a low angle, thus giving a child's viewpoint towards the peasant/mother nature figure. This photo was then used as the starting point for a series of large, grisaille watercolours executed between 1981 and 1983.

'Veils', John Stezaker's controversial contribution to *Simulacra*, was a frieze made from silk and muslin that had been screenprinted with images of headless, naked females derived from 1950s nudist photographs. During the 1980s Stezaker was increasingly attracted to out-of-date and marginal mass culture imagery from which he produced hundreds of photo-collages. Unlike many intellectuals, he does not despise kitsch; indeed his artistic project can be characterized as an attempt to redeem what is true and positive about kitsch imagery. In order to make his collages more 'musical' and ornamental, certain motifs were repeated and arranged in patterns.

Stezaker tended to work in cycles and series devoted to specific themes. (The serial nature of his art means that it is hard to do it justice via a single illustration.) For instance, for some time he was preoccupied by the theme of babies and flowers. Flowers are emblematic of nature, beauty, emotions and the transience of life. Babies evoke innocence, the direct expression of feelings, and closeness to the 'underworld' or the unconscious because they have so recently emerged from darkness into light. Like metaphors, they are bridges between two worlds. As subject matter they indicated 'a return to roots'. Play – so important in childhood – was also crucial to Stezaker's collage-making practice.

The 'Underworld' series paid homage to the baby/flower designs and paintings by the German romantic artist Philipp Otto Runge (1777–1810).

John Wilkins, 'Still Life (Ovaltinies 4)', 1981–82. Watercolour on paper, 1.3 x 1 m. Photo reproduced courtesy of the artist.

Wilkins's Ovaltine series has been the subject of complex analyses by Michael Newman and by Rosetta Brooks. Newman comments: 'Wilkins' monochrome water-colours were painted with the paper horizontal, using a staining technique, thus avoiding associations of touch as signature, the unique mark of the artist, and creating a dissolve effect through the tidemarks of dried pools of pigment. Based on anamorphic photographs of the can taken from below, the Ovaltine woman became a dominating female holding and absorbing the gaze of the viewer like some fascist poster of a political leader, liquefying in the later versions into an apocalyptic mushroom cloud of near blackness. The aesthetics of the sublime is married to the psychology of power in the corporate product-emblem. The lost agrarian paradise of the watercolour tradition mutates into an image of desire and threat salvaged from the ephemera of consumerism. The reduction of the repro-duced colour painting to monochrome aligns the resulting watercolour with repro-duction, while protecting the image of fecundity and consumer promise towards the other side of representation, to the final dissolve of an uncanny deathliness.' [5]

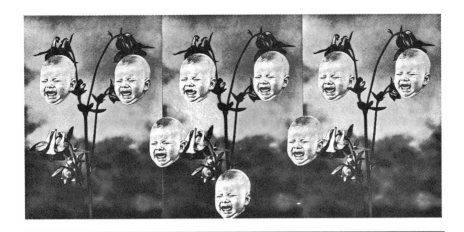

John Stezaker, Image from the 'Underworld' series, 1984.
Photo-collage, 53 x 25.3 cm. Reproduced courtesy of the artist.

Influenced by European thinkers concerned with archetypes and myths, Stezaker appropriated and reworked popular imagery intuitively, seeking the mythic dimension in the everyday imagery of the recent past. The aim of his collage juxtapositions, Stezaker declared in 1991, was 'To bring together worlds that have become separated in the twentieth century, to restore symbolism and mythology that have been taken over by the mass media ...'6 His preference for still pictures rather than moving pictures can be seen as an attempt to arrest time, to discover the eternal in the turnover of images so typical of the age of mass media.

Art, Advertising and Billboards

Adverts about the visual arts generally appear in specialist art journals, listings magazines and in information leaflets and street posters – they almost never appear on television. Simon Linke and Jeff Koons were two artists who made the advertising of art their creative concern during the 1980s. Simultaneously, other artists imitated the practice of advertisers by using billboards and electronic Spectacolor signs to make their work more widely known.

Although many fine artists look down upon advertising as an applied art, those who exhibit in private and public galleries are heavily dependent upon it for publicity purposes. Glossy art magazines contain a significant number of pages carrying adverts which often consist of nothing but the names of a gallery and a male artist. Linke, a British neo-conceptual painter exhibiting at the Lisson Gallery in the mid 1980s, seized upon this fact in order to make sardonic, elegant paintings of the adverts appearing in the influential American journal *Artforum*. The latter's square format was one factor that

influenced his choice. Linke's hand-painted lettering and impasto surfaces transformed anonymously designed, machine-made, mass produced printed matter into unique, autographic, craft objects. The tactic echoed that of Jasper Johns who, in the 1950s, made painted copies of the flat, banal image of the American flag.

Linke's paintings had a limited appeal – they were primarily an artworld in-joke. The critic Stuart Morgan dubbed them 'end-of-painting paintings', implying that the art of painting had exhausted itself, that its only remaining function was to comment, self-reflexively, on its own condition as a commodity offered for sale in commercial galleries. Although some critics regarded Linke's work as complicit with the art market rather than critical of it, his canvases had a certain use-value in highlighting the fact that in the age of consumerism and mass media, artists rely on advertising just like other producers.

As Linke's paintings revealed, many adverts in 1980s art magazines were black and white, and very clinical in their typography and design; in fact, their appearance echoed minimal and conceptual art styles. Later, some

Simon Linke, 'Ross Bleckner', 1987. Oil on canvas, 26.25 x 26.25 cm. Private Collection, Washington. Photo courtesy of the Lisson Gallery, London.

Jeff Koons, staged photograph: full-colour advert with two, semi-naked, female models, published in the November 1988 issue of *Art in America*. Also issued as one of a portfolio of 'Art Magazine Ads', 1988–9 in an edition of 50 plus ten artist's proofs. 115 x 94 cm. Reproduced courtesy of the artist.

American artists became aware of how dull art-show adverts were and they decided to take control of their own publicity. Jeff Koons, for instance, perceived that self-promotion was itself a creative opportunity; he therefore devised full colour photographic adverts in which he appeared with near-

naked female models and with pigs. These images certainly succeeded in grabbing the reader's attention and they also brought the art periodical closer to the norms of mass circulation magazines.

Large advertising hoardings or billboards are to be found in most of the world's cities (there are 126,000 poster sites in Britain alone), so their importance as a means of mass communication for those who can afford to rent such spaces – business and government – is clear. Most billboards are crude wooden structures designed to display bills or posters, the majority of which are photographic images with captions, printed in large editions. Since adverts are changed regularly, city dwellers and car drivers experience a constant turnover of images.

Peter Dunn and Loraine Leeson, 'Big Money is Moving In', photo-montage for one of a series of photo-murals, Docklands Community Poster Project, 1982–3.

During the 1980s the Docklands area of East London became the largest development and building site in western Europe. For decades this zone near the City of London had declined, then, in 1981, the Conservative government under Mrs Thatcher declared it an enterprise zone and suspended normal planning regulations. The London Docklands Development Corporation (LDDC) was formed to revamp the area. A frenzy of new construction ensued: a light railway and an airport were built, Victorian warehouses were converted into shops, flats and a Design Museum, and a plethora of new offices, shops, hotels, houses and factories were started. Canary Wharf, Isle of Dogs, a monumental complex of office buildings (which included a tower block 800 feet high) was designed by the American architect Cesar Pelli.

Since the new buildings were by different architects who employed a variety of styles, materials, shapes and sizes, Docklands rapidly became a post-modernist jumble. Given the private property free-for-all, Docklands as a whole lacked coherence; it was also without an adequate road and public transport network; as a result, many observers considered it to be a planning and architectural disaster. Local people too were resentful because the commercial developments provided little in the way of jobs and housing for them. The whole scheme ended in financial disaster: by the early 1990s even the largest office developer – Olympia and York – had gone bankrupt.

Starting in 1982 the community artists Peter Dunn and Loraine Leeson co-ordinated a campaign of criticism: the Docklands Community Poster Project, funded by the Greater London Council, Arts Associations and local government. The hoardings, 18 x 12 ft. in size, were distributed throughout the zone. To hold the attention of viewers over a period of time, each photo-mural was divided into panels which could gradually be changed so that one image was transformed step-by-step into another one. Dunn and Leeson worked closely with local people and organizations; they made sure that their views were represented and their needs articulated.

A minority of hoardings are painted rather than printed. These are the work of professional commercial artists whose names are not generally known to the public. Sign painters normally employ a photo-realist mode of representation. (James Rosenquist, the American pop artist, worked as a billboard painter early in his career.) Some billboards have cut-out elements which project beyond the board's framing edge, or even three-dimensional projections, to heighten the sense of realism or illusion. (Richard Smith's shaped canvas constructions of the early 1960s were influenced by such structures.) Pictures that move are more eye-catching than those that are still: in Britain, Ultravision billboards have revolving vertical parts which enable three adverts to appear in rotation.

Several books celebrating so-called 'billboard art' have been published but their authors do not generally mean 'billboards designed by fine artists'.[7] Nevertheless, in recent decades, a growing number of fine artists have turned to billboards in an effort to reach a wider or different audience than that available to them via art galleries. The list includes Daniel Buren, Ian Colverson, Peter Dunn and Loraine Leeson, Mona Hatoum, Joseph Kosuth, Barbara Kruger, Thomas Lawson, John Lennon and Yoko Ono, Les Levine, Denis Masi, and Michael Peel.

Les Levine (b. Dublin, 1935), a versatile Canadian artist now based in New York City, claims to have invented the terms 'media sculpture' and 'media art'. Levine firmly believes contemporary art has a social responsibility and function. Since the mid 1960s he has employed a diverse range of materials and media in order to focus on 'systems of art as they relate to society in general'. Furthermore, to address the public he has frequently resorted to mass media technology and mass communication channels, in

particular, videotapes, photographs and billboards. Levine writes: 'Media are my materials ... I want to mould media the way others mould matter ... I am interested in using my media to effect change and understanding of our environment ... If media changes man, then man must change media.' [8]

Levine's public projects are too numerous to describe here. (Interested readers should refer to the catalogue of the 1990 exhibition documenting them, entitled *Public Mind: Les Levine's Media Sculpture and Mass Ad Campaigns 1969–90*, held at the Everson Museum of Art, Syracuse.) Especially striking and controversial was the series of images plus slogans he devised for display on billboards in London and Ireland in 1985–6. The images were derived from Polaroid snapshots; Levine used flat areas of bright colour to transform them into simple, cartoon-like pictures so that, when enlarged, they would stand out in the urban environment.

Levine was critical of the killings caused by the civil strife in Northern Ireland and by the religious aspects of the dispute. He refused to take sides; his aim was to stimulate reflection, to undermine entrenched political positions by the use of deliberately provocative images of soldiers, policemen, protesters and children with guns overlaid with captions such as 'Attack God', 'Blame God', and 'Execute God'. Strong reactions were evoked: censorship problems arose and some of Levine's posters were repeatedly vandalized while commercial advertisements for American movies celebrating male violence remained

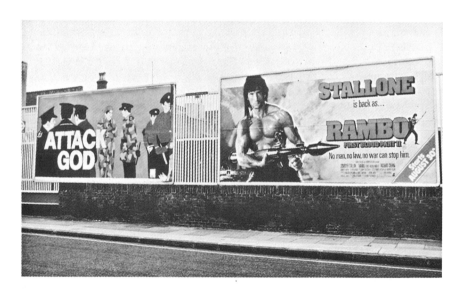

Les Levine. Left: 'Attack God' billboard (from the 'Blame God' series), 3 x 6.3 m, London, 1985.
Billboard campaign sponsored by the Artangel Trust and the Institute of Contemporary Arts. Right: *Rambo* movie poster. Photo reproduced courtesy of the artist.

untouched. Levine's media art campaigns have demonstrated that artistic interventions in the public realm can compete successfully against mass culture imagery; sometimes, the former have even outperformed the latter.

In 1992 another mass medium – television, Britain's BBC2 – showed an interest in the art/advertising relationship by featuring a series of billboards with images specially commissioned from artists as disparate as Helen Chadwick, Roderick Coyne, Ian Hamilton Finlay, Paul Graham, Richard Hamilton, Damien Hirst, Howard Hodgkin, Richard Long, and Bill Woodrow. (The project was jointly sponsored by *Radio Times* and the billboard firm of Mills & Allen. Eighteen artists were involved and 150 poster sites around Britain were used.) Hirst was the only artist who decided to avail himself of the advice and skills of advertising agency professionals. Individual billboards were then shown in short 'vox pop' TV programmes. A longer, more analytical documentary entitled 'Outing Art' (editor Keith Alexander) explored the differences and similarities between fine art and advertising. It has been argued that art requires time for its assimilation whereas advertising is

Helen Chadwick, Staged photograph for BBC2's Billboard Art Project, 1992.
Photo courtesy of the artist and Keith Alexander, Editor, Arts Features, BBC Television.

Colour photo looking down on a dense mass of yellow and reddish flowers (1,500 tulips), arranged in a target-like design around a dark orifice (a plum surrounded by engine oil). Chadwick (b. 1953) decided to present an image that was private and intimate, an image that celebrated the erotic. In contrast to the majority of billboards, Chadwick's was not selling a product or a service; it simply offered the public a moment of exquisite visual/sexual pleasure.

read rapidly. However, certain advertising campaigns of the 1980s and 1990s used all kinds of delaying and teasing tactics in order to hold viewers' attention, to entertain them and to make them work to decode the messages. So the gap between art and advertising appeared to be narrowing.

Contemporary artists use billboards to make either polemical or non-commercial aesthetic statements, consequently they still provide an alternative to the dominant advertising system, but how effective are sporadic uses of the 'scattergun' means of outdoor communication remains unclear. Complex or ambiguous images may prove meaningless to most passers-by, or they may conclude 'this poster must be advertising something, but I don't understand what'. Perhaps a more effective way of subverting the ideologies and values propagated by consumerist and political advertising is the *détournement* method favoured by the situationists: that is, the addition of words or drawings in order to criticize or change meanings. Generally such additions take the form of hand-drawn graffiti but a more sophisticated method is to use printed, typographic additions that match the style of the original advert. Two British men who regularly engaged in the latter, illegal practice were featured in the programme 'Outing Art'. They disguised their identities by calling themselves AVI (Active Visual Intervention).[9]

Electronic signs are not so common as billboards but they have certain advantages: they are capable of transmitting a rapid stream of messages; their illumination and movement attracts the eye. Jenny Holzer (b. 1950), is one of several American artists who have used such signs to good effect. (The others include Keith Haring, Barbara Kruger and Les Levine.) Holzer, a mid-westerner resident in New York since 1976, represented the United States at the Venice Biennale of 1990 with a dazzling installation of moving electronic signs featuring a series of thought-provoking messages. Holzer is a wordsmith extraordinaire: starting in the late 1970s she began to specialize in devising linguistic truisms, clichés or aphorisms. (Conceptual art was an early influence plus a desire to make a public, urban kind of art that would be accessible to a wide audience.) She communicated them to the public by various means, some transient and some permanent: printed flyposters, photostats, metal plaques, letters carved on stone benches, Spectacolor signboards, computer programmed LED 'ticker-tape' type signs, T-shirts, baseball caps, stickers, audio tapes and TV screens.[10]

Holzer's texts were invented but they closely resembled real folk sayings and the captions and headlines of the mass media. Like the latter, she preferred an even, impersonal style of address. Various proclamations were presented, either simultaneously or successively. They contradicted one another or they were sinister in meaning. Viewers were thus confused as to who was speaking and they were forced to make their own evaluations of the 'skewed content'. Later on, Holzer's slogans became even shorter and they began to reflect more of her own political and feminist views: 'Money creates taste', 'Abuse of power comes as no surprise', 'Men do not protect you any more'.

Like her friend Barbara Kruger, Holzer presented her work both indoors and out of doors, in private spaces such as galleries and in public spaces such as the street. In public spaces the works were anonymous; they appeared 'out of the blue' – sometimes directly alongside public service announcements and product advertisements. Her work imitated both the mode of address and the mode of delivery of the mass media, but it was also a critical intervention into that realm. In other words, Holzer's tactic was to infiltrate the mass media and to turn their own weapons against them.

Jenny Holzer, 'Protect Me From What I Want', 1986. Photo reproduced courtesy of the Barbara Gladstone Gallery, New York.

The above remark was part of the 'Survival series' (1983–5). It appeared on a giant electronic Spectacolor board in Times Square, New York in 1986 and on a comparable board in Piccadilly Circus, London in 1989. Such statements appeared for only an instant, and so they had to be absorbed very rapidly. At first sight this kind of art may seem to be as shallow and transient as most media information. However, a statement like 'Protect me ...' resonates in the mind for a long time. It is public and personal at the same time; it raises questions like 'who will protect "me"?' and 'what is it that "I" want?' The statement is like a prayer for help from all those who are unable to control their own desires or resist the blandishments of politicians and advertisers.

Since words were Holzer's forte, it was paradoxical that she achieved fame in the *visual* arts rather than in literature or poetry. Some critics considered the straightforward lettering she preferred and the lack of imagery in her work limited its aesthetic appeal, but this situation changed in the 1990s when she began to use pictures as well as words. Other critics thought her work was compromised by its similarity to the manipulative media it tried to subvert. Holzer maintained, however, that it was significantly different to constitute an alternative experience.

At the end of the 1980s Holzer's art proved to be of value and interest to the American cinema. For the movie *Backtrack* (1989) (*Catchfire*, UK, 1991), directed by Alan Smithee (that is, Dennis Hopper), she supplied the electronic art for a fictional female artist played by Jodie Foster.[11] Dennis Hopper, the male star of the film, is himself a keen collector of contemporary art.

Appropriationists

During the 1980s hundreds of artists 'appropriated' images from either the history of art or the mass media. This was not exactly a new departure: for centuries artists have copied the masterworks of the past; they have borrowed from their contemporaries and from popular culture. Yet there were differences in intention and practice. To illustrate this point a brief review of the work of five American artists – Thomas Lawson, David Salle, Sherrie Levine, Mike Bidlo and Barbara Kruger – will be undertaken.

Lawson (b. 1951), a Scottish-born painter, critic and theorist, moved to New York in the mid 1970s. In 1979 he founded *Real Life Magazine*, a small circulation periodical similar in some respects to *ZG*. He also wrote polemical articles for major art journals such as *Artforum*. Items in *Real Life Magazine* were often contributed by American artists interested in such media as film, television, photography and advertising. Lawson also curated and participated in exhibitions addressing the theme of art's relation to the mass media. *Real Life Magazine* provided a platform for a younger generation of artists who were enthralled by pictures and looking for a way of making art that did not simply cater to the market's appetite for macho, neo-expressionist painting. These artists included: Jack Goldstein, Barbara Kruger, Sherrie Levine, Matt Mullican, Richard Prince, David Salle, Laurie Simmons, Cindy Sherman and Walter Robinson.

Lawson's critique extended as much to high culture as it did to low culture. In his view, avant-garde art had lost its adversarial character in respect of dominant culture. Attempts at negation by means of overtly left-wing, political art were likely to fail because of the power of the art market and official institutions to absorb and recuperate all dissent. (Another common response is to dismiss such work as 'propaganda' and 'poor art'). He adopted a more oblique strategy called 'dialectical re-duplication', that is, turning the means of the mass media against themselves by reappropriating their images, styles and conventions of representation. Irony, aesthetic distance, ambiguity and contradictions were deliberately cultivated to reveal

Thomas Lawson, 'Don't Hit Her Again', 1981. Oil on canvas, 122 x 122 cm. Photo courtesy of the artist and Metro Pictures, New York.

This painting was one of a series of 'portraits' of victimized children. Child abuse is reported in the press every day but such social problems are rarely the subject for fine art. How can such a depressing topic provide aesthetic pleasure? Lawson reminds the gallery-going public of an unpalatable aspect of human behaviour while at the same time giving abused children a presence within art. The source images were anonymous snapshots and photographs taken from the *New York Post's* yearbook. Lawson remarked: 'They are people of whom you have no expectations of seeing a portrait. Neither mass culture nor high culture, but absolutely anonymous strangers. Furthermore, they are not my pictures. They are doubly anonymous – both photographed and photographer are anonymous'. [12]

the hollowness of stereotypes and to slow down the process of assimilation. This was often achieved by overlaying and obscuring representational images with skeins of pigment, brushed on in a deliberately non-seductive manner.

Somewhat surprisingly, Lawson decided that the 'discredited' art of painting was suitable for critical purposes. It had an illusionistic potential and it could serve as a means of camouflage, that is, by using an established medium (and traditional genres such as portraiture and landscape) popular with dealers and collectors, the radical artist would be able to gain access to the art market and subvert the system from within. Writing in 1990 he admitted that the 'always risky' strategy of penetrating the New York art market had 'proved a disaster' because the flow of money had so quickly replaced the flow of ideas.

During the late 1980s Lawson designed installations in which his canvases were placed against specially painted walls and accompanied by sound tapes. These installations were usually site-specific in terms of their cultural context. Like many other artists he undertook public art projects because they seemed to be a way of communicating with people and becoming politically effective. He produced panoramas and billboards in Manhattan and in Newcastle upon Tyne. Their main subject was the petrified official culture of the past as represented by neo-classical architectural monuments and museums, war memorials and nuclear power stations. One of Lawson's targets was New York's civic statuary. He described it as 'an archive of power frozen in a past time that keeps women safely allegorical and minorities all but invisible.'[13] In the paintings he made for galleries there

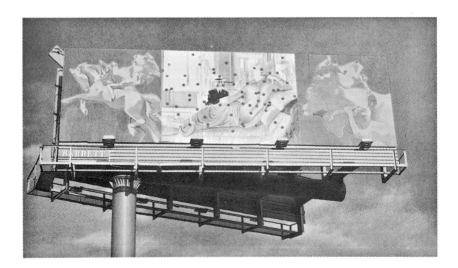

Thomas Lawson, 'Billboard Project I-95', New Haven, Connecticut, 1989. Barrett Outdoor Communications, West Haven, Connecticut. Photo courtesy of the artist.

was again a conflict between surface and depth, representation and abstraction, image and material: images were disrupted by the superimposition of abstract patterns; reading was made problematic by the use of veils of pigment.

Salle (b. 1952), along with Julian Schnabel, made a significant contribution to the resurgence of painting that occurred in the early 1980s. He specialized in rather graphic paintings consisting of drawn or tonal images, abstract patterns and smears of pigment. Intertextuality was evident in the way various styles and 'presentational modes' (Salle's own expression) appeared within a single canvas. Images were scattered across flat grounds of colour or superimposed on top of one another courtesy of a projector. (The layering of images to generate visual complexity was also typical of much graphic design, video art and pop music during the 1980s.)

Sometimes his works consisted of separate panels placed side by side. His source images dated from different periods and they were culled from a variety of sources: films, design, comics, soft-pornography and the art of the past. Salle was promiscuous in his use of images: he took them from 'high' as well as 'low' culture. His cold-blooded painting was not by any means intended as a celebration of popular culture. Readers will not be surprised to learn that Salle once worked as a picture researcher and also as a layout artist for a magazine publishing house which had a large library of illustrations. For a time, 500 images from this file formed the core of his pictorial borrowings.

Salle's art represented one possible response to the 'death of painting' crisis and the situation of image-glut/overload associated with a media-saturated environment. However, while his montages of disparate images were intriguing, their very randomness and the way they disrupted one another when they overlapped, precluded the depiction of actual space or the communication of any coherent narrative or meaning. Perhaps Salle's point was that a deluge of images produces a daydream state in which images, linked only by a chain of associations, float through our minds in a continuous stream.

While Salle appropriated fragments of existing images and translated them into paint in order to generate a new whole, Sherrie Levine (b. 1947) reproduced whole images belonging to others. For instance, she rephotographed the photographs of Walker Evans and Edward Weston and then presented them as her own – which in a literal sense they were. She also copied the works of German expressionists and other famous modern artists. This strategy was intended to subvert the ideas that art consists of original works, that modern artists must be original, and to put into question ideas of authorship and the ownership of images.

Mike Bidlo (b. 1953) was also determined not to be original or authentic: he painstakingly copied works by Picasso, Giorgio Morandi, Jackson Pollock and others (to be more precise, he copied colour reproductions of their works rather than the originals). The motive was not forgery. Bidlo's paintings were always presented as Bidlos. His argument was that there is a surfeit of art, everything has been done. All that is left for the artist now is recycling the art of the past. (There was

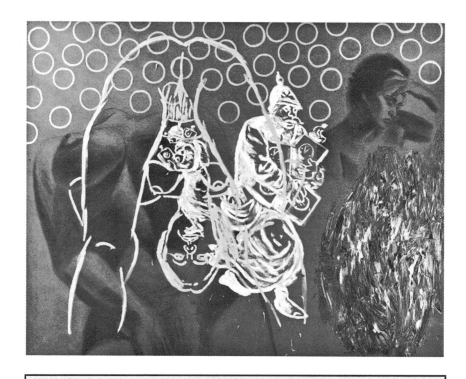

David Salle, 'The Burning Bush', 1982. Oil and acrylic on canvas, 2.34 x 3 m.
Photo courtesy of Anthony d'Offay Gallery, London.

an equivalent in rock music – what in Australia were called 'tribute
bands' – groups that imitated the styles of famous bands of the past and
performed their most popular numbers.) Bidlo's imitations attracted much
adverse criticism: he was accused of being uncreative, facile, a parasite, a
trivializer, a businessman and an entertainer. His art was certainly an
elaborate joke.

Barbara Kruger (b. 1945) is an American artist (or 'guerrilla semiolo-
gist') who became known internationally in the early 1980s for her bold,
laconic montages and posters cleverly combining slogans and high con-
trast, black-and-white photographs. Their content was generally critical –
they raised political or feminist issues and posed questions about power –
but they avoided the simplicities of left-wing agit-prop. Visually speaking
it was clear Kruger's art derived from the conventions of advertising and
magazine layout. Like Salle, she worked for several years as a graphic
designer and picture editor (for Condé Nast publications in New York).
Some of her images she created; others she borrowed from the mass
media or the history of art. A key feature of Kruger's pieces was the way
they interpellated or hailed viewers differentially, often according to their

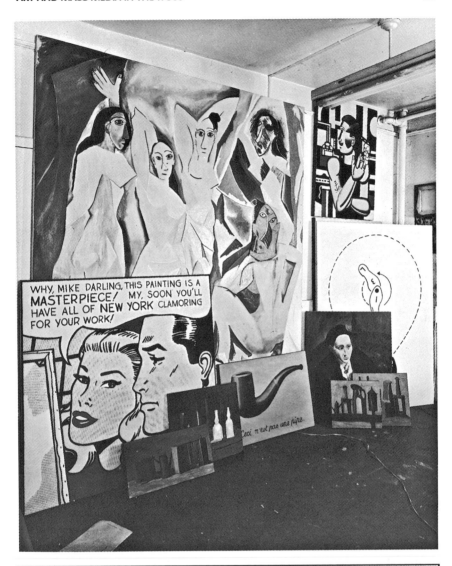

Mike Bidlo, Photo of his New York studio, 1985. Photo reproduced courtesy of the artist.

gender. Each viewer was forced to ask: 'Does the "you" in that caption refer to me? Am I the one being accused or admonished?'

Kruger's montages were marketed in private galleries (displayed in wooden frames painted with bright red enamel) and exhibited in public museums, but they also reached a wider audience by being displayed in the street in the form of posters, billboards, electronic signs, T-shirts,

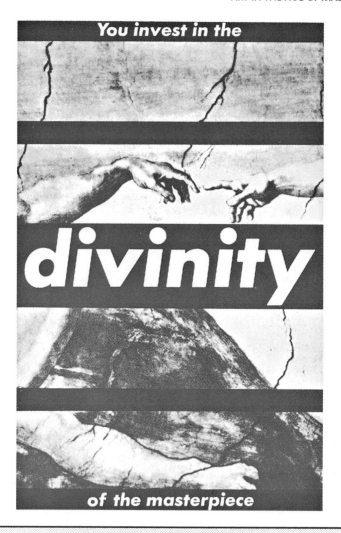

Barbara Kruger, 'Untitled', 1982. 1.82 x 1.16 m. Museum of Modern Art, New York. Reproduced courtesy of the artist.

Kruger employs a detail of one of the most famous images of western European art – Michelangelo's Sistine ceiling fresco showing God creating Adam. Not only is a divine being represented, the creator of the image was considered by his contemporaries to be divine (God's gift to Italy). There is no dispute: this is a masterpiece by one of the world's greatest male artists. However, Kruger interpolates or 'ruins' the Michelangelo by overlaying it with words and thick bands of black. The superimposed caption problematizes the idea that art comes into being as the result of some god-like or magical act of creation. Her use of the word 'invest' has a double connotation: the subjective investment we make when we worship such masterpieces; and art as a financial investment.

placards and leaflets. Furthermore, she lent her communication skills to various campaigns and radical groups including WAC – Women's Action Coalition – a women's issues, activist organization founded in New York in January 1992.

Plagiarists

Plagiarism is the appropriation and passing off as one's own the work of others. It is generally considered reprehensible, theft even, but paradoxically it has been recommended by such literary luminaries as T. S. Eliot, Lautréamont and Oscar Wilde. In 1988 a number of radical artists organized a 'Festival of Plagiarism' consisting of a series of mixed-media exhibitions and events at off-beat locations in London and San Francisco. Among those taking part were Ed Baxter, Shaun Caton, Malcolm Dickson, Graham Harwood, Steve Perkins, Ralph Rumney, Karen Strang and

JOHN

The story of John the ordinary man is a narrative in fifty-four images, set against the background of the 1985 riots, nuclear threat and ever present struggle in South Africa. It is my attempt to bridge the gap between being an artist and being working class.

Narrative has played an important part in working class culture, from talking to each other in the factory to Hogarth's description of eighteenth century politics. This narrative is in the same tradition in which the exploration of The Life of John is an attempt to expose the prejudices, values and biases imposed upon working class culture by capitalism.

John is born into a rigid, degrading culture in which his life appears mapped out. Like his parents before him, he is educated to exist as a consuming wage slave but his education is not enough to do anything about it. The story is essentially about roles and the way they are used as props for authoritarian society.

ISBN 1-870736-01-X

£4.50

9 781870 736015

Graham Harwood, Front cover of *John and Other Storys* (sic), (London: Working Press, 1987). Reproduced courtesy of the artist.

Stefan Szczelkun. Theoretical justification was supplied by the British writer Stewart Home.

The self-proclaimed 'new plagiarists' promoted the activity as an 'anti-capitalist, revolutionary tool'; they saw it as a necessary response to image glut, as an attack on private property rights, and upon artworks as commodities. To facilitate the act of copying, liberal use was made of photo-copying machines. In practice, pure plagiarism rarely took place because in most cases transformations of the originals occurred.

Harwood (b. 1960) is a British plagiarist who regards himself as a working-class artist working on behalf of the working class. (The word 'artist' and the concept 'art' are in fact problematical as far as he is concerned.) During the late 1980s he devised a complex *mélange* of black-and-white images culled from the past and the present, from mass culture as well as the history of English painting (the work of William Blake in particular). By repeated use of a photocopy machine the source images were changed, combined, enlarged and reworked by hand. The end results were arranged in dynamic configurations on the walls of non-art venues such as cafés and community centres. Some were also organized into linear narratives and published as paperbacks by an alternative press. One of Harwood's aims was to make work entirely by means of reproduction for reproduction. Because his images were iconographically complex, they took time to digest. Their critique of British society and dominant ideologies emerged as a consequence of metaphorical association and recurring motifs rather than by means of simple slogans. Subsequently, Harwood switched his attention from photocopiers to computers.

Despite plagiarism's supposed anti-capitalist stance, the illegal copying of designs, bootleg recording, and industrial espionage are in fact typical of much rapacious capitalist business practice. Some fashion designers have been ruined because their new collections have been stolen and copied by criminal rivals. Furthermore, the use of other people's images, designs and inventions occurs every day within industry and the mass media quite legitimately, that is, whenever permissions and rights are granted in return for fees and credits. Artists can generally use any copyright image they wish provided they obtain permission and pay for the privilege. If, however, copyright holders impose restrictions on the use of their images, if they refuse artists the freedom to transform existing images, then comment, caricature and satire becomes virtually impossible. When this happens, private property rights in images become a form of censorship and social control.

Koons, the Master of Kitsch and Business Art

If Andy Warhol, the pope of pop and the inventor of business art, has an heir, it is Jeff Koons. Before he became a full-time artist Koons was successful in commerce: he was an effective membership salesman for the Museum of Modern Art, New York, and later a commodities broker on Wall Street. So he fully understood the world of business and the relations between art, money, publicity and marketing. It did not take

him long to earn several million dollars from the sale of his art. Koons is American but he lives in Munich with his wife, the Italian ex-parliament deputy, ex-porn actress Ilona Staller or La Cicciolina. (She is not permitted to enter 'the land of the free'.)

During the late 1980s, Koons became notorious for stainless-steel castings of kitsch objects such as inflatable rabbits and model trains, and for large wooden, polychrome sculptures and porcelain statues (both made by Italian craftsmen) based on mass media stars such as Michael Jackson and kitsch animals such as the Pink Panther. Kitsch objects had previously been collected and appreciated by Warhol and by the British sculptor Eduardo Paolozzi, and kitsch had prompted a number of pop artworks, but no one before Koons had presented kitsch on such a scale or with such glee. Kitsch – the epitome of bad taste – fascinates and repulses at the same time; it appeared to be the last taboo as far as high culture and avant-garde art were concerned. (Later, however, it emerged that the final frontier was pornography.)

Kitsch is easy to recognize but difficult to define. Machines have made it a simple matter to manufacture and replicate, hence it is everywhere in our society. It is particularly associated with childhood, gifts, tourism and annual rituals such as Christmas. Clement Greenberg's famous 1939 essay opposed avant-garde art to kitsch, but the question arises: is kitsch different from art, or simply bad art? (Adorno once argued that kitsch was a poisonous substance mixed in with art.) Kitsch is undoubtedly more in evidence in the world of mass production than in the fine arts, but kitsch can also be found in traditional art forms such as painting; witness Vladimir Tretchikoff's immensely popular, green 'Chinese Girl' of 1952.

Koons' giant knick-knacks were grotesque; many involved a regression to the cloying tastes of childhood; they certainly shocked, amazed and amused viewers when they first appeared. Theorists were puzzled: had Koons raised kitsch to the level of art, or reduced art to the level of kitsch? The question was unresolvable because his integration of the two resulted in a new hybrid: kitsch art. Although Koons was dismissed by many critics as a puerile artist, a shallow opportunist, an utter fraud, his rapid financial and media success demonstrated that even kitsch art was acceptable to collectors and curators if it came from a 'serious' artist backed by a leading New York gallery.

Koons's explanations of his work include many references to the capitalist system and the class structure of western societies. Banality was the culture of the bourgeoisie – by celebrating kitsch he was trying to dispel the guilt and shame they felt about it. Sophisticated tastes segregated and excluded people: he was interested in penetrating mass consciousness, not appealing to a minority such as the artworld intelligentsia. By making an art that was accessible and popular he was broadening the audience for art. He even claimed to be levelling class differences by bringing 'the aristocracy down and the lower classes up'. (Presumably, so that everyone could join the class in the middle.) He told *Blitz* magazine (January 1990): 'I was making extremely bourgeois art. And I was making it on purpose. This was my political power base ... I'm at the service of that class.'

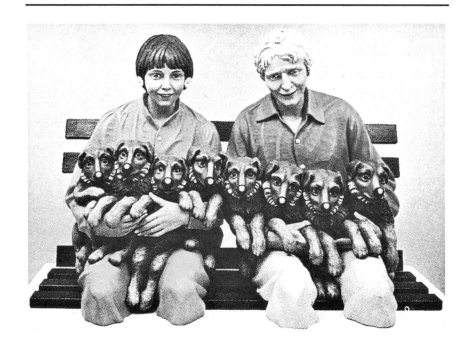

Jeff Koons, 'String of Puppies', 1988. Polychromed wood, 107 x 157 x 94 cm. Collection Phoebe Chason, Harrison, New York.

Koons (b. 1955) is an American 'neo-geo/neo-pop' artist who became famous in the 1980s for 'sculptures' consisting of new consumer goods encased in Plexiglas display cases. Subsequently, his source material became banality or kitsch. The above wooden sculpture was carved by Italian craftsmen working from a popular postcard that Koons supplied. On the postcard was a photo taken by the American photographer Art Powers.

Koons 'appropriated' the photo without asking Powers' permission or paying him a fee, even though Koons was affluent enough to afford a considerable sum. Nor did Koons bother to credit the source when 'String of Puppies' was exhibited. The outraged Powers sued for $2.8 million in damages and in 1991 Koons was found guilty of plagiarism by the American courts, even though there is a case to be made that the carving has involved a transformation of Powers's photo. There are significant differences: the sculpture is three-dimensional not flat; it is larger in size; colour has been added; other minor additions and changes of expression were also made. There is some justice, therefore, in Koons's claim that he has 'enhanced' Powers's subject in order to intensify its banality.

Koons's fame and wealth, his cavalier attitude to the law and other people's private property, prompted several other law suits for unauthorized copying.

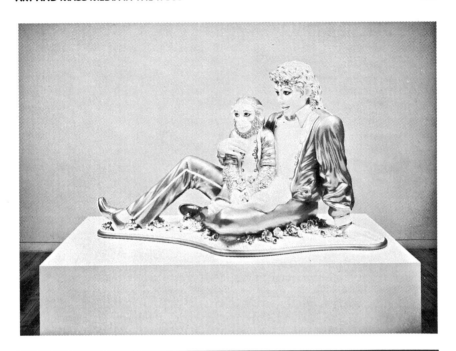

Jeff Koons, 'Michael Jackson and Bubbles', 1988. Porcelain, edition of three, 106.7 x 179 x 81.3 cm. Photo courtesy of the Sonnabend Gallery, New York.

This neo-baroque porcelain is a life-size portrait of the pop music star Michael Jackson holding his pet chimp 'Bubbles'. Its selling price was reputed to be $250,000. Koons greatly admired Jackson. He told one interviewer: 'If I could be one other living person, it would probably be Michael Jackson'; he told another that Jackson was 'the most radical artist alive today' a great 'manipulator and seducer'. Koons's statue caused controversy because the white porcelain made the black entertainer seem like a white man. (Jackson himself has lightened his skin and undergone numerous plastic surgery operations to 'improve' his appearance.) Koons approved of self-transformation no matter what the cost. It was the duty of the artist to communicate, and Jackson was a consummate communicator. It was also the duty of the artist to exploit the masses but that also involved self-exploitation. Jackson, he claimed, had to become white in order to appeal to white, pubescent, middle-class American girls.

At least Koons was frank about his class affiliation. 'Radical conservative', another of his self-descriptions, also applied to the politician who dominated Britain during the 1980s – Margaret Thatcher. One would never guess from Koons's art that the bourgeoisie was once a revolutionary class espousing the ideals of liberty, equality and fraternity. (This memory has been kept alive in the work of the Scottish artist Ian Hamilton Finlay.)

Koons's limited edition sculptures were so expensive they could only be

bought by wealthy individuals or institutions, consequently he did not really make art for the people. In any case, the masses already owned the cheap kitsch his art magnified and monumentalized, or it was available to them for the price of a day ticket to Disneyland. Yet, in spite of Koons's identification with the bourgeoisie, there was a touch of the rebel about him: he once expressed a desire to lead the bourgeoisie into a dead end, into à state of entropy. Perhaps this was the hidden motivation behind his Disney-style art.

There was one of Koons's ambitions which even those who dislike his work might regard as positive. Namely, the desire to restore some social power to art, to make it an effective means of communication again. Koons recognized that, in an age dominated by the mass media, the artist could only achieve this by learning from the media:

> I believe an artist has to have a dialogue with the media, at present, because the media define reality. [14]

> You have to embrace other media, and industries other than 'art', as the only way to be effective in contemporary society. [15]

As explained in the introduction, the art and creativity of mass culture stars such as Jackson and Madonna is not confined to live performances or products such as records and videotapes, it also encompasses every aspect of packaging, marketing, self-presentation and self-promotion. In other words, the stars need to manipulate their media appearances and to control every phase of their careers. They realize that photo-shoots and television interviews are as vital as the person or product they are about. There is then an interplay between the star's product and the media presentations, between their art and the whole metatextual narrative telling the story of the star's rise to fame and success. Fans come to admire the artist's independence, management abilities, their career moves and wealth; they share vicariously in the economic and cultural power that successful stars wield.

Like Madonna, Koons provided a succession of bodies of work themed for ease of characterization by journalists, each with sufficient shock value to guarantee a wave of media coverage. He also supplied the art press with his own adverts (staged photographs of himself) and provided provocative soundbites about his work. Like Warhol before him, Koons adopted an artificial public persona – so that people were never really sure whether or not he was sincere. (He denies any irony is intended, but then he would, wouldn't he?) Koons's persona was that of the American dream: anyone can become successful/president if they desire it enough; look at me, if I can become successful anyone can!

During the 1980s the inner workings of the capitalist financial markets became a spectacle that fascinated millions. The ruthless art of business even became the subject of a movie – Oliver Stone's *Wall Street* (1987). Koons's business art, his rise to fame, his acquisition of large sums of money, therefore, was part of a more general fascination. If someone decides to write a play about Koons, the title should be 'Triumph of a

Salesman' not 'Death of a Salesman'. Salesmen, Koons believes, 'are today's great communicators'.

In the early 1990s, again like Madonna, he retailed a cocktail of sex and religion. Koons pulled off a publicity coup at the 1990 Venice Biennale by displaying sculptures and large, silk-screened prints of colour photographs of himself and La Cicciolina copulating. Koons also began to make a film about his romance and marriage to Staller entitled *Made in Heaven*. He commented: 'Ilona and I were born for each other. She's a media woman. I'm a media man. We are the contemporary Adam and Eve.'[16]

What happened was that the great American art salesman embraced (literally) a European queen of porn in order to bring about a merger (literally a marriage) between art and pornography. The objective was to destroy or blur the boundary between the two realms. Like Koons, Staller had used her natural gifts to make herself famous and affluent. Her promotion of sex had been justified by a liberationist philosophy of love derived from the 1960s; however this proved not to be an alternative ideology to repressive morality but a means by which the sex industry could expand. Removing moral barriers was as important to the expansion of the sex industry as the removal of financial regulations was to the money markets.

Koons employed the Catholic, kitsch styles of the baroque and rococo in order to endow the wooden carvings of the copulating couple with a religious quality. Unlike the Christian art of the past – which shows Adam and Eve being expelled from the Garden of Eden because of their discovery of sex – Koons depicted an innocent, guilt-free pair enjoying the sexual act. He therefore contradicted the Bible's message that sex is sinful by informing the world that it is good and wonderful. This enabled him to make the blasphemous (?) claim: 'Through our union we're aligned once again with nature. I mean we have become God. That's the bottom line – we've become God'.[17] There's no denying Koons's ability – he is a consummate comedian. (The marriage 'made in heaven' did not last for long: in January 1994 it was reported that Koons and his wife had become estranged and in dispute concerning the custody of their son Ludwig Maximillian.)

9. ARTISTS AND NEW MEDIA TECHNOLOGIES

A survey of all the various mechanical devices visual artists have employed over the centuries would require another volume, and so this chapter will be confined to a few examples in which photography, photocopiers, video and computers were used.[1]

Like the history of avant-garde art, the history of modern industry and business is characterized by constant innovation and competition between rival groups. Experimentation and invention by scientists and engineers has resulted in new media technologies such as photography, cinematography, videotape recording, computers, etc. which in turn have given rise to huge new manufacturing and entertainment industries, mass employment and products enjoyed by billions. At first, the rarity and high cost of new media technologies meant that they were confined to wealthy organizations and specialist, professional producers. After a while, however, such devices as cameras, camcorders and computers appeared on the mass market. These developments enabled millions of people with average incomes to make and enjoy their own images, to become part-time cultural producers. The popular hobby of amateur photography is one such example.

Photography

Visual culture produced by amateurs tends to be highly restricted in terms of its content, form and social functions. Most amateur photography, for example, is concerned with the positive moments of private, domestic, family life; it is strongly associated with leisure activities and tourism. Amateur photography is less than truthful in its avoidance of the unhappy and tragic incidents of family life. Beginners and amateurs rarely question the medium they adopt. Normally they imitate the pictorial conventions of the mass media with which they are already familiar. Few of those who own cameras or camcorders think of using them as critical tools, as political weapons. For the most part, popular pastimes are used to fill or kill time rather than to use it in ways that contribute to the understanding and solution of urgent social and ecological problems.

Some radical initiatives have occurred in the twentieth century: during the 1920s and 1930s, for example, worker photography and film movements developed in Germany, Holland, Britain and the United States.[2] Prompted by left-wing parties, associations and pictorial magazines such as *A-I-Z*, these movements were intended to provide an alternative popular culture to that supplied by mainstream media. Their aim was to dispel the 'policeman in the head' syndrome and to encourage participants to become 'the eyes of the working class'. This objective was to be achieved by documenting social reality, by operating collectively in teams

to produce systematic accounts of events, and by supplying the left-wing press with images taken from a working-class viewpoint.

Community photography – a phenomenon of the 1970s – was similar in certain respects.[3] Local groups and workshops were established to provide facilities, teach skills and to encourage citizens in deprived neighbourhoods to use photography as a critical tool. A slide-tape show documenting the poor state of council housing, for instance, could serve as an effective audio-visual aid when presenting a case for repairs to local officials. In the East End of London the organization called 'Camerawork' has been a crucial influence on the non-commercial promotion of photography. It has encouraged the production of images and mounted circulating exhibitions. Camerawork also has a permanent exhibition gallery and for a number of years it published a magazine which served a vital educational function.

Jo Spence (1934–92) helped to establish Camerawork. She was one of the most energetic and courageous British photographers of recent decades to emerge from a working-class background.[4] Her early experience of working in high-street commercial photographic studios eventually resulted in disillusionment with the aesthetic and social functions the medium performed (for example, the popular genres of portraiture and wedding photographs). However, through involvement with socialist and feminist groups during the 1960s and 1970s, she developed highly original ways of using the medium to address such themes as children's and women's rights, women's working conditions, the representation of men, health services, her personal history and identity.

In 1980, feeling she lacked an understanding of the theory of photography, Spence undertook a polytechnic media course in which she studied the semiotic analysis of imagery. Besides taking photographs, Spence taught and lectured; she organized exhibitions and wrote articles and books about the medium and her own practice. With Terry Dennett she established the Photography Workshop and together they edited the first volume of an alternative photography annual entitled *Photography/ Politics* (1979).

Spence took some memorable photos of her naked, middle-aged body that were startling in their honesty and intimacy. In 1982 Spence learnt she had breast cancer. Characteristically, instead of abandoning photography, she took her camera into hospital. Later, in collaboration with Rosy Martin, she used the medium of photography as an aid to healing and self-understanding. (They devised the terms 'photo-therapy' and 'psychic-realism'.) Camera sessions were employed in order to act out scenes from the past and to explore the various images of the self from which their social identities were constructed. Photo-therapy was intended as a radical alternative to conventional portraiture and medicine.

For several decades Spence employed the method of 'staged photography' to challenge the assumptions and practices of professional, commercial, documentary, amateur and fine art photography. The fact that her iconoclastic work is so difficult to place is a tribute to its refusal of existing photographic genres and conventions of good taste and beauty.

Terry Dennett and Jo Spence, 'Realization' (Capitalism works), a staged photograph from the 'Remodelling photo-history series', 1982.
Gelatine silver print, 25.5 x 20.3 cm. Collection Terry Dennett. Copyright: T. Dennett/ J. Spence Memorial Archive.

In this parody of portrait photography, Jo Spence wears a smiling mask while playing the role of contented consumer and housewife. The photo-montage/poster 'Capitalism works – could you wish for anything more?', on the wall behind, used for ironic purposes, is by John A. Walker.

Photocopiers

A contradiction exists between capitalism's system of private property – which limits people's use of copyright images – and its encouragement of technological inventions – such as photocopiers, tape and video recorders – which make the task of copying images and sounds easier. During the 1980s the humble photocopier, invented by Chester Carlson in 1938, became a crucial tool in the creative process of many artists and designers; there was a vogue for so-called 'copy art' (or 'copier art', 'photocopy art', 'electroworks' and 'xerography'.) Exhibitions of copy art were held around the world at art fairs, in private galleries and in community centres. The first major survey – *Electroworks* – took place at George Eastman House, Rochester, New York in 1979. A year later, in San Francisco, Ginny Lloyd opened an 'electro arts' gallery in order to show local xerox artists, while in New York an International Society of Copier Artists was founded in 1982 by Louise Neaderland. Members kept in touch via a quarterly magazine which often consisted of anthologies of copy art.

Louise Odes Neaderland, 'The Nuclear Fan: to Hiroshima with Love', n.d.
A fan-form book with the text 'This is only a test'. 10 grommeted leaves with tasselled slip case, 21 x 7 cm. Photo courtesy of the artist.

Neaderland comments: 'Allows you to fan yourself with a nuclear breeze'.

Using a photocopier artists can reproduce existing images (or details of them) selected from the cornucopia of pictures supplied by the mass media simply and cheaply, but exact duplication is rarely their intention. What interest them more are the opportunities for montage, distortion and transformation. In this respect any degradation of the image during copying or recopying is an advantage rather than a disadvantage. Artists can reduce or enlarge images and modulate their original colour schemes by changing the hue and tone settings on the machine. (Colour photo-copiers date from the late 1960s but became generally available in the mid 1970s.) By moving the original during scanning, blurs and smears can be generated. Variations of colour and texture can be achieved simply by inserting different kinds of paper into the machine. By copying on to special materials, image-transfers to fabric or T-shirts are possible.

Images can also be reworked by hand and then copied again. Superimposition or layers of images result from copying on to already printed sheets of paper. The same image can be repeated over and over again and then assembled into larger patterns Warhol-fashion. Alterna-tively, different images can be collaged together to produce complex, billboard-sized murals or room-sized installations. Artists can also place their bodies on the machine and copy parts of them. Three-dimensional objects placed on the document glass of the machine are reproduced in a distorted manner because of the machine's shallow depth of field. In short, the artistic potential of the technology depends upon ways of exploiting it that stretch its normal operations and go beyond its commercial applications.

Because this form of art is based on mechanical reproduction and because copying machines are widely distributed it has a high democratic potential, in the sense that people without artistic training can make examples for small sums of money. This point was made by the Italian artist-designer Bruno Munari as early as 1970 when he installed a Rank Xerox machine at the 35th Venice Biennale for the use of visitors. Copy artists exhibit in galleries but they also publish postcards and collections of images in the form of books and magazines. Size of edition tends to be small but if additional copies are required they can easily be generated via the photocopier. In addition copy artists avail themselves of the international 'mail art' network in order to circulate and distribute their work. Mail art can be interactive in the sense that artists can add to what they receive and post it out again. Even faster than the postal system is the fax telephone machine. Copy artists can annihilate space and time by faxing their images around the globe in seconds. For example, in 1989 David Hockney faxed a giant picture called 'Tennis', sub-divided into 144 sections, from Los Angeles, California to Bradford, Yorkshire.

Photocopiers can also make works of art by professional artists available to large numbers of people at very low prices – hence the possibility of 'throwaway art' – even though when this happens it challenges the rarity value of art and the financial basis of the gallery-dealer system. It seems therefore a negation of this democratic potential

Sarah Lucas (b. 1962), 'Fat, Forty and Flabulous', 1990. Photocopy on paper. 214.5 x 312.5 cm. Photo: Gareth Winters. Reproduced courtesy of the artist and the Saatchi Collection, London.

In 1990 Lucas based a series of works on the mass circulation British publication the *Sunday Sport*. Using A5 photocopies, she enlarged several double-page spreads featuring comical, grotesque stories about, and images of, women. Giant pictures were then created by attaching the photocopies to boards (they resembled Warhol's 1960s paintings reproducing the front pages of newspapers). The *Sunday Sport* is a vulgar, sexist, tabloid 'newspaper' which wallows in bad taste. The pages reproduced above (dated 25 November 1990) recount the story of a husband who became so fed up with his wife's flabby flesh that he put her up for sale along with his house. Juxtaposed against it are telephone sex adverts and a sarcastic piece about 'arty farty' students signing up for a university course on the pop star Madonna. (Even the *Sunday Sport*, it seems, is conscious of the division between high and low culture.)

Lucas could be accused of 'uncritical reproduction of photographs which exploit women', of 'aestheticizing and monumentalizing ephemeral trash', of 'elevating unworthy material to the level of art' or 'adulterating art with base matter', but she regarded her selection and copying of misogynist imagery as a way of exposing the lumpen-proletariat end of British popular culture. In her view, the raw material was so blatant that additional critical comment was unnecessary. The re-presentation of such images and stories in a high culture, fine art context (the Saatchi Gallery, 1993) was mildly shocking and it did bring the material to the attention of liberal, middle-class viewers whose preferred reading was probably the 'quality' press. However, the *Sunday Sport's* features had an exotic appeal and, since they were readable, they still functioned as a gross form of entertainment. Perhaps the unintended result of Lucas's intervention was to highlight the crude but effective arts – the writing and layout skills – of British tabloid journalism.

when one encounters copy art murals with high price tags displayed in inner-city community centres. However, it should be admitted that what appeals to many artists about xeroxing is not its capacity to generate lots of identical images but rather its capacity to generate an endless series of unique, original images. The latter can then, if desired, serve as 'sketches' in the creation of larger-scale, more permanent silk-screened canvases (as in the art of John Stezaker). In the case of some artists, copying is just one facet of their work; others specialize in copy art.

The fact that copy artists depend upon the same machines does not mean that they share a common style or aesthetic. Artists as various as Ian Burn (a conceptual/process artist who made *Xerox Book* in 1968), Laurie Rae Chamberlain (a punk-inspired colour xeroxer exhibiting in the mid 1970s) and Helen Chadwick (a feminist artist using her own body as subject matter in the 1980s) have employed photocopiers for very different purposes. The manufacturers of copying machines are an obvious source of funding for artistic experimentation, and such companies as Rank Xerox, Canon and Selex have been willing to lend their machines, to sponsor shows and to pay for artists-in-residence schemes.

When, in the 1930s, Walter Benjamin wrote his famous essay on the impact of mechanical reproduction upon the arts, he did not anticipate the extent to which artists would embrace photomechanical technology in order to reinstate the claims of art. Using photocopiers it is all too easy to generate unimaginative results. When copy art is poor it seems nothing more than yet another example of visual pollution, but at its best it is a creative response to the mass media's deluge of images.

Video

Nam June Paik (b. 1932) is a Korean–American artist-composer and Fluxus performer who has specialized in video and television for much of his career.[5] His acquisition of a Japanese-made, portable video camera and recorder in New York in 1965 has become legendary as a crucial date in the chronology of video art. A gleeful statement he made – 'Television has been attacking us all our lives, now we can attack it back' – has also become famous. This remark reveals the antagonism Paik and many other video artists felt towards broadcast television. A spate of works followed in which TV sets were physically demolished or their images distorted (by such means as attaching magnets to the set).

Live performance was a key component of Paik's art, consequently public venues such as galleries and film/video festivals continued to be important to him. Paik constructed robotic figures and sculptures using numerous TV monitors (the latter were often antiquated and semi-defective); he and other artists also devised closed-circuit video environments involving audience participation and mixed-media installations. This kind of video art resisted assimilation by mainstream television.

A British video installation entitled 'Television Interview' is relevant

Nam June Paik, 'TV Buddha', 1974. Closed-circuit video system with eighteenth-century Buddha statue. Stedelijk Museum, Amsterdam. Photo courtesy of the artist and the Stedelijk Museum.

In this installation Buddha contemplates his own image on a circular TV set. (An alternative description of video was 'the mirror machine'). This slyly humorous work equates the eternity of religion with the eternity of television.

to this text because it directly addressed the division between video art and broadcast TV. The installation, by Kevin Atherton (b. 1950), was shown at *The British Art Show* held in Birmingham in 1984. It consisted of two TV sets facing one another. Atherton appeared on the screen of one set asking questions about video art, while on the other a doctored episode of the popular, working-class soap opera *Coronation*

Street appeared. The soap opera had been altered so that characters seemed to be replying to Atherton's queries. A sense of the uncanny was created by the sight of two TV sets conversing; also piquant was the encounter between the stars of *Coronation Street* and a British video artist.

Video art's playful and experimental aesthetic hindered its acceptance by broadcasters and the viewing public for a number of years. Radical politics was also a factor: some videos were critiques of commercial television: Richard Serra, for example, made a tape in 1973 which bluntly declared 'Television delivers the people ... You are the product of TV, you are delivered to the advertiser who is the customer.'

Of course, the attitude of video artists towards broadcast television was ambivalent. Because they realized the medium could reach much larger audiences and provide greater financial and technical resources than the gallery system, few could resist invitations to experiment with TV studios and editing suites, and most were happy to have their tapes transmitted whenever the opportunity arose. In Britain during the 1970s and 1980s a series of television arts programmes featuring a range of tapes by leading American and European video artists were shown.

Paradoxically, the short-lived vogue for quoting and treating images stolen from mainstream films and television – so-called 'scratch video' – was not featured on television very much because of the problems of clearing copyrights. However, the parodic techniques of scratch were quickly imitated by the makers of TV commercials and rock music videos.

Computers

Fine artists have employed computers to generate and manipulate images for more than two decades.[6] Since a history of computer art is beyond the scope of this book, only a few recent examples will be considered. The Quantel Paintbox, an expensive digital machine, made its appearance in 1982. It was to prove immensely valuable to graphic artists working for television. The machine was developed by the international company Quantel (similar machines were made by various other companies). A colour monitor replaced paper or canvas, consequently colours were mixed and painted in light directly on the screen via a touch tablet upon which the artist or designer drew with an electronic stylus. The machine's range of facilities included: painting, airbrush, graphics, text, cut and paste, stencil operations and picture library. Designs and colours could be altered rapidly, effortlessly and endlessly.

Arguably, these interactive machines incorporated and automated pictorial tools and techniques that had been evolved over the previous two thousand years. During the 1980s the machine was instrumental in helping to produce sophisticated TV graphics to introduce programmes and special effects in TV commercials and rock music promos. It was also used by several fine artists. For instance, in 1987 Jennifer Bartlett,

Richard Hamilton, David Hockney, Howard Hodgkin, Sidney Nolan and Larry Rivers experimented with the machine for a BBC2 TV series entitled *Painting with Light*. The artists were novices as far as the machine was concerned, so technical assistance had to be provided by Martin Holbrook, an experienced operator.

Hamilton was impressed by the Paintbox, especially by its ability to manipulate pre-existing imagery. He had often constructed his paintings from a series of photographs, so he used the machine to call up images from a library of news stills and then combined and reworked them in various ways. (Once photographs have been digitalized they can be retouched in many, undetectable ways.) What astonished the artist most was the Paintbox's ability to 'collage with soft edges', a task impossible when using scissors to cut out shapes from a photograph. The photos he used were of the Protestant Orangemen and scenes of civil strife in Northern Ireland.

One aspect troubled Hamilton about the Paintbox, namely, what he termed 'the hard copy problem'. Hard copy was available in the forms of still photographs, film or videotape recordings, but Hamilton still wanted pictures large enough and permanent enough to hang on the walls of museums. Two such pictures were subsequently created: 'Countdown' (1989) and 'The Subject' (1988–90).

Also during the 1980s the British artist William Latham (b. 1961) programmed computers to generate strange, organic forms resembling coloured intestines or fossils.[7] These forms were called 'computer sculptures' and 'proto-sculptures', even though they exist (so far) only as images. The 'sculptures' can be endlessly varied in terms of their forms, colours, textures and surface patterns; they can be made to look smooth or shiny, or like velvet or silk. Latham studied at the Royal College of Art, London, and then became a research fellow with the Graphics Applications Group of IBM at their scientific centre in Winchester. One of the programs Latham used – 'Mutator', devised by Stephen Todd – mimicked the evolutionary processes of nature. In Latham's case hard copy took two forms: still images – Cibachrome prints; and moving pictures – a film entitled *Mutations* (1991). The latter medium was obviously more effective in recording transformations over time. Latham's film showed the computer sculptures rotating, mutating, being sliced and entered. Clips appeared in popular science and computer arts programmes shown on British television.

Latham did exhibit his work in art galleries but the airing of his film on TV showed that if an artist decides to use new media technology to generate 'hard copy' in a form suited to existing media channels, rather than a form associated with galleries and museums, then the artist can use those distribution systems to reach a much larger and wider audience. Of course, temporal works of art recorded on film or video require machines to be seen and take time to view, consequently they are not so immediately available to viewers as a still image displayed on a wall. Furthermore, a painting that is in a national collection may be seen by many generations of viewers.

Richard Hamilton, 'Countdown', 1989. Humbrol enamel on Cibachrome on canvas, 100 x 100 cm. Hirshhorn Museum and Sculpture Garden, Smithsonian Institution, Washington, Holenia Trust Fund, 1991. Photo: Lee Stalsworth, reproduced courtesy of the artist.

This work is a clear example of Hamilton's lifelong fascination with modern media technologies and techniques. 'Countdown' was the result of a complex process in which a still image passed through several media and several phases of transformation. A news photo of an Orangeman marching was scanned and stored in the memory of a Quantel Paintbox. Later it was called up to appear on the machine's colour monitor for the purposes of electronic masking and reworking by Hamilton during the course of making the TV arts programme *Painting with Light*. Hamilton's interaction with the Paintbox was recorded on videotape for editing purposes – hence the frame numbers at the top. Next, Hamilton made a transparency from one frame of the editing tape. The transparency was then used to make a Cibachrome print for mounting on canvas. Finally, enamel paint was added by hand. 'Countdown' is a hybrid artefact, a blend of photography, computers, video and painting.

William Latham, 'Computer Sculptures', 1988. Photographs courtesy of the artist.

These bizarre objects represented a convergence of artistic creativity, science and technology. They seemed to make visible the processes of nature but, fascinating though they were, some viewers felt the lack of a human, social dimension.

Graham Harwood, Poster given away free with *If Comix: Mental*, 1991.
58 x 41 cm. (London, Working Press/Counter Productions.) Reproduced courtesy of
the artist.

During the 1980s, picture books about serious subjects aimed at adult readers – so-called 'graphic novels' – became fashionable, and their illustrations set a new standard in terms of high-quality drawing, colour and printing. Of course, comic strips and books have been forms of mass communication for over a century and a number of fine artists have adopted them in order to appeal to a popular audience. Graham Harwood is one such artist. Earlier I discussed his use of photocopiers and printed books. Subsequently, his interest shifted to computers with graphics facilities. Harwood aims to demystify advanced technology; he believes anyone can use it and bend it to their own purposes.

By modifying 'borrowed' computer programs he discovered ways of distorting existing images in a striking and original fashion. Harwood's computer-treated figures consisted of striations (mainly horizontal) with strong black-to-white tonal gradations; this gave them a shiny, metallic, robotic quality; they seemed to pulsate with light or electricity. The striations extended across the figures and their environments, so that the characters appeared to be victims of powerful internal and external forces.

Images were then arranged in a narrative and published in a magazine format (a poster and flexi-disc were also issued). Harwood claimed that his *If Comix: Mental* was the first all-computer generated comic to be created. It explored the subject of the Gulf War of 1991 as if viewed by the director of the movie *Apocalypse Now*. One familiar pop painting Harwood repeatedly mangled was Lichtenstein's 'Whaam!'. The comic's combination of dynamic imagery, obscene language, deranged plot and violent anti-war rhetoric, made for a potent brew of art and politics. In the next chapter two further artistic responses to the subject of the Gulf war will be considered.

10. WAR, THE MEDIA AND ART IN THE 1990s

In western democracies modern wars are normally reported immediately and in detail by television, radio and the press. Many images and much information reaches the public in spite of government censorship and the selection/editing procedures undertaken by the media themselves. Given the availability of such information, the question arises: what can a work of art say about war that news reports do not? Arguably, art is able to be more complex and truthful because artists have more time and more freedom to digest the information and to reflect upon its significance. Unlike news reporters and photo-journalists, artists do not have to be 'objective' and 'balanced'. If they wish they can include personal responses and critical comments in their works. Artists may also be capable of generating pictures and sculptures that are more imaginative and/or monumental than news photos or film-footage, and if these enter the collections of national museums and galleries then they may have a much longer lifespan.

In 1991 John Keane (b. 1954), a British figurative painter, was commissioned by the Imperial War Museum to cover the Gulf War. A member of the Labour Party and a veteran of trips to Northern Ireland and Nicaragua, Keane was reputed to be 'an anti-establishment artist'. His painting 'Mickey Mouse at the Front' was prompted by his visit to the devastated seafront near Kuwait City once Iraq's army had been expelled. The artist employed modern media recording technologies – videotape and still cameras – to 'sketch' in the field but, somewhat paradoxically, what emerged from his London studio were traditional, hand-painted canvases and drawings executed in a vehement, quasi-expressionist style. A qualification is needed: in some instances a collage or montage approach was used. For example, he surrounded one painted image with a border of still photos taken from video; he glued dollar bills to the surface of other works; and he painted on grounds consisting of printed matter.

The British press made certain that knowledge of Keane's war pictures was widely disseminated: one was reproduced in full colour in the *Guardian* (5 April 1991) and later, when the series was complete, other newspapers ensured that their public reception was accompanied by controversy and misunderstanding.

An earlier work of art about war that included a figure based on Mickey Mouse was Michael Sandle's 'A Twentieth Century Memorial'. During the 1960s, while Sandle was in Berkeley, California, he witnessed students being beaten up by the police during anti-Vietnam War demonstrations. So the immediate impetus for the work was the Vietnam War, and Mickey Mouse served as a symbol of the involvement of the United States, but the sculpture took Sandle seven years to complete partly because his researches revealed that the Americans were not the only ones at fault. The final work does not refer to any particular war, it is a

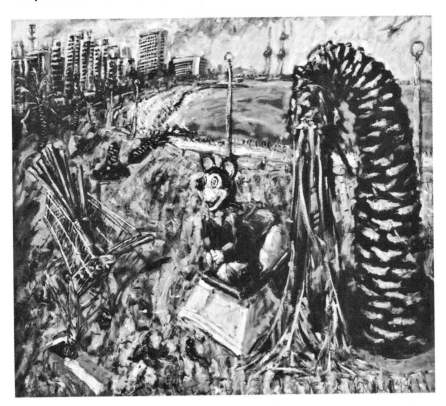

John Keane, 'Mickey Mouse at the Front', 1991. Oil on canvas, 172.8 x 198 cm. Photo courtesy of the Imperial War Museum, London.

Keane depicts a melancholy vista of shattered palm trees next to a supermarket trolley loaded with grenade launchers, a scene that a news reporter might not have bothered with. The appearance of a broken but still grinning Mickey Mouse child's amusement ride in the foreground – which naturally reminded viewers of the strong American presence among the Allies – caused a fuss when it was exhibited at the Imperial War Museum in March 1992 because it was assumed by some people that criticism of the United States was implied. Keane was also suspected of insulting the war dead, of 'taking the Mickey out of Gulf troops', and he was accused by one government politician of 'trivialising an important event'. Keane protested that no insults were intended, that his painting was a truthful record of one disturbing scene he witnessed in the Gulf.

generalized statement about all the wars and atrocities that have taken place in the twentieth century. Sandle told one interviewer: 'although it's about war, it's not necessarily anti-war, it's to do with my rather ambiguous thoughts about my own aggression, and war as a historical constant'.[1]

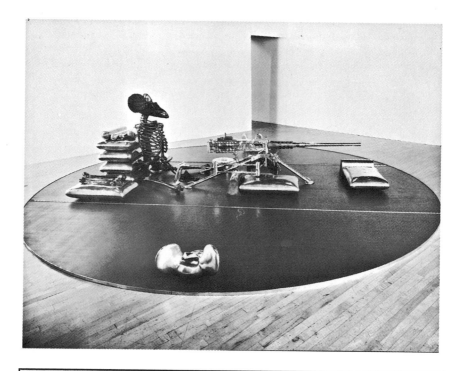

Michael Sandle, 'A Twentieth Century Memorial', 1971–8.
Bronze on painted wood base, 570 cm. in diameter, 140 cm. high.
Photo by D. Atkins, reproduced courtesy of the artist.

This impressive sculpture is just one of many contemporary works of art that feature the image of Mickey Mouse. Indeed, a whole book has been devoted to works taking Walt Disney's famous cartoon character as their subject matter. Most representations of Mickey have been affectionate, but in Sandle's case the mouse is a machine gunner, a sinister personification of violence and death. According to the artist, the mouse is blind to symbolize 'the stupidity of war'; his rotting corpse stands for 'capitalist decay'; the mouse also has connotations of 'obscenely light-weight' (that is, 'an amplification of the expression "Mickey Mouse", widely used to describe a certain kind of pervasive and essentially twentieth century mediocrity').

Another British artist who responded to the Gulf War of 1991 was Richard Hamilton, though unlike Keane he did not visit the Middle East. Like most of the populace of Europe and North America, Hamilton watched the war unfold on television. (Reports about the high-tech war were relayed daily via satellite transmissions.) Frequently, what viewers at home saw on television were pictures of TV monitors, computer screens and studio simulations, hence the war was doubly mediated. The subject of Hamilton's painting was thus the Gulf War as mediated by the mass media,

rather than the war as directly perceived. Hamilton used his home video recorder to tape clips from news programmes; a still frame was then selected and he photographed it along with the TV set and video recorder, plus a newspaper with the headline 'Mother of all battles'. Next, the

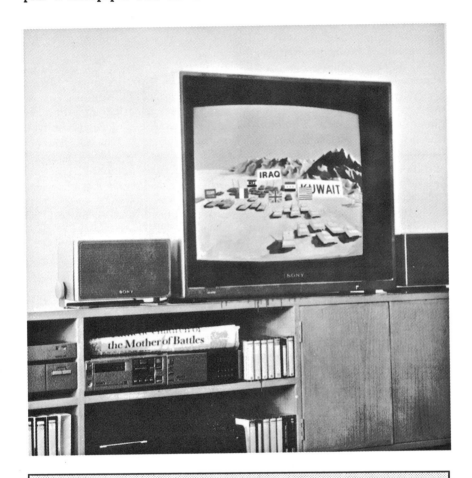

Richard Hamilton, 'War Games', 1991–2. Oil on Scanachrome on canvas. 200 x 200 cm. Collection the artist. Reproduced courtesy of R. Hamilton.

While watching the Gulf War coverage on TV, Hamilton was incensed by a sandpit model used by BBC's *Newsnight* programme to explain the disposition of forces. He thought it disguised the killing and suffering war actually causes. To drive this point home he added dribbles of red paint (to represent blood) to the completed work. The 'blood' seeps out from beneath the TV set. In 1992 'War Games' was due to appear on a London billboard (as part of BBC2's billboard project) but it was banned from one poster site by City of London authorities because they considered it too contentious.

photograph was enlarged via the computer-controlled Scanachrome colour system, transferred first to panel (for an outdoor exhibition in Hanover) and second to canvas (for gallery display) and painted over with oils.

So, like Keane, Hamilton employed modern media technology to produce a highly traditional end result. Hamilton evidently believes that the art of painting still has an important social function, that it can generate long-lasting, monumental icons that museums will preserve for the benefit of future generations.

Hamilton's reliance on media coverage of events is not that unprecedented in the history of art. During the 1860s Edouard Manet, a resident of Paris, painted a series of canvases in response to an incident which took place in Mexico – the shooting in 1867 by Mexican forces of the Emperor Maximilian (an Austrian Archduke who was a puppet of Napoleon III, the then ruler of France). Manet's paintings were based upon mass media sources: newspaper accounts and documentary photographs. During his lifetime Manet's 'Execution' series was subject to strict censorship, consequently his intended political intervention never succeeded.[2] Like Manet before him, Hamilton aimed to create a major history picture about a controversial contemporary event.

11. CONCLUSION

The interactions between art and mass media documented in this book seem set to continue as long as they both survive and retain their relative autonomies. Any 'conclusion', therefore, is likely to be provisional. However, it is clear that artists have used the mass media in a multitude of ways (and vice versa), and that some artists have adopted the modes of address, the technologies and means of communication associated with the mass media in order to reach a larger and broader public.

Robert Hughes, the art critic of *Time* magazine, once argued that fine art could not compete with the mass media on their own terms:

> Pop art was big and brash. It had learned from other media. But there was no chance it could survive outside the museum. Equally though, there is no way the museum arts can rival the commercial extravaganzas of the real world ... in any showdown between painting and the big media, painting cannot win.[1]

Characteristically Hughes privileges the art of painting (as if no other artforms exist). He is probably right to say 'painting cannot win' if he means small oil paintings on canvas, but a large wall mural in the street could well stand more of a chance. This is even more true of works of art appearing on billboards and Spectacolor signs, photo-montages printed in magazines and newspapers, videos transmitted on mainstream TV channels, audio works on tape and disc, etc. Enough examples of this kind have been described, I believe, to show that fine art can stand up to the mass media when it is prepared to employ the same forms and methods. Furthermore, when fine artists execute commissions for the mass media – as they do from time to time – their work becomes part of popular culture.

Hughes's conception of art as a rival to the mass media can also be questioned. Does fine art really attempt to perform the same aesthetic and social functions? This text has identified numerous contemporary artists who are providing a critique of the mass media's ideological assumptions, politics and manipulative methods. Art's ability to reach and influence people may be much less than the mass media's, but the critical independence manifested by politically-conscious artists is of genuine educational and social value.

Artists whose only base is the artworld are less able to make a social impact than those who infiltrate the mass media. But again many examples have been cited of artists who find it essential to have a foot in both camps: to show in galleries but also to undertake public projects.

In recent decades, new media technologies, TV channels and other communication systems have proliferated. We now live in a multi-channel and a multi-cultural environment. As a result, there are many specialist magazines, cinemas and TV channels appealing to audiences with particular interests. Compared to the mass audiences of the past, such

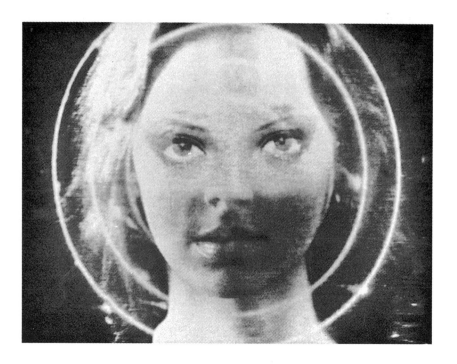

**Peter Greenaway and Tom Phillips (directors), Still image from *A TV Dante*
showing Joanne Whalley-Kilmer as Beatrice. An Anglo-Dutch co-production, the
series was first shown on Channel 4 in July 1990.**

A TV Dante was a series of eight, short (eleven minutes) television programmes
based on the eight Cantos of Dante's *Inferno*. Michael Kustow, who commissioned
the series in 1984, wanted to bring together the film-making skills of Peter
Greenaway and the painterly skills of Tom Phillips. The latter had translated and
illustrated Dante's *Inferno* (published by Talfourd Press in 1983, reprinted by
Thames & Hudson in 1985); this book provided the starting point. Bob Peck played
the part of Dante and Sir John Gielgud played the role of Virgil.

This TV version of a literary classic was remarkable for its pictorial complexity:
superimposition generated multiple layers of images (up to 16 at one point), and
small pictures within larger pictures enabled a visual commentary to be provided
(various experts appeared who supplied 'footnotes' to Dante's text). Often, the
soundtrack was also multi-layered. The directors' aim to create polysemic television
was made possible by the synthesizing and special effects capabilities of the TV
editing suite (video post-production was by Bill Saint).

It is clear from the above that *A TV Dante* was the result of an extraordinary blend
of different media and arts, both ancient and modern: literature, painting, acting,
still photographs, film footage, video and television.

audiences may be 'minorities', yet they can be quite substantial. (A late night British arts review TV programme is watched by several hundred thousand people.) This has enabled creators like Brian Eno (b. 1948), Derek Jarman (b. 1942) and Peter Greenaway (b. 1942), who all trained as fine artists but who later adopted audio-visual media such as film, music recording, video and computers, to produce work capable of appealing to these audiences. In other words, we can discern the emergence of an intermediate category of artists who exhibit some of the characteristics of fine art and some of the characteristics of the mass media. Greenaway's willingness to join forces with the British painter Tom Phillips (b. 1937) to generate a TV series reinterpreting a classic of Italian literature, Dante's *Inferno*, also exemplifies a fertile way forward for fine artists, that is, an experimental, collaborative practice making use of the arts and media of the past and the present.[2]

NOTES AND REFERENCES

Introduction

1. Although architecture has been less influenced by the mass media than the other fine arts it is still a subject of mass media representations. There are also instances of media impact in terms of the design and style of buildings – for example the work of Morris Lapidus (b. 1902), a prolific and highly successful American (of Russian–Jewish origin) commercial architect and interior designer, was inspired by the cinema; it also contributed to the cinema. (Some critics dismiss Lapidus's buildings as 'kitsch' and 'intentional nonsense', while others charaterize them as 'post-modern'.) He is best known for designing luxury hotels situated along Miami Beach. While searching for an opulent style, neither period nor modern, that would satisfy the popular tastes of his clients and the majority of the hotel guests, Lapidus realized that the cinema was a form of culture they all shared: 'So I imagined myself the set designer for a movie producer who was doing a film set in the most luxurious tropical setting...' Both movies and hotels, he concluded, were about escaping everyday reality, about illusion, fantasy and entertainment. His designs were so theatrical they attracted the attention of Hollywood film-makers. One of his hotels – the Fontainebleau (1953) – has been used as a film location: the 1964 James Bond film *Goldfinger* and the 1992 Kevin Costner movie *The Bodyguard*, for instance, included scenes shot there. Thus 'the imagined film set became the real one'. (Quotes derived from M. Düttmann and F. Schneider (eds), *Morris Lapidus: Architect of the American Dream* (Basel, Berlin, Boston: Birkhäuser Verlag, 1992), pp. 114-15.)

2. L. Alloway, 'The Arts and Mass Media', *Architectural Design* February 1958; J. McHale, 'The Fine Arts and Mass Media', *Cambridge Opinion* (17), 1959. On the work and career of John McHale see the exhibition catalogue written by C. Kotik and others: *The Expendable Icon: Works by John McHale* (Buffalo, New York: Albright-Knox Art Gallery, 1984).

3. The exhibitions include (title in italics indicates exhibition catalogue):
 Art in the Age of Mechanical Reproduction (Melbourne: George Paton Gallery, University of Melbourne, 1982).
 A Fatal Attraction: Art and the Media (Chicago: The Renaissance Society at the University of Chicago, 1982).
 Image Scavengers: Painting (Philadelphia: Institute of Contemporary Art, University of Pennsylvania, 1982).
 Simulacra: a New Art from Britain (London: Riverside Studios, 1982).
 Urban Kisses (London: Institute of Contemporary Arts, 1982).
 Popism (Melbourne: National Gallery of Victoria, 1982).
 Beyond the Purloined Image (London: Riverside Studios, 1983).
 The Comic Art Show (New York: Whitney Museum of American Art, 1983).
 Between Here and Nowhere: 9 New York Artists (London: Riverside Studios, 1984).

Disinformation: the Manufacture of Consent (New York: Alternative Museum, 1985).

Infotainment: 18 Artists from New York (New Orleans: Contemporary Arts Center, 1985).

Talking Back to the Media (Amsterdam: Stedelijk Museum, 1985).

Art & Advertising: Commercial Photography by Artists (New York: International Center for Photography, 1986).

Television's Impact on Contemporary Art (Flushing, New York: Queens Museum, 1986).

The Arts for Television (Los Angeles: Museum of Contemporary Art/ Amsterdam: Stedelijk Museum, 1987).

Comic Iconoclasm (London: Institute of Contemporary Arts, 1987).

The Image Multiplied: Five Centuries of Printed Reproductions of Paintings and Drawings (London: Victoria & Albert Museum, 1987–8).

Media Post Media (New York: Scott Hanson Gallery, 1988).

A Forest of Signs: Art in the Crisis of Representation (Los Angeles: Museum of Contemporary Art, 1989).

Image World: Art and Media Culture (New York: Whitney Museum of American Art, 1989–90).

High and Low: Modern Art and Popular Culture (New York: Museum of Modern Art, 1990).

Art et Publicité (Paris: Pompidou Centre, 1990).

The Independent Group (London: Institute of Contemporary Arts, 1990).

Pop Art (London: Royal Academy, 1991).

Objects for the Ideal Home, the Legacy of Pop Art: Artists of the 1980s and '90s (London: Serpentine Gallery, 1991).

'Art and Media Culture', (Eindhoven: Stedelijk Van Abbemuseum, 1992).

Pop and Artvertising (Venlo, Netherlands: MUBO [Museum Van Bommel-Van Dam], 1992).

Haring, Warhol, Disney (Phoenix, Arizona: Phoenix Art Museum, 1992).

1. Core Terms/Concepts

1. For an illustrated history of Fisher Park's rock set designs see: S. Lyall's *Rock Sets: the Astonishing Art of Rock Concert Design: the Works of Fisher Park* (London: Thames & Hudson, 1992).

2. A. Swingewood, *The Myth of Mass Culture* (London: Macmillan, 1977), p. 119.

3. A. Mattelart, *Mass Media, Ideologies and the Revolutionary Movement* (Sussex: Harvester, 1980), p. 30.

4. 'True' artists in the sense that they attract and fascinate huge audiences around the world. One minor sign of their cultural and economic power is the amount of academic comment and interpretation they provoke. In the case of Madonna this has been considerable. See, for example, the anthology of 13 articles entitled *The Madonna Connection: Representational Politics, Subcultural Identities and Cultural Theory* (ed) C. Schwichtenberg (Boulder, Colorado: Westview Press, 1992).

2. Art Uses Mass Culture

1. T. J. Clark, *Image of the People: Gustave Courbet and the 1848 Revolution* (London: Thames & Hudson, 1973), p. 140.

2. H. Toussaint, *Gustave Courbet 1819–73* (London: Royal Academy, 1978), p. 99.

3. Van Gogh's period in England and his interest in English art and illustration are described in detail in the two catalogues: *English Influences on Vincent Van Gogh* (Nottingham: and London: Fine Art Department, University of Nottingham/Arts Council, 1974–5); *Van Gogh in England: Portrait of the Artist as a Young Man* (London: Barbican Art Gallery, 1992).

4. For more on the political aspects of Van Gogh's work see my book *Van Gogh Studies* (London: JAW Publications, 1981).

5. P. Fuller, 'Out of the Doldrums' *Studio International* 198 (1008), 1985, p. 40.

6. R. Hamilton, 'An Exposition of "$he"', *Collected Words 1953–82* (London: Thames & Hudson, 1982), pp. 35–9. A revised version of an essay first published in *Architectural Design*, October 1962.

7. Hamilton, *Collected Words*, 1982, p. 38.

8. For a detailed and scholarly study of Hamilton's work see: R. Morphet and others, *Richard Hamilton* (London: Tate Gallery, 1992).

9. B. Collins, '*Life* Magazine and the Abstract Expressionists, 1948–51: a Historiographic Study of a Late Bohemian Enterprise', *The Art Bulletin* LXXIII (2), June 1991, pp. 283–308.

10. See the articles: D. Kuspit, 'Pop Art: a Reactionary Realism', *Art Journal* 36 (1), fall 1976, pp. 31-8, and D. Kunzle, 'Pop Art as Consumerist Realism', *Studies in Visual Communication*, 10 (2), spring 1984, pp. 16–33.

11. A. Warhol, *From A to B and Back Again: the Philosophy of Andy Warhol* (London: Pan Books, 1976), p. 96.

12. Ibid, p. 88.

13. For a survey of critical responses to pop, see my article: 'Pop Art: Differential Responses and Changing Perceptions', *And: Journal of Art and Art Education* (26), 1991, pp. 9–16.

14. D. Hebdige, 'In Poor Taste: Notes on Pop', *Block* (8), 1983, pp. 54–68.

3. The Mass Media Use Art

1. An exhibition documenting the relationship between Magritte and advertising was held at the Museum of Advertising, Paris, and toured Japan in 1983. The curator was G. Roque. He is also the author of the article 'The Advertising of Magritte/The Magritte in Advertising', *Print*, March–April 1985, pp. 67–73, 110.

2. For more about the Benson & Hedges campaign and the advertising of cigarettes see my article: 'All that Glitters ...' *Camerawork* (15), September 1979, pp. 4–5; B. Hatton, 'A Woman is Just a Woman, but a Good Cigar is a Smoke', *ZG* (7) 1982, pp. 1–2; J. Williamson, '...But I Know

What I Like: the Function of Art in Advertising' (1984), *Consuming Passions: the Dynamics of Popular Culture* (London/New York: Marion Boyars, 1986), pp. 67–74.

3. The programmes in question were: E. Lucie-Smith, 'Art on the Streets', (BBC Radio 3, 25 June 1980); G. Greer, 'Art of the Ad', (*The South Bank Show*, LWT, 7 February 1982); C. Frayling's 'Picasso – I Don't Know Which Agency He Was At', programme six of the TV series *The Art of Persuasion* (Channel 4, 1985); another TV programme about art and advertising was 'Outing Art: the BBC2 Billboard Project', (BBC2, 1992).

4. See my essay 'The Van Gogh Industry', *Van Gogh Studies* (London: JAW Publications, 1981), pp. 41–6, and T. Ködera (ed) The Mythology of Vincent Van Gogh (Amsterdam: John Benjamins, 1993).

5. Armand Mattelart has written perceptively about the political implications of what he calls 'the fragmented universe of communications':

The authoritarian forms in which cultural products are transmitted on a mass scale crystallize the social division inherent in bourgeois society. The fragmentation of communication practices into genres and stereotyped formats (magazines, photo-strip romances, sports reviews, comics, etc.) introduces the reader or listener to particular worlds which appear autonomous and compartmentalized. By concealing their fragmented nature these prevent comprehension of the real world as a totality within which class conflicts are at work. Through this creation of a variety of different publics, bourgeois and imperialist power ensures the satisfactory functioning of its society. It gives material form to divisions between individuals and classes. It concretizes the dichotomies contained in its language and in its culture of domination by granting to compartmentalized users privileged access to different spheres of interest, rules of conduct, taboos and specially reserved fields.

(*Mass Media, Ideologies and the Revolutionary Movement* (Sussex: Harvester, 1980, p. 80.)

6. J. Vercruysse, 'Vercruysse' [statement about Documenta 9], *Art Monthly* (159), September 1992, p. 14.

4. Mechanical Reproduction and the Fine Arts

1. The literature on the topics of art and reproduction, art and photography, is extensive. It includes (in date order): W. Benjamin, 'The Work of Art in the Age of Mechanical Reproduction' (1936), *Illuminations* (London: Fontana/Collins, 1973), pp. 219–53; W. Ivins, *Prints and Visual Communication* (London: Routledge & Kegan Paul, 1953); A. Malraux, *The Voices of Silence* (London: Secker & Warburg, 1954); E. Wind, 'The Mechanization of Art', *The Listener*, 15 December 1960, pp. 1095–8; C. Petrucci and others, 'Engravings and Other Print Media' Encyclopedia of World Art vol 4, (New York: McGraw-Hill, 1961) cols 748–5; A. Scharf, *Art and Photography* (London: Allen Lane, 1968); J. Berger, *Ways of Seeing* (London & Harmondsworth: BBC/Penguin Books, 1972); Van Deren Coke, *The Painter and the Photograph* (University of New Mexico Press, 2nd rev edn., 1972); E. Jussim, *Visual Communication and the Graphic Arts* (New York: Bowker, 1974); *The Cult of Images: Baudelaire and the Nineteenth Century Media Explosion* (Santa Barbara: University of

California, 1977); 'The One and the Many: Art and Mass Reproduction', *Art News* 81 (9), November 1982 (several articles); A. Dyson, *Pictures to Print: the Nineteenth Century Engraving Trade* (London: Farrand Press, 1984); A. Grundberg and K. Gauss, *Photography as Art: Interactions Since 1946* (New York: Abbeville Press, 1987); S. Lambert, *The Image Multiplied: Five Centuries of Printed Reproductions of Paintings and Drawings* (London: Trefoil Publications, 1987) exhibition catalogue to show at the Victoria & Albert Museum, 1987–8; 'The Work of Art in the Electronic Age' *Block* (14), autumn 1988 (several articles); P. Mattick, 'Mechanical Reproduction in the Age of Art', *Arts Magazine* 65 (1), September 1990, pp. 62–9.

2. Writings on John Berger's *Ways of Seeing* include: Art & Language Group, 'Ways of Seeing' *Art-Language* 4 (3), October 1978; P. Fuller, *Seeing Berger: a Revaluation of Ways of Seeing* (London: Writers & Readers, 1980); G. Dyer's *Ways of Telling: the Work of John Berger* (London: Pluto Press, 1986); P. Fuller, *Seeing through Berger*, (London: Claridge Press, 1988); J. Bruck and J. Docker, 'Puritanic Rationalism: John Berger's *Ways of Seeing* and Media and Culture Studies' *Theory Culture & Society* 8 (4), November 1991, pp. 79–96; J. A. Walker, 'Ways of Seeing Twenty Years On', *Art Monthly* (154), March 1992, pp. 3–6.

3. W. Benjamin, 'The Author as Producer', *Understanding Brecht* (London: New Left Books, 1973), pp. 85–103.

4. McCollum, quoted in *Allan McCollum* (Eindhoven: Stedelijk Van Abbemuseum, 1989), catalogue of a touring exhibition which was also shown at the Serpentine Gallery, London in 1990. The catalogue contains several illuminating essays.

5. High Culture: Affirmative or Negative?

1. H. Marcuse, 'The Affirmative Character of Culture', *Negations* (Harmondsworth: Penguin Books, 1972), p. 95.

2. Marcuse returned to the subject of art towards the end of his life in a short book entitled *The Aesthetic Dimension: Toward a Critique of Marxist Aesthetics* (London: Macmillan, 1979). This book was welcomed and highly praised by certain critics but, in my opinion, it was confused and contradictory; it added little of relevance to his earlier writings. There is no space here to undertake a detailed critique of the book's arguments.

3. M. Horkheimer and T. W. Adorno, *Dialectic of Enlightenment* (London: Allen Lane, 1973), p. 135.

4. T. W. Adorno, *The Philosophy of Modern Music* (London: Sheed & Ward, 1973), p. 25.

5. T. W. Adorno, quoted in P. Slater, 'The Aesthetic Theory of the Frankfurt School', *Working Papers in Cultural Studies* (6), autumn 1974, pp. 172–211.

6. T. W. Adorno, *Prisms* (London: Neville Spearman, 1967), p. 32.

7. Picasso, it seems, was greatly impressed by the African sculptures he saw when he visited the Trocadéro ethnographic museum in Paris while working on 'Les Demoiselles'. Picasso scholars argue that the painting

was influenced by 'primitive' Iberian and Oceanic carvings as well as African. They also claim the artist feared illness and death from sexually transmitted diseases and that one of the reasons 'primitive' objects appealed to him was because they had a magical power to exorcize such fears. For a more detailed study of the evolution and iconography of the painting see: W. Rubin's essay 'Picasso' in *'Primitivism' in Twentieth Century Art: Affinity of the Tribal and the Modern* 2 vols, (ed) W. Rubin (New York: Museum of Modern Art, 1984), pp. 240–343.

8. C. Duncan, 'Virility and Domination in Early Twentieth-century Vanguard Painting', in *Feminism and Art History: Questioning the Litany* (eds) N. Broude and M. Garrard (New York: Harper & Row, 1982), pp. 293–313.

9. W. Benjamin, 'Theses on the Philosophy of History', *Illuminations* (Glasgow: Fontana/Collins, 1973), p. 258.

6. Cultural Pluralism and Post-modernism

1. C. Jencks, *The Language of Post-modern Architecture* (London: Academy Editions, 1977).

2. J. Stezaker, 'The Avant Garde and Popular Culture', in *Art and Politics '77* (ed) B. Taylor (Winchester School of Art Press, 1977), pp. 101–6.

3. P. Dunn, 'Digital Highways, Local Narratives' *And: Journal of Art and Art Education* (27), 1992, pp. 4–5.

7. Alternatives

1. On the work of John Heartfield see: *John Heartfield* (London: Arts Council of Great Britain, 1969); J Berger, 'The Political Uses of Photomontage' in *Selected Essays and Articles: the Look of Things* (Harmondsworth: Penguin Books, 1972), pp. 183–9; J. Heartfield, *Photomontages of the Nazi Period* (London: Gordon Fraser/Universe Books, 1977); E. Siepmann and others, *Montage: John Heartfield* (Berlin: Elefanten Press Galerie, 1977); D. Kahn, *John Heartfield: Art and Mass Media* (NY: Tanam Press, 1985); P. Pachnicke and K. Honnef (eds) *John Heartfield* (New York: Abrams, 1992); D. Evans, *John Heartfield AIZ/VI 1930–8* (New York: Kent Fine Arts, 1992).

2. P. Kennard, *Images for the End of the Century: Photomontage Equations* (London: Journeyman Press, 1990). For a more detailed analysis of the art and politics of Kennard's work see J. Roberts, *Postmodernism, Politics and Art* (Manchester University Press, 1990), pp. 101–3.

3. C. Cockburn, *The Local State: Management of Cities and People* (London: Pluto Press, 1977).

8. Art and Mass Media in the 1980s

1. On the work of Laurie Anderson see: *Laurie Anderson: Works from 1969 to 1982* (Philadelphia: Institute of Contemporary Art, 1983) and L. Anderson, *United States* (New York: Harper & Row, 1984).

2. On the life and work of Keith Haring see: J. Gruen, *Keith Haring: the Authorized Biography* (London: Thames & Hudson, 1991); B. Blinderman (ed) *Keith Haring: Future Primaeval*, (New York: Abbeville Press, 1992); and G. Celant (ed) *Keith Haring* (Munich: Prestel Verlag, 1992).

3. M. Newman, *Simulacra: a New Art from Britain* (London: Riverside Studios, 1982). Typescript.

4. For writings by Jean Baudrillard see: *Simulations* (New York: Semiotext(e), 1983); 'The Precession of Simulacra', *Art & Text* (11), spring 1983, pp. 3–47; *Jean Baudrillard: Selected Writings* (ed) M. Poster (Cambridge and Palo Alto: Polity Press and Stanford University Press, 1988); *The Revenge of the Crystal: a Baudrillard Reader* (ed) M. Carter (London: Pluto Press, 1990). For books about Baudrillard see: D. Kellner, *Jean Baudrillard: From Marxism to Postmodernism and Beyond* (Cambridge: Polity Press, 1989); M. Gane, *Baudrillard: Critical and Fatal Theory* (London: Routledge, 1990); W. Stearns and W. Chaloupka (eds) *Jean Baudrillard: the Disappearance of Art and Politics* (London: Macmillan, 1992).

5. On the work of John Wilkins see: R. Brooks, 'Everything you Want ... and a Little Bit More', *ZG* (7), 1982 (Desire Issue), pp. 28-30, and M. Newman, *John Wilkins*, (London: Anthony Reynolds Gallery, 1989).

6. A. Dannatt, 'John Stezaker' (Interview) *Flash Art* (160), October 1991, pp. 114–17.

7. On 'billboard art' see: S. Henderson and R. Landau, *Billboard Art* (London: Angus and Robertson, 1981) and Wei Yew (ed) *Gotcha! The Art of the Billboard* (Edmonton, Alberta: Quon Editions, 1990).

8. Les Levine (artist's statement), *Contemporary Artists* (ed) C. Naylor (Chicago and London: St James Press, 3rd edn 1989), pp. 554–6.

9. 'Poster Modernism: an Interview with AVI: the Art Terrorists', *Independent Media* (108) 1991, pp 6–7.

10. On the work of Jenny Holzer see: B. Ferguson and J. Simon, *Jenny Holzer: Signs* (London: Institute of Contemporary Arts/Art Data, 1988), revised edition of a catalogue first produced by Des Moines Art Center, Iowa, 1986.

11. For a review of the film see: T. Milne, 'Catchfire', *Monthly Film Bulletin* 58 (685), February 1991, pp. 39–40.

12. Tom Lawson interviewed by D. Robbins, *Arts Magazine* 58 (1), September 1983, p. 114.

13. Tom Lawson, 'Going Public', *Art & Design* 6 (1/2), 1990, pp. 73–7, (Profile 19: New Art International).

14. Interview with Jeff Koons, *Flash Art* (132), February–March 1987, p. 76.

15. Jeff Koons interviewed by M. Collings, *Modern Painters* 2 (2), summer 1989, p. 61.

16. *The Jeff Koons Handbook* (London: Thames & Hudson/Anthony d'Offay Gallery, 1992), p. 140.

17. Ibid.

9. Artists and New Media Technologies

1. A more extended discussion of the relationship between the arts and new technologies can be found in the anthology *Culture, Technology and Creativity in the Late Twentieth Century* (ed) P. Hayward (London, Paris, Rome: John Libbey, 1990).

2. For further information on worker photography see: 'Left Photography Between the Wars: the International Worker Photography Movement', several articles in T. Dennett and J. Spence, *Photography/Politics: One* (London: Photography Workshop, 1979; S. Braden, *Committing Photography* (London: Pluto Press, 1983); L. Ollman, *Camera as Weapon: Worker Photography Between the Wars* (San Diego: Museum of Photographic Arts, 1992).

3. For more about community photography see: 'Photography in the Community', *Camerawork* (19) 1979; H. Nigg and G. Wade's *Community Media: Community Communication in the UK: Video, Local TV, Film and Photography* (Zurich: Regenbogen-Verlag, 1980); D. Slater, 'Community Photography', *Camerawork* (20) 1981, pp. 8–9; S. Braden's *Committing Photo-graphy* (London: Pluto Press, 1983).

4. J. Spence, *Putting Myself in the Picture: a Political, Personal and Photographic Autobiography* (London: Camden Press, 1986).

5. On the work of Nam June Paik see: J. Hanhardt, *Nam June Paik* (New York: Whitney Museum of American Art/Norton, 1982); E. Decker, *Paik Video* (Cologne: Dumont, 1988); W. Herzogenrath, *Nam June Paik: Video Works 1963–88* (London: Hayward Gallery, 1988).

6. A well-illustrated survey of computer art is C. Goodman's *Digital Visions: Computers and Art* (New York: Abrams, 1987).

7. S. Todd and W. Latham, *Evolutionary Art and Computers* (London: Academic Press, 1992).

10. War, the Media and Art in the 1990s

1. M. Livingstone and J. Bird, *Michael Sandle: Sculpture and Drawings 1957–88* (London: Whitechapel Art Gallery, 1988), p. 35.

2. A detailed account of Manet's 'Execution' series is given in the catalogue *Manet: the Execution of Maximilian, Painting, Politics and Censorship* (London: National Gallery, 1992) with essays by J. Wilson-Bareau, J. House and D. Johnson.

11. Conclusion

1. R. Hughes, 'The Shock of the New VII: Mass Production and the pressure to go "Pop"', the *Listener*, 6 November 1980, pp. 609–12.

2. T. Phillips, *A TV Dante Directed by Tom Phillips and Peter Greenaway* (London: Channel 4 Television, 1990). Booklet to accompany the TV series.

BIBLIOGRAPHY

Items are arranged under subject headings and then by date of publication.

Art and Mass Media

G.F. Hartlaub, 'Art as Advertising' (1928), *Design Issues* 9 (2), Fall 1993, pp. 72–6.

W. Benjamin, 'The Author as Producer' (1934) *Understanding Brecht* (London: NewLeft Books, 1977), pp. 85–103.

W. Benjamin, 'The Work of Art in the Age of Mechanical Reproduction' (1936), *Illuminations* (London: J. Cape, 1970), pp. 219–53.

C. Greenberg, 'The Avant-Garde and Kitsch' (1939), *Art and Culture* (London: Thames & Hudson, 1973), pp. 3–21.

M. Horkheimer, 'Art and Mass Culture' (1941), *Critical Theory: Selected Essays* (New York: Herder & Herder, 1972), pp. 188–243.

Modern Art in Advertising: an Exhibition of Designs for the Container Corporation of America (Chicago: Art Institute, 1945).

W. Ivins, *Prints and Visual Communication* (London: Routledge & Kegan Paul, 1953).

A. Malraux, *The Voices of Silence* (London: Secker & Warburg, 1954).

A. and P. Smithson, 'But Today we Collect Ads', *Ark* (18), November 1956, pp. 48–50.

L. Alloway, 'The Arts and Mass Media', *Architectural Design* February 1958, pp. 84–5.

L. Alloway, 'The Long Front of Culture', *Cambridge Opinion* (17), 1959, pp. 25–6.

J. McHale, 'The Fine Arts and Mass Media', *Cambridge Opinion* (17) 1959, pp. 29–32.

W. Schack, *Art and Argyrol: the Life and Career of Dr Albert C. Barnes* (New York: Yoseloff, 1960).

E. Wind, 'The Mechanization of Art', the *Listener* 15 December 1960, pp. 1095–8.

R. Banham, 'The Atavism of the Short–distance Mini–cyclist', *Living Arts* (3), 1964, pp. 91–7.

E. Lucie–Smith, 'Pop and the Mass Audience', *Studio International* 172 (880), August 1966, pp. 96–7.

A. Scharf, *Art and Photography* (London: Allen Lane, 1968).

L. Alloway, 'Popular Culture and Pop Art', *Studio International* 178 (913), July–August 1969, pp. 17–21.

H. Rosenberg, 'Art and its Double', *Artworks and Packages* (New York: Dell, 1969), pp. 11–23.

J. Berger, *Ways of Seeing* (London and Harmondsworth: BBC/Penguin Books, 1972).

R. Saudek, 'Visual Arts in the Age of Mass Communication', *Arts in Society* 9 (2), summer–fFall 1972.

V. D. Coke, *The Painter and the Photograph* (University of New Mexico Press, 2nd rev edn., 1972).

E. Jussim, *Visual Communication and the Graphic Arts* (New York: Bowker, 1974).

H. Rosenberg, 'The "Mona Lisa" Without a Mustache: Art in the Media Age' (1976), *Art and Other Serious Matters* (Chicago: University of Chicago Press, 1985), pp. 3–10.

M. Ayres et al, *Shared Meanings and Critical Views: an Exhibition of Painting, Sculpture and Drawing* (London: Cockpit Theatre, 1977).

E. Bloch et al, *Aesthetics and Politics* (London: New Left Books, 1977).

The Cult of Images: Baudelaire and the Nineteenth Century Media Explosion (Santa Barbara: University of California, 1977).

J. Stezaker, 'Social Expression: Social Reality', *Meantime* (1), April 1977, pp. 32–4.

J. McHale, 'The Future of Art and Mass Culture', *Futures,* 10 (3), June 1978, pp. 178–90.

R. Taylor, *Art: an Enemy of the People* (Sussex: Harvester, 1978).

E. Siepmann, 'Heartfield's Millions Montage: (Attempt At) a Structural Analysis', *Photography/Politics: One* 1979, pp. 38–50.

A. Tomkins, 'The Image of Art in Consumer Society', *Schooling and Culture* (4), spring 1979, pp. 35–41.

R. Hughes, 'Mass Production and the Pressure to go "Pop"', the *Listener* 6 November 1980, pp. 609–12.

E. Lucie–Smith, 'Art on the Streets', the *Listener* 103 (2667), 26 June 1980, pp. 820–1.

J. Stezaker, 'The Avant Garde and Popular Culture', *Art and Politics '77* (ed) B. Taylor (Winchester School of Art Press, 1980), pp. 101–6.

T. Lawson, 'Last Exit: Painting', *Artforum* 20 (2), October 1981, pp. 40–7.

C. Tisdall and S. Nairne (eds) *Conrad Atkinson: Picturing the System* (London: Pluto Press/Institute of Contemporary Arts, 1981).

Art in the Age of Mechanical Reproduction (Melbourne: George Patton Gallery, University of Melbourne, 1982).

'Brand New York', *Literary Review* October 1982. (Special issue on New York art at the Institute of Contemporary Arts, London.)

N. Broude and M. Garrard (eds), *Feminism and Art History: Questioning the Litany* (New York: Harper & Row, 1982).

V. Burgin (ed), *Thinking Photography* (London: Macmillan, 1982).

H. Foster, 'Between Modernism and the Media', *Art in America* 70 (6), summer 1982, pp. 13–17.

D. Graham, 'McLaren's Children', *ZG* (7), 1982, pp. 18–20.

R. Hamilton, *Collected Words 1953–82* (London: Thames & Hudson, 1982).

J. Kardon, *Image Scavengers: Painting* (Philadelphia: Institute of Contemporary Arts, University of Pennsylvania, 1982–3).

T. Lawson, *A Fatal Attraction: Art and the Media* (Chicago: The Renaissance Society at the University of Chicago, 1982).

T. Lawson, 'The Dark Side of the Light', *Artforum* 21 (3), November 1982, pp. 62–6.

K. Linker, 'Melodramatic Tactics', *Artforum* 21 (1), September 1982, pp. 30–2.

M. Newman, 'Irony and the Amazonians: Post–modernism in the Media Jungle', *Art Monthly* (61), November 1982, pp. 30–2.

M. Newman, *Simulacra: a New Art From Britain* (London: Riverside Studios, 1982).

R. Rosenblum et al, 'The One and the Many: Art and Mass Reproduction', *Art News* 81 (9), November 1982, pp. 110–20. (Several articles.)

P. Taylor, *Popism* (Melbourne: National Gallery of Victoria, 1982).

J. S. Allen, *The Romance of Commerce and Culture* (Chicago and London: University of Chicago Press, 1983).

'Art and the Media' *Art & Artists* (203), August 1983. (Several articles.)

J. Carlin and S. Wagstaff, *The Comic Art Show: Cartoons in Painting and Popular Culture* (New York: Whitney Museum/Fantagraphics Books, 1983).

D. Crimp, 'Appropriating Appropriation', *Tension* (2), September–October 1983, pp. 12–14.

T. Crow, 'Modernism and Mass Culture in the Visual Arts', *Modernism and Modernity: the Vancouver Conference Papers* (ed) B. Buchloh et al (Halifax, Nova Scotia: Press of the Nova Scotia College of Art and Design, 1983), pp. 215–64.

B. Hatton, 'Simulacra at the Riverside', *Artscribe* (39), February 1983, pp. 30–4.

'Image Scavengers Issue', *Art & Text* (9), autumn 1983.

M. Kelly, 'Beyond the Purloined Image', *Block* (9), 1983, pp. 68–72.

J. Roberts, 'Masks and Mirrors', *Art Monthly* (63), February 1983, pp. 5–9.

G. Roque, *Ceci n'est pas un Magritte: Essai sur Magritte et la publicité* (Paris: Flammarion, 1983).

J. Runnacre, 'Zen and the Art of Painting' (Duggie Fields), *Art Line* (4), February 1983, p. 6.

R. Brooks, *Between Here and Nowhere: Nine New York Artists* (London: Riverside Studios, 1984).

A. Dyson, *Pictures to Print: the Nineteenth Century Engraving Trade* (London: Farrand Press, 1984).

C. Kotik et al, *The Expendable Icon: Works by John McHale* (Buffalo, New York: Albright–Knox Art Gallery, 1984).

D. Kuspit, 'Art in the Age of Mass Mediation', *The Critic as Artist: the Intentionality of Art* (Ann Arbor, Michigan: UMI Research Press, 1984), pp. 387–94.

L. Lippard, *Get the Message? A Decade of Art for Social Change* (New York: Dutton, 1984).

A. Smith, 'The Media as Contexts for Creativity', *Leonardo* 17 (1), 1984, pp. 46–8.

D. Tuer, 'Four Questions on the Reception of the Work of Art in the Age of Mass Media', C (3), fall 1984, pp. 62–5.

'Feature: Art and the Mass Media', Studio International 198 (1008), March 1985, pp. 28–38.

H. Foster, Recodings: Art, Spectacle, Cultural Politics (Port Townsend, Washington: Bay Press, 1985).

D. Kahn, John Heartfield: Art and Mass Media (New York: Tanam Press, 1985).

M. Lavin, 'Advertising Utopia: Schwitters as Commercial Designer', Art in America 73 (10), October 1985, pp. 135–9, 165.

R. Pelfrey and M. Hall–Pelfrey, Art and Mass Media (New York: Harper & Row, 1985).

G. Roque, 'The Advertising of Magritte/The Magritte in Advertising', Print March–April 1985, pp. 67–73, 110.

G. Rodriguez et al, Disinformation: the Manufacture of Consent (New York: Alternative Museum, 1985).

Blame God: Billboard Projects (Les Levine), (London: Institute of Contemporary Arts, 1986).

M. Miller (Curator), Television's Impact on Contemporary Art (New York: Queens Museum, 1986).

S. Frith and H. Horne, Art into Pop (London and New York: Methuen, 1987).

A. Grundberg and K. Gauss, Photography as Art: Interactions Since 1946 (New York: Abbeville Press, 1987).

S. Lambert, The Image Multiplied: Five Centuries of Printed Reproductions of Paintings and Drawings (London: Trefoil, 1987).

S. Wagstaff et al, Comic Iconoclasm (London: Institute of Contemporary Arts, 1987).

J. A. Walker, Cross–overs: Art into Pop, Pop into Art (London: Comedia/ Methuen, 1987).

J. Capitaine and C. Zagrodzki, Le peintre et l'affiche de Lautrec à Warhol (Paris: Musée L'Affiche et de la Publicité, 1988).

T. Collins and R. Milazzo, Media Post Media (New York: Scott Hanson Gallery, 1988).

P. Hayward (ed), Picture This: Media Representations of Visual Art and Artists (London and Paris: John Libbey, 1988).

J. Lansdown et al, The Conquest of Form: Computer Art by William Latham (Bristol: Arnolfini Gallery, 1988).

'The Work of Art in the Electronic Age', Block (14) autumn 1988. (Several articles.)

A. Dannatt, Andrew Heard (Frankfurt: Friedman–Guinness Gallery, 1989).

M. Eisenbeis and H. Hagebolling (eds), Synthesis: Visual Arts in the Electronic Culture (Offenbach, Main: School of Art and Design/Bonn: German Commission for UNESCO, 1989).

M. Lovejoy, Post–modern Currents: Art and Artists in the Age of Electronic Media (Ann Arbor, Michigan: UMI Research Press, 1989).

A. Rorimer et al, Allan McCollum (Eindhoven: Stedelijk Van Abbemuseum, 1989).

C. Gudis (ed), *A Forest of Signs: Art in the Crisis of Representation* (Los Angeles: Museum of Contemporary Art/Cambridge, Mass: MIT Press, 1989).

M. Heiferman, L. Phillips and J. Hanhardt, *Image World: Art and Media Culture* (New York: Whitney Museum, 1989).

A. Dannatt and R. Brooks, *Andrew Heard: Dear Heaven* (Zürich: Turske & Turske, 1990).

Art et Publicité (Paris: Editions du Centre Pompidou, 1990).

J. Bird, 'Report from London: Dystopia on the Thames' (Docklands), *Art in America* 78 (7), July 1990, pp. 89–97.

P. Hayward (ed), *Culture, Technology and Creativity in the Late Twentieth Century* (London and Paris: John Libbey, 1990).

R.F. Malina, 'Digital Image – Digital Cinema: the Work of Art in the Age of Post-mechanical Reproduction', *Leonardo* Digital Image – Digital Cinema Supplemental Issue, 1990, pp. 33–8.

P. Mattick, 'Mechanical Reproduction in the Age of Art', *Arts Magazine* 65 (1), September 1990, pp. 62–9.

D. Nahas (curator), *Public Mind: Les Levine's Media Sculpture and Mass Ad Campaigns 1969–90* (Syracuse, New York: Everson Museum of Art, 1990).

Passages de l'image (Paris: Musée National d'Art Moderne/Pompidou Centre, 1990).

K. Varnedoe and A. Gopnik, *High and Low: Modern Art and Popular Culture* (New York: MOMA/Abrams, 1990).

K. Varnedoe and A. Gopnik (eds), *Modern Art and Popular Culture: Readings in High and Low* (New York: MOMA/Abrams, 1990).

L. Buck and P. Dodd, *Relative Values or What's Art Worth?* (London: BBC Books, 1991).

B. R. Collins, *'Life* Magazine and the Abstract Expressionists 1948–51', *Art Bulletin* LXXIII (2), 1991, pp. 283–308.

L. W. Levine, *Highbrow/Lowbrow: the Emergence of Cultural Hierarchy in America* (Harvard University Press, 1991).

B. Blinderman (ed), *Keith Haring: Future Primaeval* (New York: Abbeville Press, 1992).

J. Caldwell et al, *Jeff Koons* (San Francisco Museum of Modern Art, 1992).

J. Carey, *The Intellectuals and the Masses* (London: Faber, 1992).

G. Celant (ed), *Keith Haring* (Munich: Prestel Verlag, 1992).

P. Dunn, 'Digital Highways, Local Narratives', *And: Journal of Art and Art Education* (27), 1992, pp. 4–5.

M. Düttmann and F. Schneider (eds), *Morris Lapidus: Architect of the American Dream* (Basel, Berlin, Boston: Birkäuser Verlag, 1992).

D. Evans, *John Heartfield AIZ/VI 1930–38* (New York: Kent Fine Art, 1992).

B. Forster et al, *Mediabiennale Leipzig '92* (Leipzig: Pögedruck, 1992).

R. Hamilton, 'The Hard Copy Problem', *And: Journal of Art and Art Education* (27), 1992, p. 10.

J. Koons, *The Jeff Koons Handbook* (London: Thames & Hudson/Anthony d'Offay Gallery, 1992). (With an essay by Robert Rosenblum.)

B. Kurtz (ed), *Haring, Warhol, Disney* (Munich and London: Prestel Verlag/ Thames & Hudson, 1992).

A. Muthesius (ed), *Jeff Koons* (Cologne: Benedikt Taschen, 1992).

P. Pachnicke and K. Honnef (ed), *John Heartfield* (New York: Abrams, 1992).

S. Todd and W. Latham, *Evolutionary Art and Computers* (London: Academic Press, 1992).

C. Yoe and J. Morra–Yoe (eds), *The Art of Mickey Mouse* (New York: Hyperion, 1992).

M. Dery, 'Fast Forward: Art Goes High Tech', *Art News* 92 (2), February 1993, pp. 74–83.

N. Friend, 'Viewpoint: the Treacherous Slide', *The Art Quarterly* (UK), spring 1993, pp. 26–7.

S. Kent, *Young British Artists II: Rose Finn–Kelcey, Sarah Lucas, Marc Quinn, Mark Wallinger* (London: Saatchi Collection, 1993).

T. Ködera (ed), *The Mythology of Vincent Van Gogh* (Amsterdam: John Benjamins, 1993).

J. A. Walker, *Art and Artists on Screen* (Manchester University Press, 1993).

J. A. Walker, *Arts TV: a History of Arts Television in Britain* (London: Arts Council/John Libbey, 1993).

P. Wollen, *Raiding the Icebox: Reflections on Twentieth Century Culture* (London: Verso, 1993).

Pop Art

L. Alloway, 'Pop Art Since 1949', the *Listener* 27 December 1962, p. 1085.

R. Banham, 'Who is this "Pop"?', *Motif* (10), 1963. Reprinted in R. Banham, *Design by Choice* (ed) P. Sparke (London: Academy Editions, 1981).

R. Hamilton, 'Urbane Image', *Living Arts* (2), 1963, pp. 44–59. (Reprinted in *Collected Words 1953–82* (London: Thames & Hudson, 1982).)

M. Amaya, *Pop as Art: a Survey of the New Super Realism* (London: Studio Vista, 1965).

J. Rublowsky, *Pop Art: Images of the American Dream* (New York: Nelson, 1965).

L. Lippard et al, *Pop Art* (London: Thames & Hudson, 1966).

A, Boime, 'Roy Lichtenstein and the Comic Strip', *Art Journal* 28 (2), winter 1968–9, pp. 155–9.

C. Finch, *Pop Art: Object and Image* (London: Studio Vista, 1968).

M. Wood, 'Painting as Language' (1968), *Arts in Society* (ed) P. Barker (Glasgow: Fontana/Collins, 1977), pp. 57–61.

L. Alloway, 'Popular Culture and Pop Art', *Studio International* 178 (913), July–August 1969, pp. 17–21.

R. Banham, 'Representations in Protest' (1969), *Arts in Society* (ed) P. Baker (Glasgow: Fontana/Collins, 1977), pp. 61–6.

C. Finch, *Image as Language: Aspects of British Art 1950–68* (Harmondsworth: Penguin, 1969).

J. Russell et al, *Pop Art Redefined* (London: Thames & Hudson, 1969).

M. Compton, *Pop Art* (London: Hamlyn, 1970).

G. Melly, *Revolt into Style: the Pop Arts in Britain* (London: Allen Lane, 1970).

R. Morphet, *Richard Hamilton* (London: Tate Gallery, 1970).

R. Morphet, *Warhol* (London: Tate Gallery, 1971).

L. Alloway, *American Pop Art* (New York: Collier–Macmillan, 1974).

A. Huyssen, 'The Cultural Politics of Pop', *New German Critique* (4), 1974, pp. 77–97.

S. Wilson, *Pop Art* (London: Thames & Hudson, 1974).

T. del Renzio, 'Pop', *Art & Artists* 11 (5), August 1976, pp. 14–19.

D. Kuspit, 'Pop Art: a Reactionary Realism', *Art Journal* 36 (1), fall 1976, pp. 31–8.

V. Schneede, *Pop Art in England* (Hamburg: Kunstverein, 1976).

A. Warhol and P. Hackett, *Popism* (London: Hutchinson, 1981).

R. Hamilton, *Collected Words 1953–82* (London: Thames & Hudson, 1982).

R. Hughes, 'The Rise of Andy Warhol', *New York Review of Books* 29 (2), 18 February 1982, pp. 6–10.

J. Baudrillard, 'Is Pop Art an Art of Consumption?', *Tension* (2), September–October 1983, pp. 33–5.

D. Hebdige, 'In Poor Taste: Notes on Pop', *Block* (8), 1983, pp. 54–68.

B. Haskell, *Blam! the Explosion of Pop, Minimalism and Performance 1958–64* (New York: Whitney Museum of American Art, 1984).

D. Kunzle, 'Pop Art as Consumerist Realism', *Studies in Visual Communication* 10 (2), spring 1984, pp. 16–33.

H. Geldzahler, *Pop Art 1955–70* (Sydney: Art Gallery of New South Wales, 1985).

D. Boland, 'Pop Art – a Reflection', *Aspects* (33), winter 1986, pp. 10–11.

J. Harris et al, *1966 and All That: Design and the Consumer in Britain 1960–69* (Manchester and London: Whitworth Art Gallery/Trefoil, 1986).

C. Mashun (ed), *Pop Art and the Critics* (Ann Arbor, Michigan: UMI Research Press, 1987).

N. Whiteley, *Pop Design: Modernism to Mod* (London: Design Council, 1987).

L. Alloway et al, *Modern Dreams: the Rise and Fall and Rise of Pop* (New York and Cambridge, Mass: Institute for Contemporary Art, Clocktower Gallery/ MIT Press, 1988).

C. Mashun (ed), *Pop Art: the Critical Dialogue* (Ann Arbor, Michigan: UMI Research Press, 1988).

V. Bockris, *Warhol* (London: Frederick Muller, 1989).

K. McShine (ed), *Andy Warhol: a Retrospective* (New York: Museum of Modern Art, 1989).

P. Taylor (ed), *Post–Pop Art* (Cambridge, Mass: MIT Press, 1989).

M. Livingstone, *Pop Art: a Continuing History* (London: Thames & Hudson, 1990).

D. Robbins (ed), *The Independent Group: Post–war Britain and the Aesthetics of Plenty* (Cambridge, Mass: MIT Press, 1990).

M. Livingstone (ed), *Pop Art* (London: Royal Academy/Weidenfeld & Nicolson, 1991).

M. Livingstone et al, *Objects for the Ideal Home: the Legacy of Pop Art: Artists of the 1980s and 1990s* (London: Serpentine Gallery, 1991).

J. A. Walker, 'Pop Art: Differential Responses and Changing Perceptions', *And: Journal of Art and Art Education* (26), 1991, pp. 9–16.

S. Maharaj, 'Pop Art's Pharmacies: Kitsch ...' *Art History* 13 (3), September 1992, pp. 334–50.

C. Mamiya, *Pop Art and Consumer Culture: American Super Market* (Austin, Texas: University of Texas Press, 1992).

R. Morphet et al, *Richard Hamilton* (London: Tate Gallery, 1992).

P. Schimmel and D. DeSalvo, *Hand–painted Pop: American Art in Transition 1955–62* (New York: Rizzoli, 1992).

Post–modernism

R. Venturi, *Complexity and Contradiction in Architecture* (New York: MOMA, 1966).

C. Jencks, *The Language of Post-modern Architecture* (London: Academy Editions, 1977, 6th rev. edn. 1991).

'Post–Modernism', *Architectural Design* 1977. AD Profile 4.

'Special Issue on Modernism', *New German Critique* (22), winter 1981.

H. Foster (ed), *The Anti-aesthetic: Essays on Postmodern Culture* (Port Townsend, Washington: Bay Press, 1983). Also published as *Postmodern Culture* (London: Pluto Press, 1985).

J-F. Lyotard, *The Post-modern Condition: a Report on Knowledge* (Manchester University Press, 1984).

'Modernity and Postmodernity', *New German Critique* (33), fall 1984.

B. Wallis (ed), *Art after Modernism: Rethinking Representation* (New York: New Museum/David R. Godine, 1985).

L. Appignanesi (ed), *Post-modernism* (London: Institute of Contemporary Arts documents 4/5, 1986).

V. Burgin, *The End of Art Theory: Criticism and Postmodernity* (Basingstoke and London: Macmillan Education, 1986).

H. Foster, *Recodings: Art, Spectacle, Cultural Politics* (Port Townsend, Washington: Bay Press, 1986).

A. Huyssen, *After the Great Divide: Modernism, Mass Culture, Postmodernism* (London: Macmillan, 1986).

S. Nairne et al, *State of the Art: Ideas and Images in the 1980s* (London: Chatto & Windus/Channel 4 Television, 1987).

J. Baudrillard, *Selected Writings* (ed) M. Poster (Cambridge: Polity Press, 1988).

D. Hebdige, *Hiding in the Light: on Images and Things* (London: Comedia/Routledge, 1988).

C. Jencks, *Post Modernism: the New Classicism in Art and Architecture* (London: Academy Editions, 1988).

E. Kaplan (ed), *Postmodernism and its Discontents* (London: Verso, 1988).

'Post–modernism', *Theory, Culture & Society* 5 (2/3), June 1988.

D. Harvey, *The Condition of Post-modernity* (Oxford: Blackwell, 1989).

R. Hewison, *Future Tense: a New Art for the Nineties* (London: Methuen, 1990).

F. Jameson, *Postmodernism or the Cultural Logic of Late Capitalism* (London: Verso, 1991).

C. Jencks (ed), *The Postmodern Reader* (London: Academy Editions, 1992).

The Mass Media

W. Schramm (ed), *Mass Communications* (University of Illinois Press, 1960).

N. Jacobs, *Culture for the Millions: Mass Media in Modern Society* (Boston: Beacon Press, 1964).

M. McLuhan, *Understanding Media: the Extensions of Man* (London: Routledge & Kegan Paul, 1964).

R. Williams, *Communications* (Harmondsworth: Penguin, 1966).

D. McQuail, *Towards a Sociology of Mass Communication* (London: Macmillan, 1969).

H. I. Schiller, *Mass Communication and American Empire* (New York: A. Kelly, 1969).

H. M. Enzenberger, 'Constituents of a Theory of the Media' (1970), *Raids and Reconstructions* (London: Pluto Press, 1976), pp. 20–53.

M. D. Carter, *An Introduction to Mass Communications* (London: Macmillan, 1971).

S. Hood, *The Mass Media* (London: Macmillan, 1972).

D. McQuail (ed), *Sociology of Mass Communications* (Harmondsworth: Penguin, 1972).

S. Cohen and J. Young, *The Manufacture of News: Social Problems, Deviance and the Mass Media* (London: Constable, 1973).

P. Golding, *The Mass Media* (London: Longman, 1974).

R. Williams, *Television: Technology and Cultural Form* (Glasgow: Fontana/ Collins, 1974).

M. L. de Fleur and S. Ball-Rokeach, *Theories of Mass Communication* (London: Longman, 1975).

A. Dorfman and A. Mattelart, *How to Read Donald Duck* (New York: International General, 1975).

Glasgow University Media Group, *Bad News* (London: Routledge & Kegan Paul, 1976).

R. Sobel, *The Manipulators: America in the Media Age* (New York: Doubleday, 1976).

J. Curran et al (eds), *Mass Communications and Society* (London: E. Arnold, 1977).

R. Barthes, *Image–Music–Ttext* (Glasgow: Fontana/Collins, 1977).

T. Bennett et al, *Mass Communications and Society Units 1–15* (Milton Keynes: Open University Press, 1977).

J. Tunstall, *The Media are American: Anglo–American Media in the World* (London: Constable, 1977).

J. Monaco, *Celebrity: the Media as Image Maker* (New York: Delta, 1978).

J. Monaco, *Media Culture* (New York: Delta, 1978).

J. Williamson, *Decoding Advertisements: Ideology and Meaning in Advertising* (London: Marion Boyars, 1978).

C. Gardner (ed), *Media, Politics and Culture: a Socialist View* (London: Macmillan, 1979).

Media, Culture and Society, vol. 1, no. 1, 1979.

J. Whale, *The Politics of the Media* (Glasgow: Fontana/Collins, rev. edn. 1979).

J. Downing, *The Media Machine* (London: Pluto Press, 1980).

S. Hall et al (eds), *Culture, Media, Language* (London: Hutchinson, 1980).

A. Mattelart, *Mass Media, Ideologies and the Revolutionary Movement* (Sussex: Harvester, 1980).

H. Nigg and G. Wade, *Community Media* (Zurich: Regenborg, 1980).

J. Baudrillard, 'Requiem for the Media', *For a Critique of the Political Economy of the Sign* (St Louis: Telos Press, 1981), pp. 164–84.

J. Curran and J. Seaton, *Power Without Responsibility: Press and Broadcasting in Britain* (Glasgow: Fontana/Collins, 1981).

B. Nicholls, *Ideology and the Image* (Bloomington: Indiana University Press, 1981).

H. Davis and P. Walton (eds), *Language, Image, Media* (Oxford: Blackwell, 1983).

G. Dyer, *Advertising as Communication* (London: Methuen, 1982).

M. Gurevitch et al (eds), *Culture, Society and the Media* (London: Methuen, 1982).

A. Dorfman, *The Empire's Old Clothes* (London: Pluto Press, 1983).

J. Tunstall, *The Media in Britain* (London: Constable, 1983).

H. Jonsson et al, *Visual Paraphrases: Studies in Mass Media Imagery* (Stockholm: Almquist & Wiksell International, 1984).

R. C. Toll, *The Entertainment Machine* (Oxford University Press, 1984).

L. Masterman, *Teaching the Media* (London: Comedia, 1985).

R. Collins et al (eds), *Media, Culture and Society: a Critical Reader* (London: Sage, 1986).

B. Winston, *Misunderstanding Media* (London: Routledge, 1986).

J. Curren (ed), *Impact and Influences: Media Power in the Twentieth Century* (London: Methuen, 1987).

D. McQuail, *Mass Communication Theory* (London: Sage, 2nd edn. 1987).

B. Bagdikian, *The Media Monopoly* (Boston: Beacon Press, 3rd edn. 1989).

J. Wyver, *The Moving Image: an International History of Film, Television and Video* (Oxford: Blackwell, 1989).

F. Inglis, *Media Theory: an Introduction* (Oxford: Blackwell, 1990).

J. B. Thompson, *Ideology and Mass Culture: Critical Social Theory in the Era of Mass Communication* (Cambridge: Polity Press, 1990).

Popular and Mass Culture

M. Arnold, *Culture and Anarchy* (1869), (Cambridge University Press, 1960).

F. R. Leavis, *Mass Civilisation and Minority Culture* (Cambridge: Heffer, 1930).

J. Ortega y Gasset, *The Revolt of the Masses* (London: Allen & Unwin, 1932).

F. R. Leavis and D. Thompson, *Culture and Environment* (London: Chatto, 1933).

H. Marcuse, 'The Affirmative Character of Culture' (1937), *Negations* (Harmondsworth: Penguin University Books, 1972), pp. 88–133.

M. Horkheimer and T. Adorno, 'The Culture Industry: Enlightenment as Mass Deception' (1944), *Dialectic of Enlightenment* (London: Allen Lane, 1973), pp. 120–67.

T. S. Eliot, *Notes Towards a Definition of Culture* (London: Faber, 1948).

M. McLuhan, *The Mechanical Man: Folklore of Industrial Man* (New York: Vanguard Press, 1951).

D. McDonald, 'A Theory of Mass Culture', *Diogenes* (3), summer 1953, pp. 1–17.

R. Hoggart, *The Uses of Literacy* (London: Chatto & Windus, 1957).

B. Rosenberg and D. White (eds), *Mass Culture: the Popular Arts in America* (Glencoe, Illinois: Free Press, 1957).

R. Williams, *Culture and Society 1780–1950* (London: Chatto & Windus, 1958).

N. Jacob (ed), *Culture for the Millions?* (Princeton NJ: Van Nostrand, 1959).

R. Williams, *The Long Revolution* (London: Chatto & Windus, 1960).

D. Boorstin, *The Image or Whatever Happened to the American Dream* (London: Weidenfeld & Nicolson, 1962).

D. MacDonald, *Against the American Grain: Essays on the Effect of Mass Culture* (New York: Vintage, 1962).

S. Hall and P. Whannel, *The Popular Arts* (London: Hutchinson, 1964).

H. Marcuse, *One Dimensional Man* (London: Routledge & Kegan Paul, 1964).

D. Thompson (ed), *Discrimination and Popular Culture* (Harmondsworth: Penguin, 1964).

A. Toffler, *The Culture Consumers* (New York: St Martin's Press, 1964).

H. Mendelsohn, *Mass Entertainment* (New Haven: College & University Press, 1966).

T. Adorno, *Prisms* (London: Spearman, 1967).

J. Hall and B. Ulanov (eds), *Modern Culture and the Arts* (New York: McGraw-Hill, 1967).

J. McHale, 'The Plastic Parthenon', *Kitsch* (ed) G. Dorfles, (London: Studio Vista, 1969), pp. 98–110.

G. Debord, *Society of the Spectacle* (Detroit: Red & Black, 1970).

M. Fishwick and R. Browne (eds), *Icons of Popular Culture* (Bowling Green, Ohio: Bowling Green University Popular Press, 1970).

A. Gowans, *The Unchanging Arts: New Forms for the Traditional Functions of Arts in Society* (Philadelphia and New York: Lippincott, 1971).

H. Lefebvre, *Everyday Life in the Modern World* (New York: Harper & Row, 1971).

B. Rosenberg and D. White, *Mass Culture Revisited* (New York: Van Nostrand, 1971).

'Aspects of Popular Culture', *Cultures* 1 (2), 1973.

R. Barthes, *Mythologies* (London: Paladin, 1973).

R. Browne (ed) *Popular Culture and the Expanding Consciousness* (New York: John Wiley, 1973).

M. Fishwick, *Parameters of Popular Culture* (Bowling Green, Ohio: Bowling Green University Popular Press, 1974).

H. Gans, *Popular Culture and High Culture* (New York: Basic Books, 1974).

T. Adorno, 'Culture Industry Reconsidered', *New German Critique* (6), fall 1975, pp. 12–19.

C. Bigsby (ed), *Superculture: American Popular Culture and Europe* (London: Elek, 1975).

C. Bigsby (ed), *Approaches to Popular Culture* (London: E. Arnold, 1976).

S. Hall and T. Jefferson (eds), *Resistance Through Rituals* (London: Hutchinson, 1976).

R. Williams, *Keywords* (Glasgow: Fontana/Collins, 1976).

P. Barker (ed), *Arts in Society: a New Society Collection* (Glasgow: Fontana/Collins, 1977).

M. Real, *Mass-mediated Culture* (Englewood Cliffs, NJ: Prentice-Hall, 1977).

P. Willis, *Profane Culture* (London: Routledge & Kegan Paul, 1977).

A. Swingewood, *The Myth of Mass Culture* (London: Macmillan, 1977).

J. Clarke et al (eds), *Working Class Culture* (London: Hutchinson, 1979).

D. Hebdige, *Subculture: the Meaning of Style* (London: Methuen, 1979).

Social Text (1), winter 1979. (Special issue on mass culture.)

T. Bennett et al (eds), *Popular Television and Film* (London: BFI, 1981).

Open University, *Popular Culture U203, Units 1–32* (Milton Keynes: Open University Press, 1981).

B. Waites (ed), *Popular Culture Past and Present* (London: Croom Helm, 1981).

S. Radnoti, 'Mass Culture', *Telos* (48), summer 1981, pp. 41–7.

P. Brantlinger, *Bread and Circuses: Theories of Mass Culture as Social Decay* (Ithaca and London: Cornell University Press, 1984).

J. Golby and A. Purdue, *The Civilisation of the Crowd: Popular Culture in England 1750–1900* (London: Batsford, 1984).

C. McGregor, *Pop Goes the Culture* (London: Pluto Press, 1984).

M. Fishwick, *Seven Pillars of Popular Culture* (Westport, Connecticut: Greenwood Press, 1985).

S. Kaplan (ed), *Understanding Popular Culture* (The Hague: Mouton, 1985).

K. Andersen, 'Pop goes the Culture', *Time*, 16 June 1986, pp. 52–8.

T. Bennett et al, *Popular Culture and Social Relations* (Milton Keynes: Open University Press, 1986).

G. Brett, *Through our Own Eyes: Popular Art and Modern History* (London: Heretic, 1986).

I. Chambers, *Popular Culture: the Metropolitan Experience* (London: Methuen 1986).

D. Horne, *The Public Culture: the Triumph of Industrialism* (London: Pluto Press, 1986).

C. McCabe, *High Theory/Low Culture* (Manchester University Press, 1986).

T. Modleski (ed), *Studies in Entertainment: Critical Approaches to Mass Culture* (Bloomington: Indiana University Press, 1986).

J. Williamson, *Consuming Passions: the Dynamics of Popular Culture* (London: Marion Boyars, 1986).

P. Buhle (ed), *Popular Culture in America* (Minneapolis: University of Minnesota, 1987).

Cultural Studies vol 1, no 1, 1987.

D. Lazere (ed), *American Media and Mass Culture: Left Perspectives* (Berkeley and Los Angeles: University of California Press, 1987).

F. Inglis, *Popular Culture and Political Power* (Hemel Hempstead: Harvester Wheatsheaf, 1988).

R. Kroes (ed), *High Brow Meets Low Brow: American Culture as an Intellectual Concern* (Amsterdam: Free University Press, 1988).

M. Shiach, *Discourse on Popular Culture* (Cambridge: Polity Press, 1988).

J. Collins, *Uncommon Cultures: Popular Culture and Postmodernism* (New York: Routledge & Kegan Paul, 1989).

J. Fiske, *Understanding Popular Culture* (London: Unwin Hyman, 1989).

R. Maltby (ed), *Dreams for Sale: Popular Culture in the 20th Century* (London: Harrap, 1989).

A. Ross, *No Respect: Intellectuals and Popular Culture* (New York and London: Routledge, 1989).

G. Day (ed), *Readings in Popular Culture* (London: Macmillan, 1990).

T. W. Adorno, *The Culture Industry: Selected Essays* (London: Routledge, 1991).

P. Fussell, *BAD, or, the Dumbing of America* (New York: Summit Books, 1991).

The Modern Review vol 1, no 1, 1991.

R. Dyer, *Only Entertainment* (London: Routledge, 1992).

J. McGuigan, *Cultural Populism* (London: Routledge, 1992).

J. Rubin, *The Making of Middlebrow Culture* (University of North Carolina Press, 1992).

B. Smart, *Modern Conditions, Postmodern Controversies* (London: Routledge, 1992).

INDEX